Appreciating
ART

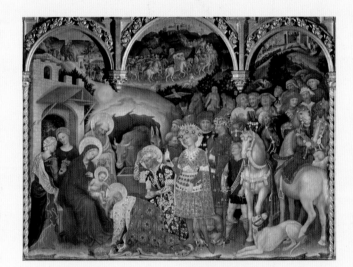

Appreciating
ART

An expert companion to help you
understand, interpret and enjoy

Diana Newall

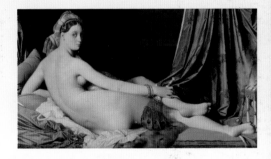

First published in Great Britain 2008 by

A&C Black Publishers

38 Soho Square

London WID 3HB

www.acblack.com

Text copyright © Diana Newall 2008

Design copyright © Ivy Press Limited 2008

ISBN: 978-0-7136-8730-9

A CIP catalogue record for this book is available
from the British Library.

This book was created by

Ivy Press

The Old Candlemakers

Lewes, East Sussex BN7 2NZ, UK

Creative Director Peter Bridgewater

Publisher Jason Hook

Editorial Director Caroline Earle

Art Director Sarah Howerd

Senior Project Editor Stephanie Evans

Design Andrew Milne

Subject Consultant Dr Grant Pooke

Printed in China

**This book is dedicated to the memory
of my parents, Mary and Freddie Newall,
and their passion for art and design.**

Contents

Appreciating Art

Art can be appreciated in many different ways. The pleasure of a painting's visual impact – its aesthetic qualities – can begin an exploration into style or technique; subject matter or hidden meanings; or its deeper cultural significance. Painting offers a window onto society's values and ideals but its appreciation can arise simply from its artistic appeal. Although interests or tastes differ and the variety of painting may seem bewildering, it is possible to approach art in a way that reveals its many different facets and extends its appreciation onto many new levels.

This book describes the different forms and genres in western European painting and the contexts in which they developed over the centuries. Primarily it aims to develop ideas about how to get more out of looking at and understanding paintings. It also explores contemporary ideas about art, offering a deeper understanding and appreciation of art's significance to western European cultural history as a whole.

Starting from the Painting

This book is designed to be a companion for looking at painting and aims to help the viewer get more out of the experience. When we visit an art gallery or museum we may be drawn to particular favourites or may browse to see what captures our interest. When we find ourselves standing in front of a painting, how do we start to appreciate and learn about it? Our first step

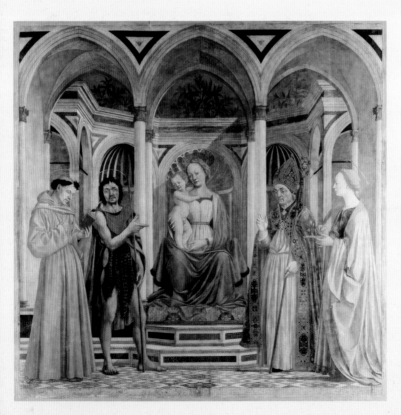

■ DOMENICO VENEZIANO (c.1410–61)
The Madonna and Child with Saints c.1445, Galleria degli Uffizi, Florence.

The Virgin and Child are enthroned within a loggia attended by four saints – (left to right) Francis, John the Baptist (whose face is the artist's self-portrait), Zenobius and Lucy. They stand casually talking to each other as if attending an audience chamber.

JAMES MCNEILL WHISTLER
(1834-1903)
Arrangement in Grey and Black: Portrait of the Artist's Mother 1871, Musée d'Orsay, Paris.

The sitter's sideways position, the muted tones and bold composition were a radical change from traditional portrait forms. The areas of grey and black give the image austerity only partly alleviated by her calm face and the picture on the wall.

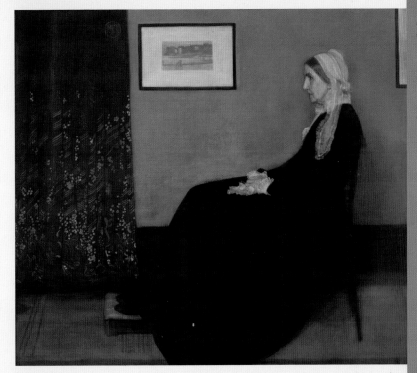

might be to study the painting to see how we feel about what we are looking at. We might be drawn by the skill of the artist; the choice of colours and tones; the shape or line of a figure; the naturalism of the form; the resonance of the narrative or the overall impact of the composition.

Then we might start to ask questions about the artist or the patron, the circumstances of the painting's production or its social or political context. What functions and meanings did the painting have? We might want to know how the style of the work relates to others by the artist or his or her contemporaries. What is its history? How has the artist's style been understood and valued, whether economically, culturally or aesthetically)?

This book helps to explore and answer these questions and reveals art as a visual record of western European cultural, social and political history of equal importance to literature and written histories. In appreciating more wide-ranging explanations for art, the viewer can also begin to get more out of the experience of art beyond an understanding of a single work or movement.

Why is Painting Important?

Painting has been one of the main media for art since Classical times. For many centuries since the Renaissance it has been used to create the illusion of three-dimensional space, as if viewing the subject through a window. During the 20th century it was central to the development of abstract art, which sought to stimulate the visual senses through the use of colour, line and form without mimesis. Although most recently, other forms of art have come to prominence – including three-dimensional installations and sculptures, video and photomontage – painting is still central to the contemporary art world.

Painting has been used for numerous purposes throughout human existence – for the mundane decoration of walls, floors and pots; for the simple enjoyment of recording a *beautiful* subject; for communicating religious messages or contributing to religious experience; for recording important events or telling a story; and for signifying power and status. Its forms and artistic values through the centuries have contributed to our visual framework – our ideas, that is, of identity, place and cultural values.

The Scope of this Book

This book explores painting from the western European tradition, which extends to North America from the late 18th century onwards. Starting from the 15th century it explores art from the Renaissance but each chapter also briefly looks back to outline the predecessors and influential earlier visual forms. It is important to understand the connections between art from different times and places, particularly the Classical heritage of western European art. The book concludes with a discussion of contemporary art and some of the issues which concern painting in the 21st century.

The Academy, Genres and Chapter Format

The chapters of this book largely follow the categories – or genres – of art that were defined by the academies of art across Europe from the 16th century.

The first academies of art were established in Florence in 1563 and in Rome in 1593. Others followed, including one in Paris in 1648 and one in London in 1748. Academies trained artists, setting the standards for art practice, strongly influencing or controlling the production, valuation and sale of art until the late 19th century. Other countries had their academies, too, including the Dutch Republic in Haarlem (1583), and later schools in Utrecht, Amsterdam and the Hague; The Saint Petersburg Academy was established in 1757, and in the USA the first academy was formed in Philadelphia in 1749.

The hierarchy of genres defined by the academies was, in order of importance: historical painting (including mythological and religious subjects); portraiture; landscape; 'genre' subjects taken from everyday life; and, finally, still life. Some works of art crossed these boundaries and the hierarchy was not universal. For example, in the Dutch Republic 'genre' and still-life paintings were more important than elsewhere, and from the 19th century landscape grew increasingly in importance.

The development of each category of art follows a different path, rising to prominence in different places at various times. Hence, religious painting, for example, is most important during the 15th and 16th centuries in both Italy and the Netherlands; still-life and 'genre' painting reach their peaks in the 17th and 18th centuries largely in the Dutch Republic; and landscape painting is of particular significance in 19th-century England, France and the USA. The structure of each chapter follows these patterns, emphasising the most significant periods chronologically.

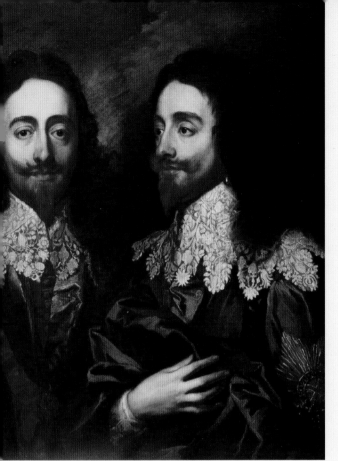

▮ **ANTHONY VAN DYCK**
(1599–1641)
Charles I, King of England, in Three Positions 1636,
Windsor Castle,
Royal Collection, UK.

This was painted to provide a model for a sculpted bust of Charles by Gian Lorenzo Bernini (1598–1680) in Rome. Van Dyck's portraits offer an intimate view of the Royal Family and echo Charles' belief in his divinely ordained role.

▮ **SAMUEL PALMER**
(1805–81)
In Cusop Dingle near Hay-on-Wye 1837,
Private Collection.

Palmer's landscapes explored the romantic ideal of the natural world. The translucence of watercolour captured the scene's frosty qualities. The medium grew in popularity in Britain from the mid 18th century and was employed by Turner for landscape sketches.

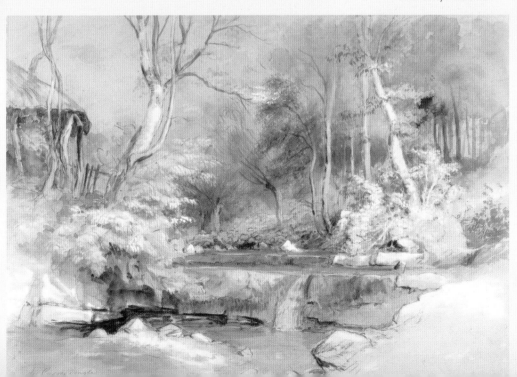

How to Use this Book

The first eight chapters discuss the categories of Western painting from 1400 to 1900 and the final one considers painting in the 20th and 21st centuries. The chapters can be read as a whole, providing a survey of the development of each category and drawing on a selection of paintings that characterise the subject. The introduction to each chapter provides an overview and highlights some of the themes that are discussed in more depth within the chapter.

The following spread (*pages 12–13*) demonstrates how a single painting can provide pointers to analysing its key elements. This can be used in conjunction with any chapter, or painting, and aims to help the viewer get more out of looking at a painting. The development of painting from 1400 is summarised in a Chronology (*pages 14–19*). This acts as a quick reference for periods, movements and artists as well as for setting individual paintings within the broader framework of art history. The information in the Chronology gives a reference to individual chapter pages and therefore can be used to locate artists and paintings in the book.

The Appendices list major art galleries and museums around the world, with addresses and websites to guide you to the places where you can see the key works discussed in the book. A glossary of terms and keywords appears on page 183. Suggested further reading covers art, art history in general and in each category; and Web Resources offers a guide to art on the internet.

How to Use Individual Pages
Double pages in each chapter cover periods within the category, for example, The Portrait 1400–99. Each spread discusses relevant themes using a number of paintings chosen to exemplify the art and artists of the period. The main text is

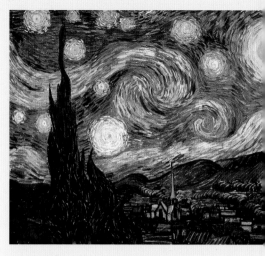

▎ **VINCENT VAN GOGH** (1853–90)
Starry Night 1889, Museum of Modern Art, New York.

The energy in van Gogh's brushstrokes and the rich contrasting colours in the sky capture the twinkling halos of stars and moon. The dark blue and violet landscape studded with orange candle-lit windows is balanced by the spiral tree and church spire.

▎ **SALVADOR DALÍ** (1904–89)
Le Rêve (The Dream) 1931, Private Collection.

Dalí's smooth surfaces, disturbing details, such as closed eyes, missing anatomy and melting clocks engage the viewer in an irrational subconscious world.

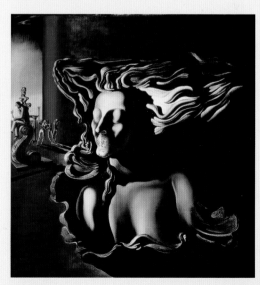

supported by panels that act as navigational and information guides. These boxed features are ideal starting points for studying any featured painting or a related work. They can also be used to study any work that falls within the category or period – either similar works by the featured artists or their contemporaries. Simply look at the date and category of the painting to locate the relevant chapter to which it can be related.

Appreciating...

This panel highlights key issues that are relevant to the period with the aim of consolidating interpretations of the art and extending appreciation.

Related Works

This panel lists other works by artists relevant to the period discussed on the page. It includes works by contemporary artists together with details of where to see the paintings.

Keywords

Terms or words relevant to the category are defined in clear panels on the page. Usually these are art historical terms but the panels may also include the definition of key art movements and people, which are particularly associated with the period.

Related Topics/Artists

Cross-references to connected works in other chapters are provided in the margin panel.

Quick Artists Reference

The opening page of each chapter includes a Quick Artists Reference to indicate the key artists associated with the genre in each century.

APPRECIATING...

Exploring the significance of landscape in religious art:

- consider the relationship between landscape and subject

- how does the landscape contribute to the narrative?

- how do the detail, figures, activities, architecture and nature of landscape contribute to the religious message and provide tangible context for the scene?

RELATED WORKS

- **Fra Angelico** *The Cortona Altarpiece* (The Annunciation) 1433–34, Museo Diocesano, Cortona.
- **Andrea Mantegna** *The Agony in the Garden* c.1459, National Gallery, London.
- **Hans Memling** *Saint John Altarpiece* 1474–79, Memlingmuseum, Sint-Janshospitaal, Bruges.

KEYWORDS

Single-point perspective single-point perspective was developed by Filippo Brunelleschi during the early 15th century. Scenes were constructed to have a vanishing point, that is, the line of buildings and sizes of figures were arranged to recede to a single point. Religious paintings were viewed as though from one position, communicating directly to humans.

QUICK ARTISTS REFERENCE

15th century Sandro Botticelli, Masaccio, Antonio Pollaiuolo

16th century Agnolo Bronzino, Caravaggio, Annibale Carracci, Correggio, Lucas Cranach the Elder, Michelangelo, Titian

17th century Caesar Boetius van Everdingen, Nicolas Poussin, Rembrandt van Rijn, Pieter Pauwel Rubens, Diego Velázquez

18th century François Boucher

19th century William Bouguereau, Paul Cézanne, Edgar Degas, Eugène Delacroix, William Etty, Jean-Léon Gérôme, Jean-Auguste-Dominique Ingres, Édouard Manet, Pierre-Auguste Renoir

RELATED TOPICS/ARTISTS SEE HOW TO LOOK ON PAGES 12–13; SEE ALSO THE GLOSSARY, PAGE 183

How to Look

Art historian Erwin Panofsky (1892–1968) proposed a three-stage approach – trichotomy – to analysing art. First is the pre-iconographic stage, in which formal qualities are studied – basic forms, composition, colour, tone, line, etc. Second is the iconographic stage, in which symbols are explored. Third is the study of iconology or broader social context. This annotated spread gives guidance for exploring Panofsky's first two stages, identifying elements to be analysed either individually or collectively. The suggested approach can then be used to explore other paintings or representations.

What colours are used, and what are their types?

Primary/secondary, complementary/adjacent, bright/muted, hot/cold, or dominant/recessive colours? Most are mute, emphasising Liberty's dress, the flag and the figure at Liberty's feet. The warm yellow echoed across the painting unifies the scene without detracting from the revolutionary colours.

Has the paint medium affected the style?

Tempera was hard-edged and long lasting; oil (used here) allowed for greater blending, naturalism, thickness and texture. Watercolour layers and washes produce translucence and fine detail. Modern paints such as gouache (a watercolour with white pigment), acrylic and commercial paints have different qualities which suit the diversity of contemporary painting.

How has the scene been composed?

Light and dark create depth and space; lines reinforce perspective, vanishing points and foreshortening; figures, objects and shapes create balance and symmetry; the scene may have a foreground, middle ground and background. The lines of the guns lead the eye to Liberty. Other lines, for example the satchel strap on the left-hand figure, add complexity and balance. The action is all in the foreground with the massed crowd in the middle ground and Paris crumbling in the background.

What is the style?

Style was a connoisseurial term generally used to judge quality. It is still used to explore the degree of naturalism in the representation; to consider the type of brushstroke – visible/ smooth, thickly/thinly applied; to explore formal features which typify an artist's work. Delacroix uses light, tone and colour to create vibrancy. His soft brushstrokes and sketchy detail contrast works by his contemporary Jean-Auguste-Dominique Ingres (1780–1867) (see pages 32 and 51).

Is the scene active, lively, static or calm?

Are the figures contorted, elongated or twisted? Movement is apparent in the swirling smoke, crowd activity and Liberty's raised arms. The upright figures contrast to the dead or dying, but they are not exaggerated. Liberty turns her head back to check that the crowd is following, as if she were pausing before the final assault.

How are lines used?

Liberty's arm, body and gun are one group of lines that thrust forward, echoed by the child and the weapons of the figures behind; the limbs of fallen figures provide another group of lines that form a base to the composition.

Which parts are light and dark, and is there any direction to the light?

How has tone been used to create shape, depth and form? The light shines from the top left onto Liberty and the fallen figure to the left. The light picks out faces, figures and detail drawing the viewer's eye around the painting and linking Liberty to the crowd.

How have the figures been defined?

Is the shape of the limbs pronounced; are the clothes darkly folded? Have lines been used to emphasise limbs or are they softly coloured? Delacroix's figures have dark shadows with softly painted folds. Some details are sketchy emphasising the key figures in the action.

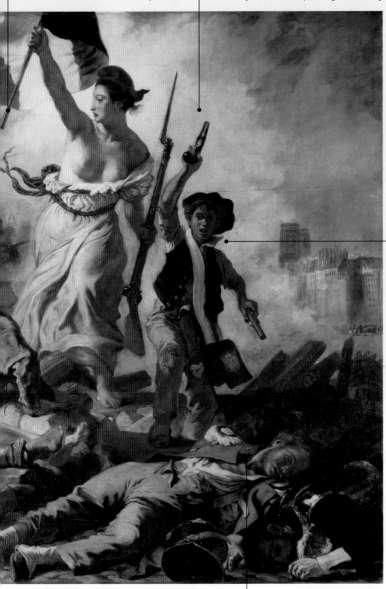

❙ **EUGÈNE DELACROIX** (1798–1863)
Liberty Leading the People (28th July 1830)
1830, Musée du Louvre, Paris.

The political message of Delacroix's painting of French Republicanism draws on the representation of contemporary events. The allegorical female figure of Liberty with her bare breast commemorated the July Revolution which overthrew King Charles X, the last Bourbon King of France. The citizens, including the artist's self portrait as the top-hatted figure to the left, surge to victory over the fallen, creating one of the most evocative revolutionary images.

Are there any symbols?

The symbols of the revolution are the tricolour flag, the fallen figure's rosette, the emblems on the satchels and helmets. Less obvious are the dead soldier's worn boots; the vulnerable, half-naked figure possibly symbolising France, and the female personification of Liberty signifying the Republican cause: liberté, égalité, fraternité (liberty, equality, brotherhood).

13

1400–1600

EARLY RENAISSANCE

Masaccio
1401–28

page 56

Fra Angelico
c.1400–55

page 57

Piero della Francesca
c.1415–92

pages 58–59

Paolo Uccello
c.1397–1475
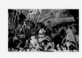
pages 90–91

Sandro Botticelli
1445–1510
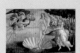
page 24

Domenico Veneziano
c.1410–61
page 6

NORTHERN RENAISSANCE

Jan van Eyck
1395–1441

page 39

Hugo van der Goes
c.1440–82

page 121

Hans Memling
c.1440–94
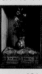
page 106

Hieronymus Bosch
c.1450–1516

page 72

Rogier van der Weyden
c.1400–64
page 57

INTERNATIONAL GOTHIC

Limbourg brothers
c.1385–1416

page 140

Gentile da Fabriano
c.1370–1427
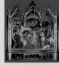
page 38

Pisanello
1395–1455

page 39

Giovanni Bellini
early 1430s–1516

page 61

Andrea Mantegna
c.1430/31–1506

page 141

Timeline

This can be used to locate artists within the traditional movements and periods of Western European art. Some works are illustrated and other artists are included whose paintings appear in this book. A more comprehensive list of all the artists referenced appears in the index (see pages 188–91).

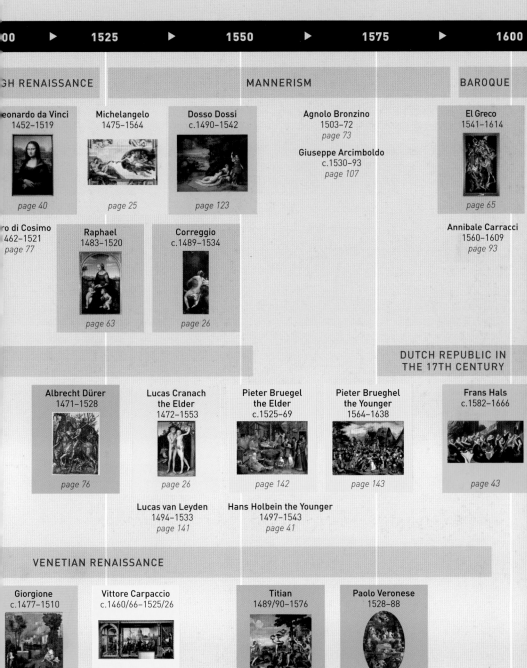

| 00 | ▶ | 1525 | ▶ | 1550 | ▶ | 1575 | ▶ | 1600 |

GH RENAISSANCE　　　　　**MANNERISM**　　　　　**BAROQUE**

eonardo da Vinci
1452–1519

page 40

Michelangelo
1475–1564

page 25

Dosso Dossi
c.1490–1542

page 123

Agnolo Bronzino
1503–72
page 73

Giuseppe Arcimboldo
c.1530–93
page 107

El Greco
1541–1614

page 65

ro di Cosimo
462–1521
page 77

Raphael
1483–1520

page 63

Correggio
c.1489–1534

page 26

Annibale Carracci
1560–1609
page 93

**DUTCH REPUBLIC IN
THE 17TH CENTURY**

Albrecht Dürer
1471–1528

page 76

**Lucas Cranach
the Elder**
1472–1553

page 26

**Pieter Bruegel
the Elder**
c.1525–69

page 142

**Pieter Brueghel
the Younger**
1564–1638

page 143

Frans Hals
c.1582–1666

page 43

Lucas van Leyden
1494–1533
page 141

Hans Holbein the Younger
1497–1543
page 41

VENETIAN RENAISSANCE

Giorgione
c.1477–1510

page 122

Vittore Carpaccio
c.1460/66–1525/26

page 91

Titian
1489/90–1576

page 77

Paolo Veronese
1528–88

page 78

15

c.1600–1800

MANNERISM

BAROQUE

Caravaggio
c.1571–1610

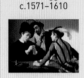

page 143

Pieter Pauwel Rubens 1577–1640

page 42

Diego Velázquez
1599–1660

page 30

Nicolas Poussin
1594–1665

page 125

Claude (Lorrain)
c.1600/5–82

page 124

Jan Brueghel the Elder
c.1568–1625
page 125

Artemisia Gentileschi
1593–1652
page 65

Juan de Espinosa
c.1628–59

page 109

Bartolomé Murillo
1617–82
page 66

Anthony van Dyck
1599–1641
pages 8–9

Guido Reni
1575–1642
page 79

**Charles
le Brun**
1619–90
page 94

DUTCH REPUBLIC IN THE 17TH CENTURY

Ambrosius Bosschaert the Elder 1573–1621

page 108

Pieter Claesz
1597–1661

pages 110–11

Johannes Vermeer van Delft 1632–75

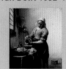

pages 146–47

Jacob Isaackszon van Ruisdael
1628–82

pages 126–27

Aelbert Cuyp
1620–91

page 126

Pieter Codde
1599–1678

page 145

Rembrandt van Rijn
1606–69

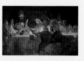

page 95

Gerrit Dou
1613–75

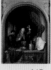

page 145

Jan Steen
1626–79

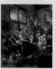

page 139

Cornelis Claesz. van Wieringen 1580–1633
page 92

Hendrick Avercamp
1585–1635
page 123

Caesar Boetius van Everdingen
c.1617–78
page 79

David Teniers the Younger 1610–90
pages 144–45

Willem van Aelst
1627– c.1683
page 109

| 0 ▶ | 1725 ▶ | 1750 ▶ | 1775 ▶ | 1800 |

ROCOCO

NEO-CLASSICISM

...spar Andriaans van Wittel 1653–1736

page 128

Giovanni Battista Tiepolo 1696–1770

page 66

Jean-Baptiste-Siméon Chardin 1699–1779

page 113

Jacques-Louis David 1748–1825

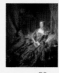

page 50

Marie-Louise Élisabeth Vigée-Lebrun 1755–1842

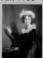

page 49

...o Maratti 25–1713 ...age 45

Giuseppe Maria Crespi 1665–1747 page 112

Canaletto 1697–1768

page 129

Giovanni Paolo Pannini 1691–1765 page 129

François Boucher 1703–70

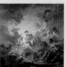

page 31

Benjamin West 1738–1820 page 97

Rosalba Carriera 1675–1757 page 73

Jean-Honoré Fragonard 1732–1806 page 150

ROMANTICISM

Pietro Longhi 1702–83 page 148

Francisco de Goya y Lucientes 1746–1828

page 49

Henry Fuseli 1741–1825 page 81

...an van Huysum 1682–1749

page 112

BRITAIN IN THE 18TH & 19TH CENTURIES

William Hogarth 1697–1764

page 97

George Stubbs 1724–1806

page 151

Joseph Wright of Derby 1734–97

pages 150–51

Angelica Kauffmann 1741–1807

page 81

Allan Ramsay 1713–84 page 48

Thomas Gainsborough 1727–88 pages 46–47

1800–Present

1800	▷	1825	▷	1850	▷	1875	▷	19

NEO–CLASSICISM

**Jean-Auguste-
Dominique Ingres**
1780–1867

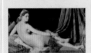

page 32

REALISM

Gustave Courbet
1819–77

page 152

Édouard Manet
1832–83

page 101

Camille Corot
1796–1875
page 131

Camille Pissarro
1830–1903
page 135

Gustave Caillebotte
1848–94
page 114

IMPRESSIONISM

Claude Monet
1840–1926

pages 132–33

Mary Cassatt
1844–1926
page 153

Edgar Degas
1834–1917
page 33

PO

Paul Cézanne
1839–1906

page 135

Paul Gauguin
1848–1903
page 69

Vincent van Gog
1853–90
page 10

Georges Seura
1859–91
page 119

**Henri de Toulous
Lautrec** 1864–19
page 153

ROMANTICISM

John Constable
1776–1837

page 118

**Caspar David
Friedrich** 1774–1840

page 130

Eugène Delacroix
1798–1863
pages 12–13

Josef von Führich
1800–76
page 68

Samuel Palmer
1805–81
page 9

Théodore Géricault
1791–1824
pages 100–1

**Joseph Mallord
William Turner**
1775–1851
page 100

**Jean-Léon
Gérôme**
1824–1904
page 33

19TH-CENTURY
AMERICAN ARTISTS

**James McNeill
Whistler** 1834–1903

page 7

Albert Bierstadt
1830–1902
pages 130–31

BRITAIN IN THE 18TH & 19TH CENTURIES

William Blake
1757–1827

page 67

**William Powell
Frith** 1819–1909

page 153

**William Holman
Hunt** 1827–1910

page 69

**Dante Gabriel
Rossetti** 1828–82

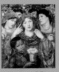

page 85

Frederic Leighton
1830–96
page 84

**John Singer
Sargent** 1856–19

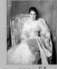

page 51

**Samuel John
Peploe** 1871–1935
page 156

▶	**1925**	▶	**1950**	▶	**1975**	▶	**2000**

**PRESS-
NISM**

**CUBISM &
FUTURISM**

ABSTRACT ART

MINIMALISM

Umberto Boccioni
1882–1916

page 159

Kasimir Malevich
1878–1935

page 160

Jackson Pollock
1912–56
page 157

Mark Rothko
1903–70
page 161

Bridget Riley
b.1931

page 169

Pablo Picasso
1881–1973
page 165

Vassily Kandinsky
1866–1944
page 161

Sol LeWitt
1928–2007
page 168

Frank Stella
b.1936
page 169

ndré Derain
880–1954
page 158

**20TH-CENTURY
REALISM**

POSTMODERNISM

Isaac Brodsky
1884–1939

page 164

Gerald Laing
b.1936

page 173

Marc Quinn
b.1964

page 172

David Hockney
b.1937
page 165

Anselm Kiefer
b.1945
page 170

Anish Kapoor
b.1954
page 173

Tracey Emin
b.1963
page 171

Jenny Saville
b.1970
page 171

DADA & SURREALISM

POP ART

Max Ernst
1891–1976
page 163

Salvador Dali
1904–89

page 10

Richard Hamilton
b.1922
page 166

René Magritte
1898–1967
page 162

Roy Lichtenstein
1923–97
page 167

iorgio de Chirico
1888–1978
page 163

Andy Warhol
1928–87
page 167

The Nude

'The nude does not simply represent the body, but relates it, by analogy, to all structures that have become part of our imaginative experience.'

KENNETH CLARK (1903–83)

QUICK ARTISTS REFERENCE

15th century Sandro Botticelli, Masaccio, Antonio Pollaiuolo

16th century Agnolo Bronzino, Caravaggio, Annibale Carracci, Correggio, Lucas Cranach the Elder, Michelangelo, Titian

17th century Caesar Boetius van Everdingen, Nicolas Poussin, Rembrandt van Rijn, Pieter Pauwel Rubens, Diego Velázquez

18th century François Boucher

19th century William Bouguereau, Paul Cézanne, Edgar Degas, Eugène Delacroix, William Etty, Jean-Léon Gérôme, Jean-Auguste-Dominique Ingres, Édouard Manet, Pierre-Auguste Renoir

Representing the human body has been central to art for millennia. This is demonstrated by the small stone carving of a naked, well-rounded, faceless female figure known as the *Venus of Willendorf*, dated to 20,000–24,000BC. In his book *The Nude* (1956) the art historian Kenneth Clark explored the genre from Classical Greece to the 20th century. He distinguished between 'naked' and 'nude': the natural human form and its idealised or stylised representation. More recently, consideration of the nude has centred on the relationship between its form, the viewer and a wider debate on gender relationships and power.

What does the term 'nude' mean? The distinction between 'naked' and 'nude' is that the former is the state of being unclothed, whereas in the latter, the human body is displayed for the pleasure of the typically male viewer. Female and male nudes elicit different responses, reflecting the varied contexts of the images. From the time of Classical Greece (5th century BC) naked representations of gods, goddesses and heroes more closely emulated the natural form of the human body. These works provided models for Renaissance artists. From the 15th century, representations of the Roman goddess of love – Venus – allowed for the display of the nude female form for the patron's pleasure. The viewer had become a voyeur – the sexuality and eroticism within these images was veiled but implied. Mythological subjects of love, sexual desire and coupling became popular vehicles for the nude.

Challenges to the hidden meanings of the female nude began in the mid-19th century with Édouard Manet's *Le Déjeuner sur l'Herbe* (1863) which mimicked the composition of pastoral scenes by Titian, Giorgione and Marcantonio Raimondi. The confident expression of the naked woman in the foreground, however, overturns the dominance of the viewer's gaze. During the early 20th century, the form of the nude continued to absorb artists (*see Picasso, page 159*). More recently, feminist theory has argued that the nude objectifies the female body, reinforcing the patriarchal hegemony of Western society. Contemporary artists, such as Lucian Freud and Jenny Saville (*see page 171*) represent the unidealised, naked human body in order to explore and challenge concepts of the nude, beauty, identity and gender.

Idealised Images of the Classical World

Representations of the human body in ancient cultures were often stylised, for example, in Cycladic (3300–2000BC) and Egyptian (c.3000–0BC) art. In these cultures, the human body would be drawn or sculpted into artificially regular shapes – unmistakably human, but formulaic. The development of more naturalistic forms around the 5th century BC, in Classical Greece, is traditionally associated with the rise of democratic political structures in Athens. The idealised, naked, male body signified youth, virility and the Greek ideal of superiority. Athletes performed naked at the games, while warriors, such as the Spartans, fought with little but armour to protect them.

The Classical Male Nude

The naturalism of Classical Greek sculpture is belied by its idealisation. Naturalistic forms developed gradually, with standing male figures first acquiring a tilt of the hips, and then movement, with greater muscular and skeletal definition. However, the face, hair, limbs and torso continued to have regular and perfected forms.

Contemporary texts describe the rules of the artist Polykleitos (mid-5th century BC) for the perfectly proportioned physique. Such sculptures as *Discobolos* (a Roman marble copy of a Classical Greek original by Myron, c.450BC) represent a discus-thrower with emphasised musculature and a formalised pose. Greek youths trained and developed their physical prowess for the games, especially those held at Olympia. The naked male form symbolised the strength and ideals of the Greek athlete, warrior, hero and city-state. These sculptures might have been created to commemorate to the gods an athlete's success or a warrior's death. The gods and heroes of Greek mythology – including Apollo, Herakles (Roman: Hercules), Jason and Perseus – were also represented as naked humans, reinforcing the association between male nakedness and heroism. Greek pot decorations recounted heroic exploits, whilst statues of the gods were used in their temples.

The importance of the Classical Greek representation of the human form to Western art cannot be over-emphasised. Central to the rise of naturalism in the Renaissance, the art of Classical Greece was also valorised by the art historian Johannes Joachim Winckelmann (1717–68) as

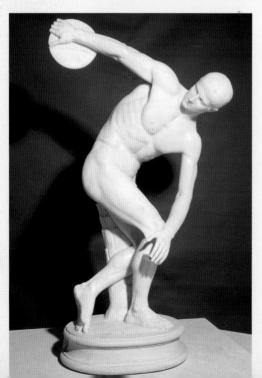

▌ CLASSICAL GREECE *Discobolos*
(Roman copy of the Greek original by Myron)
c.450BC, Palazzo Masimo,
Museo Nazionale Romano, Rome.

Many Roman copies of Myron's sculpture survive, such as in the British Museum, London. Comparable sculptures from this period include Doryphoros *(a spear-bearer, original by Polykleitos, mid-5th century BC) and sculptures from the temple of Zeus at Olympia (c.460BC) and the Parthenon (440s–430sBC).*

the ultimate achievement of perfect form. His writings laid the foundation for western European art-historical theories, which were not challenged until the 20th century.

Aphrodite Revealed

The Hellenistic period spans the three centuries from the spread of Greek power after Alexander the Great's death (323BC) to the fall of the Greek Ptolemaic dynasty in Egypt with the suicide of Cleopatra (30BC). In art, the human form became more exaggerated and expressive. This is exemplified in the Great Altar (before 133BC, now in the Pergamonmuseum, Berlin) from the Attalid capital of Pergamum, founded by one of Alexander's generals in western Turkey, and in the *Laocoon* (date uncertain, *see page 89*). These sculptures emphasise the contorted bodies and extreme emotions of battle in contrast to the serenity of the Classical period.

The first Greek representation of the nude female form probably dates to this period. According to Pliny the Elder (AD23–79), the artist Praxiteles created a nude representation of the goddess Aphrodite (Roman: Venus) around the mid-4th century BC. Worshipped and prized by the people of Knidos, this sculpture gained fame for its beauty. Although the original sculpture does not survive, we have a Roman account of a visit to the goddess' temple, describing the powerful, erotic impact of the statue's beauty. Aphrodite was described as naked, with her hand covering her modesty. The *Venus de Milo* (from the island of Milos, late 2nd or 1st century BC) with a conveniently draped robe, demonstrates the attractions of the nude goddess. Her idealised, remote form, fine features and stylised hair became the model for nude representations of Venus during the Renaissance.

Interpreting the Nude

Classical male and female nude forms signified meaning in different ways, the former symbolising heroic ideals and the latter portraying ethereal, feminine beauty. Their significance was determined by the cultural values of contemporary Greek society. From the Renaissance, nude forms emulated Classical models, but their function and significance was different. In exploring the nude in Western art, one must continue to ask oneself, 'Why was this image created?'

RELATED TOPICS/ARTISTS
LAOCOON, PAGE 89

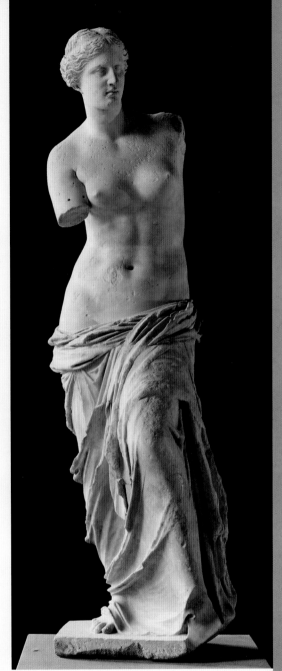

▌ HELLENISTIC GREECE *Venus de Milo*
Late 2nd or 1st century BC, Musée du Louvre, Paris.

Possibly one of the best-known Greek sculptures of Venus (Greek: Aphrodite), her smooth skin, young figure and perfect, enigmatic face may account for her notoriety. The original position of the arms has fuelled hot debate – was she playing a musical instrument or adjusting her hair? A late-19th-century cartoon mocked this obsession, with one version depicting her blowing her nose!

The Renaissance Nude

Renewed interest in Classical myths and artistic forms during the 15th century presented novel subjects for artists and patrons. In religious art, the naked human form had been primarily associated with Adam and Eve, for example, in *The Expulsion* (1420s) by Masaccio. Translations of Classical texts and studies of antique sculpture provided a new paradigm for the nude.

KEYWORDS

Renaissance (renewal or rebirth) coined in the 19th century to describe the return to Classical artistic values in 14th–16th-century Italy. The Italian word *rinascita* ('rebirth') was similarly used by Giorgio Vasari (1511–74). The concept of one Classical revival has been challenged, and the word is now used in other contexts. In Italy, the *Early Renaissance* spans the 15th century, and the *High Renaissance*, the period from Leonardo da Vinci, c.1490s–1527.

Venus Reborn

During the 15th century, the Medici and other prominent families were integral to the artistic developments in Early Renaissance Florence. Cosimo de' Medici's (1389–1464) return from exile in 1434 heralded a flourishing of artistic patronage and innovation across art and architectural practice. His grandson, Lorenzo, called 'the Magnificent', continued the tradition of supporting the arts and had associations with Leonardo da Vinci, Sandro Botticelli and Michelangelo Buonarroti.

Within Lorenzo's circle, the Neo-Platonist philosopher and theologian Marsilio Ficino (1433–99) sought to unite Classical Greek philosophical ideals and values with Christian theology. It is thought that Botticelli's *Primavera* (c.1482, *see page 74*) and *The Birth of Venus* (c.1484–86) are symbolic of the Classical female virtues applied to contemporary Florentine society. The Roman goddess of love, Venus, born fully grown, is blown ashore by a zephyr and nymph, where her attendant waits to robe her. Venus covers herself with her hair and hands in the form of the Classical 'modest Venus'.

Botticelli's works were among the first paintings to represent Classical subjects since

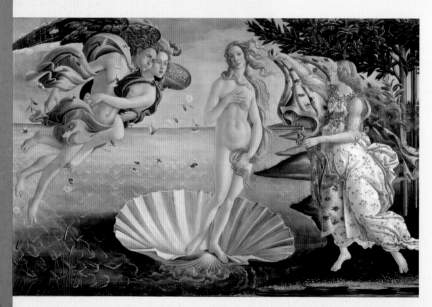

❚ SANDRO BOTTICELLI (1445–1510)
The Birth of Venus c.1484–86, Galleria degli Uffizi, Florence.

Despite her awkward feet and over-long neck, Botticelli's Venus encapsulates an ideal of feminine beauty. Using tempera mixed with a little oil, his painting style is highly refined, with exceptionally fine detail, subtle colours and soft toning.

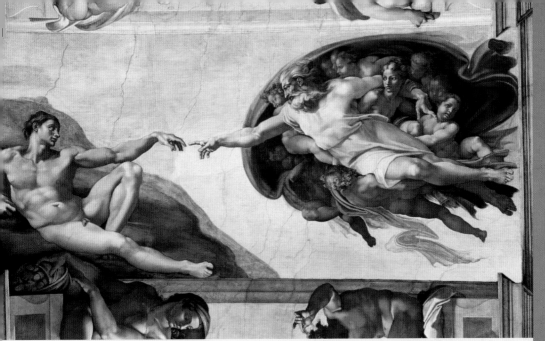

antiquity. Antonio Pollaiuolo also painted scenes of the Labours of Hercules (c.1460) in which the muscular, nude hero battles malevolent forces. These works were probably commissioned for the Medici palazzo.

'... and man became a living soul' (Gen. 2:7)
Nude representations of biblical figures drew on the concept of the hero and naturalistic forms from the Classical world. Such artists as Donatello went to Rome to study, and his bronze *David* (c.1446–60) demonstrates his knowledge of the Classical nude. Michelangelo's marble *David* (1501–4) captures the calmness of Classical Greek sculpture in its taut musculature and sinews, idealised face and stylised, windswept hair. Michelangelo visited Rome between 1496 and 1499, and returned in 1505 to work for Giuliano della Rovere, Pope Julius II (pontiff from 1503–13). He was commissioned to sculpt Julius' tomb (there were many different plans, but the completed tomb is in San Pietro in Vincoli, Rome) yet the painting of the Sistine Chapel ceiling took precedence. In the centre, God stretches out his hand to give life to the languid Adam. Michelangelo's style emulates his sculptural works, with strong tonal contrasts and delineated forms creating the muscular power of the figures. The Classical world truly brought the Christian message alive.

▌ **MICHELANGELO BUONAROTTI** (1475–1564)
Sistine Chapel: Detail of God and Adam
1508–12, Vatican, Rome.

Pope Julius II fought, literally, to regain the Papal States, pursuing Church reform and an artistic programme that spread across Rome. The Laocoon *(see page 89), discovered in 1506, demonstrates muscular power and sculptural detail comparable to those seen in Michelangelo's Adam.*

RELATED WORKS

- **Masaccio** *The Expulsion* 1420s, Brancacci Chapel, Santa Maria del Carmine, Florence.
- **Antonio Pollaiuolo** *Hercules and the Hydra and Hercules and Antaeus* c.1460, Galleria degli Uffizi, Florence.

APPRECIATING...

The Renaissance nude explored ideas and values that were initially religious, but which became increasingly secular. The nude genre, along with other 15th-century art practices, signified the emergent world-view of a merchant and aristocratic class concerned with propagating Classical ideals through the prism of their own values. Representations of the nude during this period typically presented the woman as an object for the connoisseurial gaze of the patron.

Love, Sexual Desire & Sinful Nakedness

Certain patrons demanded more explicit nude subjects during the 16th century. Venus, Cupid and the sexual exploits of the Classical gods became particularly popular. The first reclining female nudes represented both titillation, in the provocative pose, and the detached ideal of sexual fulfilment. In contrast, in northern Europe, the nakedness of Adam and Eve continued to symbolise the vulnerability of humanity in the context of sin and redemption. Throughout the period, however, nudity continued to be idealised.

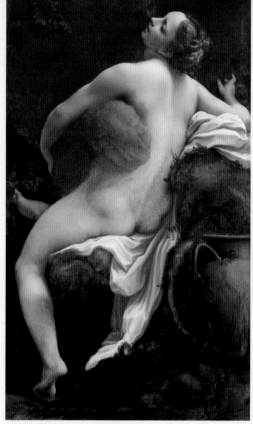

❚ CORREGGIO (c.1489–1534)
Jupiter and Io (detail) 1531–32, Kunsthistorisches Museum, Vienna.

Federigo II Gonzaga, Duke of Mantua, planned to line a room with images of Jupiter's lovers. Here the hand and mouth of the ghostly god embracing Io is just visible. Her apparent ecstasy was designed to stir the imagination of Federigo and his court, and to echo his own amorous exploits.

Related Works
- **Titian** *Venus of Urbino* finished 1538, Galleria degli Uffizi, Florence.
- **Annibale** Carracci *Venus Adonis and Cupid* c.1595, Museo del Prado, Madrid.
- **After Michelangelo** *Leda and the Swan* after 1530, National Gallery, London.

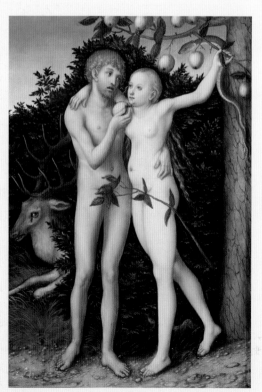

❚ LUCAS CRANACH THE ELDER (1472–1553)
The Fall 1538, Kunsthistorisches Museum, Vienna.

Cranach painted numerous representations of this subject, characterised by the snake, a seductive Eve, a hesitant Adam, the lush Garden of Eden, and a stag – symbolising Christ's resurrection. The delicately placed leaves emphasise Adam and Eve's nakedness, alluding to their imminent fall.

APPRECIATING...

Representations of nudes during this period developed within the sphere of wealthy male patrons seeking novel and stimulating images for their palaces. Whether in the eyes of the male viewer or the knowing Cupid, the female body became a central theme of painting. It is unsurprising that the subject of love, desire and sexual encounter should have been of keen interest to the male patron. The objectification of the female body in these nudes, however, increasingly signified the subordinate status of woman within a dominant patriarchal society.

Gods, Goddesses and Lovers

Graeco–Roman myths provided a wide selection of subjects relating to love, sexual desire and erotic stimulation. Aristocratic male patrons commissioned paintings that encapsulated their amorous and sexual exploits. The subjects, setting and style of painting all contributed to the effect.

Representations of Venus (the Roman goddess of love) and Cupid (the god of erotic love) offered thinly veiled allusions to sexual engagements. Titian's *Venus of Urbino* (finished 1538) like its predecessor, *Sleeping Venus* (c.1510), started by Giorgione, unmistakably places the female body on display for the pleasure of the viewer. More elaborate scenes usually involved a female character being courted, embraced or even raped by a male antagonist, as in *Leda and the Swan*, after Michelangelo (after 1530), Correggio's *Jupiter and Io* (1531–32) and Annibale Carracci's *Venus, Adonis and Cupid* (c.1595). Representations of Jupiter's (Greek: Zeus') exploits when he assumed non-human forms – for example, golden light or rain to impregnate Danaë with Perseus – held overtones of conquest and submission.

Although never presenting explicit sexuality, the smooth skin, shining and abundant hair, sensuous textiles, bedroom settings and rich trappings in such paintings signified the pleasures of the flesh.

'...and they knew that they were naked' (Gen. 3:7)

On the other side of the coin, nakedness and nudity alluded to the sins of humankind. Lucas Cranach the Elder's representations of Adam and Eve focus on the point when Eve is deceived by the snake into offering the apple of the Tree of Knowledge to Adam. They realise that they are naked, and, in his anger,

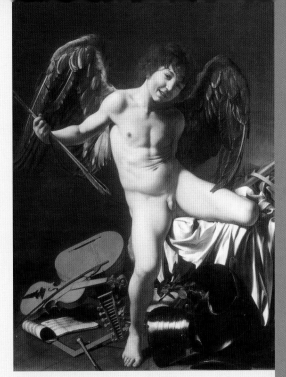

■ **CARAVAGGIO** (c.1571–1610)
Victorious Cupid (Amor Vincit Omnia) c.1602,
Staatliche Museen, Berlin.

The cheeky, blatantly exposed figure of Love is portrayed victorious over academic and earthly pursuits, symbolised by papers, armour, crown and instruments. Caravaggio's characteristic high tonal contrasts illuminate the adolescent Cupid and smooth, sensuous surfaces.

God expels them from the Garden of Eden. Cranach also painted Classical subjects, such as the Three Graces, Venus and Cupid, using the same pale form of the nude as in *The Fall* (1538). Perhaps less sensuous or overtly erotic than contemporary Italian works, Cranach's nudes also exploit the symbolism of the naked human body.

KEYWORDS

Northern Renaissance a broad term encompassing the works of mid-15th-century Flanders, but including the spread of Italian Renaissance forms and subjects from the second half of the 15th century. Naturalistic forms and humanist interests developed in northern Europe in parallel with earlier styles, reaching England during the Elizabethan period (1558–1603).

Shining Beauty

Putti

The presence of small, winged, child-like figures (singular putto, *plural* putti) *in works of this period are often associated with love and sexual encounters. They act here to crown Venus for her beauty.*

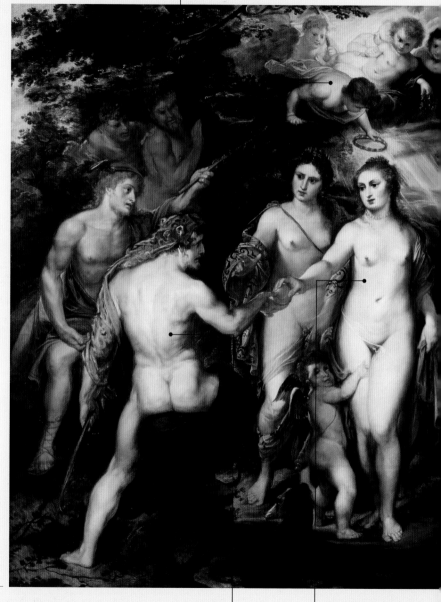

■ PIETER PAUWEL RUBENS (1577–1640) *The Judgement of Paris* c.1599, National Gallery, London.

The Judge

The male figures – Paris, Mercury and a water god to the right – are coloured subtly differently, with rich yellows and gold. The colouring emphasises the soft pinks of the goddesses. With his back to the viewer, Paris is not the one on display. We are encouraged to view the scene through his eyes.

Venus Crowned

Venus' beauty symbolises the high value placed on this virtue in women, and the choice of love as the most important quality that they can offer.

The Body Beautiful

Small breasts and wide hips were the desired contemporary body form, valuing roundness and softness over thinness. The goddesses' poses leave no doubt about the desired female shape.

In his long career, Rubens painted many nude subjects. His female nudes are characterised by their rounded and voluptuous figures, posed to emphasise these qualities. They are used to symbolise desirable female virtues, both physical and temperamental. The scene of Paris – son of Priam, King of Troy, and a leading character of Homer's *Iliad* – judging the beauty of the goddesses Venus, Minerva and Juno was very popular throughout the 16th and 17th centuries. Paris has just chosen Venus as the most beautiful goddess, giving her the golden apple. The ideal of love is symbolised as the ultimate goal for the male hero. Although all of the figures in the scene are naked, the female figures are those on display, and the implied innocence conceals the male voyeurism of the scene. These larger scenes containing nudes developed more complex symbolism for the patron's pleasure.

The Three Graces

Paris is judging between (from left to right):
Juno *(Greek: Hera) wife of Jupiter – symbolising wifely fidelity*
Venus *(Greek: Aphrodite) – goddess of love*
Minerva *(Greek: Athena) – goddess of just causes and wisdom, with her armour.*
Their composition is similar to that of the Three Graces, another mythological group symbolic of female virtues: beauty, charm and good cheer.

RELATED WORKS

- **Rubens** *Hero and Leander* c.1605, Gemäldegalerie, Dresden, and Yale University Art Gallery, New Haven; *Venus, Cupid, Bacchus and Ceres* 1612–13, Staatliche Museen, Kassel; and *Diana and her Nymphs Surprised by the Fauns* 1638–40, Museo del Prado, Madrid.
- **Nicolas Poussin** *The Birth of Venus* 1638–40, George W Elkins Collection, Philadelphia Museum of Art, Philadelphia.

Rubens' Style

The creamy fleshiness of Rubens' women is emphasised by the use of pale-green shadows and rose-pink highlights. Details of red and gold draw out sensuous features, such as nipples, lips and cheeks.

The Self-conscious Venus

Artists and patrons during the 17th and 18th centuries explored and developed forms and contexts for the female nude. Mythical subjects continued to provide metaphors for amorous encounters, with Venus still a popular symbol of ideal love. Female nudes were extensively incorporated into allegorical themes.

APPRECIATING...

By the 17th century, the nude had become a commonplace element of paintings, with complex scenes and subjects containing many nude figures. Tastes varied from scenes of abandoned revelry to frivolous, cavorting goddesses and *putti*, but Venus maintained her central role.

RELATED WORKS

- **Rubens** *Bacchus* 1638–40, State Hermitage Museum, Saint Petersburg, and *Bacchanalia* c.1615, The Pushkin Museum of Fine Arts, Moscow.
- **Velázquez** *The Triumph of Bacchus* (*The Topers*) 1628, Museo del Prado, Madrid.
- **François Boucher** *The Odalisk* 1753, Musée du Louvre, Paris.

The Mirror and the Gaze

Standing out amongst the nudes of this period is *Venus and Cupid* (1647–51) by Diego Velázquez. Painted for a notorious womaniser in Spain, the figure of Venus lies with her back to the viewer as she gazes into a mirror held by Cupid. Velázquez's Venus appears to be a more contemporary figure, probably based on a life study, with her slim waist and soft, dark-brown hair. The mirror motif originates within Renaissance Venice and adds a new dimension to the subject.

Feminist theorists have explored how artistic traditions of western Europe, and especially of the nude, were formulated to meet the desires of the male gaze. In this painting, we also have the gaze of Venus overtly presented in the mirror. Although not undermining the male dominance of the subject, it points to a more complex dynamic between the viewer and the viewed.

The Apollonian and Dionysian

Interpreting the symbolism and hidden allegories within nude subjects engages with fundamental elements within human nature. Polarities of human behaviour have been characterised as either Apollonian – controlled – or Dionysian – abandoned. Drawing on the mythical Greek gods Apollo, the god of medicine, healing and truth, and Dionysius (Roman: Bacchus) the god of wine and intoxication, these adjectives provide

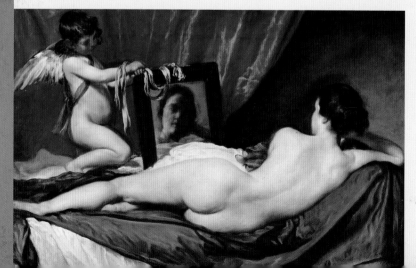

■ DIEGO VELÁZQUEZ
(1599–1660)
Venus and Cupid ('The Rokeby Venus') 1647–51, National Gallery, London.

Under the threat of the Inquisition, paintings of nudes were rare in 17th-century Spain. This work is important for the mirror reflecting the face of Venus. Her slight figure is less idealised and contemporary. Her gaze – is she looking at herself or at the viewer? – disturbs the normal dynamic of the nude.

RELATED TOPICS/ARTISTS
ANNIBALE CARRACCI'S *TRIUMPH OF BACCHUS AND ARIADNE*, PAGE 93

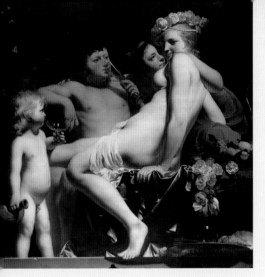

■ CAESAR BOETIUS VAN EVERDINGEN (c.1617–78)
Bacchus with Two Nymphs and Cupid c.1650/60,
Alte Meister Gemäldegalerie, Dresden.

*The pale female and child, possibly Flora and Cupid,
contrast with the swarthy, drinking male, who is probably
Bacchus. The setting is arranged with rich fruits, flowers
and wine, symbolising fertility and the plentiful delights of
the bacchanalia.*

■ FRANÇOIS BOUCHER (1703–70)
Venus in Vulcan's Smithy 1757, Musée du Louvre, Paris.

*Vulcan, the Roman god of fire and destruction, offers Venus
armour for her son Aeneas, the Trojan hero of Homer's Iliad
and Virgil's Aeneid, and the legendary founder of Rome.
The curling garlands of flowers, floating silks, billowing
clouds and* putti *describe the typical 'S' and 'C' shapes of
the Rococo style.*

a framework for exploring some of these
fascinating paintings in greater depth.

We have seen chaste, idealised and remote
Apollonian figures, such as in Botticelli's *Birth
of Venus*, and the more sensuous and physical
Dionysian nudes painted by Rubens. The subjects
of Bacchus and the bacchanalia were also used
to represent the female nude and her male
encounters. In antiquity, the bacchanal was a
women-only cult established in c.200BC, repressed
shortly afterwards by the Roman Senate. The term
'bacchanalia' can also refer to any drunken or
debauched party. The painted scenes of Bacchus
and the bacchanalia often present the vibrant
debauchery of Dionysian behaviour, with nude
male and female figures abandoning themselves
to the pleasures of the flesh, as, for example, in
Pieter Pauwel Rubens' *Bacchus* (1638–40) and
Caesar Boetius van Everdingen's *Bacchus with Two
Nymphs and Cupid* (c.1650/60).

Art at the French Court
King Louis XIV (1638–1715) ruled France for nearly
72 years. He built the palace at Versailles (begun
in 1669) which became the official residence of the
court in 1682, and expanded the Palais du Louvre.

His court had significant control over the arts,
which tended towards Classicism during his reign
(for example, Charles le Brun, *see page 94*). The
court of his great-grandson Louis XV (1710–74) had
different artistic interests, typified by the Rococo
painters François Boucher and Jean-Honoré
Fragonard (*see page 150*). Boucher's nudes exude
light-heartedness: the figures lie on their front,
with pink cheeks on display, surrounded by rich
silks and velvets, as in *The Odalisk* (1753). In the
tableau scenes, such as *Venus in Vulcan's Smithy*
(1757) smiling nude and semi-nude figures lie
about on soft, pale silks, with numerous chubby
putti in attendance.

KEYWORDS

Rococo after the French *rocaille*, meaning 'shell' or 'rock-
work', a style primarily associated with the French court
in the first half of the 18th century. Most prominent in the
decorative arts, it was characterised by S and C shapes.
It was first used in a derogatory way, signifying frivolity.

Challenging Tradition

The 19th century saw both continuity and innovation in representations of the nude form. Some artists continued the titillating forms of previous centuries, but new subjects and contexts emerged as Europe's horizons stretched across the world. Ideas of modernity, however, encouraged artists to paint contemporary, rather than mythical, subjects, and challenges developed to the traditional representations of the female form.

The Challenges of Modernity

While such artists as Jean-Auguste-Dominique Ingres and William Bouguereau used almost photographic precision in their paintings, others took new directions. Gustave Courbet and Édouard Manet painted subjects from everyday life. Manet's *Olympia* (1863) and *Le Déjeuner sur l'Herbe* (1863), for example, presented traditional compositions with contemporary characters. In *Olympia*, which was modelled on Titian's *Venus of Urbino* (finished 1538), the reclining figure is unmistakably a courtesan or high-class prostitute. A servant presents an admirer's flowers, and a small, black cat at her feet symbolises her trade (instead of Titian's dog). Her nakedness is emphasised by

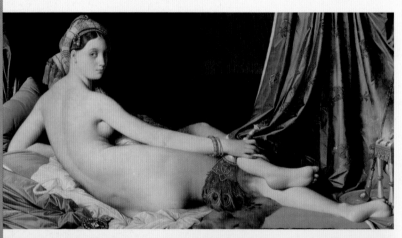

■ JEAN-AUGUSTE-DOMINIQUE INGRES (1780–1867)
The Grand Odalisque
1814, Musée du Louvre, Paris.

Comparing Ingres' work with Manet's demonstrates the different style and demeanour of these nudes. The fine texture and rounded precision of Ingres' work contrasts with the flat, and sketchy style of Manet's.

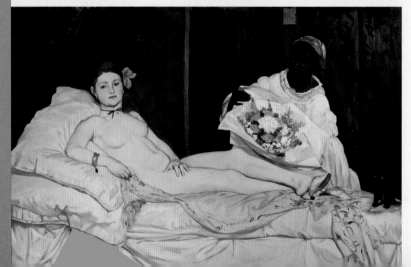

■ ÉDOUARD MANET (1832–83)
Olympia 1863, Musée d'Orsay, Paris.

Whereas Ingres' nude looks coyly over her shoulder, as if to collude with and lure the viewer, Olympia's calm gaze captures the viewer's attention – it is mildly challenging, confident and detached. The role of each figure is clear, but their attitude to it is dramatically different.

RELATED WORKS

- **Eugène Delacroix** *The Death of Sardanapalus*, 1827, Musée du Louvre, Paris.
- **Jean-Léon Gérôme** *The Snake Charmer* 1883, Clark Art Institute, Williamstown.
- **William Bouguereau** *The Birth of Venus* 1879, Musée d'Orsay, Paris.
- **Édouard Manet** *Le Déjeuner sur l'Herbe* 1863, Musée d'Orsay, Paris.
- **Edgar Degas, Pierre-Auguste Renoir** and **Paul Cézanne** – many paintings of bathers.

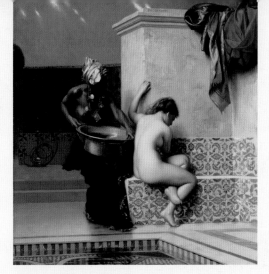

her ribbon choker and dainty slippers, and her knowing gaze challenges the viewer.

As in *Le Déjeuner sur l'Herbe*, bathing became a popular context for nudes by Impressionist artists Edgar Degas, Pierre-Auguste Renoir and Post-Impressionist Paul Cézanne. Edgar Degas' representations of women bathing seem to capture the private moment as if by chance.

Orientalism

During the 19th century, artists became fascinated by the exotic idea of the East. Many artists, among them Jean-Léon Gérôme, William Holman Hunt, Eugène Delacroix and Pierre-Auguste Renoir, painted Eastern-inspired subjects, often including women. The nude odalisque was popular, and Gérôme's *Moorish Bath* (1870) typifies the fantastical and erotic overtones of the imaginary interaction of East and West. Slave markets, harems and Turkish baths provided new contexts for the nude.

In his influential book *Orientalism* (1978) Edward Said explored the theory that Western colonial societies had constructed an idea of the East as exotic, dangerous and inferior. The paintings of the mid-19th century exemplify this concept by placing females in exotic and controlled situations. The East provided a new prism through which the male gaze could pursue and mediate its fantasies.

▌ EDGAR DEGAS (1834–1917)
The Tub 1886, Musée d'Orsay, Paris.

The intimacy of Degas' paintings of dancers, singers, prostitutes and female workers, often apparently captured in private moments, is striking. There is a mixed response to this – is Degas exploiting women for voyeuristic reasons, or are these engaging images celebrating womanhood?

▌ JEAN-LÉON GÉRÔME (1824–1904)
Moorish Bath 1870, Museum of Fine Arts, Boston.

The western European fascination with the East created a fantasy world of exotic women, harems and Turkish baths. The representation of the nude within this context added to the allure of the genre.

APPRECIATING...

The 19th century created new contexts for the nude and challenges to the traditions of previous centuries. In the modern world, real subjects injected greater awareness into the genre.

KEYWORDS

Odalisque (odalisk) a French term from the Turkish word for a female virgin slave found in a sultan's harem.

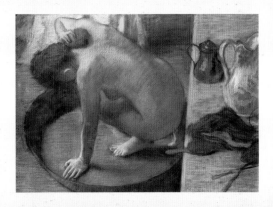

The Portrait

'I have heard of your paintings too, well
enough; God has given you one face, and
you make yourselves another.'

WILLIAM SHAKESPEARE (1564–1616),

HAMLET, 3, I

QUICK ARTISTS REFERENCE

15th century Sandro Botticelli,
Jan van Eyck, Gentile da Fabriano, Hugo van der Goes,
Benozzo Gozzoli, Andrea Mantegna, Masaccio,
Hans Memling, Pisanello

16th century Sofonisba Anguissola, Giovanni Bellini,
Agnolo Bronzino, Lucas Cranach the Elder, Albrecht Dürer, El Greco,
Hans Holbein the Younger, Lorenzo Lotto, Isaac Oliver, Raphael,
Tintoretto, Titian, Leonardo da Vinci

17th century Anthony van Dyck, Frans Hals, Carlo Maratti, Rembrandt,
Pieter Pauwel Rubens, Diego Velázquez

18th century François Boucher, Thomas Gainsborough,
Francisco de Goya y Lucientes, Angelica Kauffmann, Henry Raeburn,
Allan Ramsay, Joshua Reynolds, Élisabeth Vigée-Lebrun, Johann Zoffany

19th century Jacques-Louis David, Edgar Degas,
Jean-Auguste-Dominique Ingres, Thomas Lawrence,
Berthe Morisot, Pierre-Auguste Renoir, John Singer Sargent,
Vincent van Gogh, James McNeill Whistler

The portrait is perhaps the genre that most closely signifies social and cultural values. A portrait is the visual expression of a patron's self-perception or aspirations within the society in which he or she lives. In other words, the way in which someone chooses to represent themselves, their family or circumstances in a portrait reflects not only their personal values, but also those of the contemporary society that views it. The range of portrait styles, forms and approaches in western European art demonstrates how versatile artists and patrons have been in seeking to capture ideal representations.

The enigma of the portrait is how to interpret the many elements that contribute to its content and purpose. Central issues involve the likeness, character and demeanour of the represented individual. Equally, the context and accoutrements provide a sense of the sitter's status, the portrait's function and its symbolic meanings. The various forms of portraiture operate on different levels: men, women, families, children, groups and self-portraits. The dynamic between artist, patron and art work – what is called the 'triangle of engagement' by art historian Michael Baxandall – also determines the meaning. Viewing portraits from a distance of centuries, however, adds complications. How do we know how close the likeness is to the sitter? What was the significance of particular details? How can we know or interpret the intentions of the artist? What were the expectations of the patron or the reactions of contemporary viewers?

It is tempting to view a portrait as an accurate reflection of the sitter; to look into their eyes and try to read their character. We might see a Renaissance family's piety as its members kneel before the Virgin Mary; a Dutch merchant's austerity; a fine-featured ruler's wealth and power. In the current world of airbrushed celebrity, we should remember that the portrait offered the ultimate opportunity to represent someone in any way they chose. By asking the right questions, however, it is possible to understand how we were meant to see the sitters, and to gain insights into the people and societies behind the portrait. The portrait provides a unique opportunity to get close to the people of the past.

Portraits in Antiquity

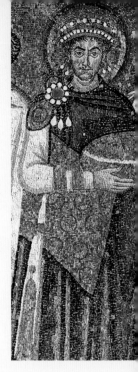

Representations of monarchs across the ancient world survive, including giant statues of Rameses II (mid-13th century BC) at Abu Simbel, Egypt, and Darius, King of Persia, towering over his defeated enemies (c.515BC), at Bisitun, Iran. In Classical Greece, such heroes as the tyrannicides Harmodius and Aristogeiton (6th-century BC Athenian heroes), Perikles (leader of democratic Athens, 5th century BC) and Leonidas (king of Sparta and hero of the Battle of Thermopylae, 480BC) were celebrated in sculptures. These representations appear, however, to have been largely idealised, following generic forms of representation rather than being attempts to capture a true likeness.

▮ BYZANTINE
(AD 4th–15th centuries)
Emperor Justinian, detail of *Imperial Panel* AD540s, San Vitale, Ravenna.

Justinian has distinctive features that can also be seen in a medallion portrait in the apse of Saint Catherine's Monastery on Mount Sinai, Egypt (c.AD465/6). Several mosaic representations of other Byzantine emperors survive in the Saint Sophia, Istanbul.

Emperors and Patricians

Portraits of Greek rulers on coins (2nd century BC) in kingdoms established by Alexander the Great's conquests were early examples of more individualised representations. In the late Roman Republic (1st century BC), bust portraits of high-ranking figures became popular. Sculptures of Gnaeus Pompeius Magnus (106–48BC) show a thin-lipped, round-faced man (c.50BC, Ny Carlsberg Glyptotek, Copenhagen). Portraits of Julius Caesar (100–44BC) also demonstrate attention to naturalistic detail – in his furrowed brow, firm jaw, high cheeks and aquiline nose – although the hair is still stylised. This 'warts-and-all' style of portraiture contrasts with the idealised representations of previous centuries and signals the beginning of a powerful Roman portraiture tradition.

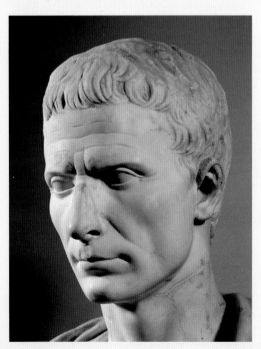

▮ ROMAN
(2nd century BC–AD 4th century)
Julius Caesar 1st century BC, Kunsthistorisches Museum, Vienna.

It is not difficult to see the exceptional character of a successful general and politician in this portrait. Julius Caesar's actions were seen as threatening the Roman Republic, and he was assassinated on the ides of March, 44BC.

As the republic slipped away during the rule of Octavian (later known as Augustus Caesar, Rome's sole ruler 31BC–AD14), his supporters discovered the potential power of imperial portraiture. Images of Octavian proliferated across the Empire and were used as propaganda to support his position. The *Prima Porta* statue (c.AD15, Vatican Museums, Rome) shows a return to the idealised, heroic features of Classical Greece, combined with allegorical elements that sought to reinforce Augustus' hegemony.

In Memoriam

Portraiture in the Roman Empire spread throughout society, with sculptures apparently immortalising whole families – mothers, sisters, children and old men (a collection of AD 1st-century portrait sculptures, possibly from one site in Rome, and now at Ny Carlsberg Glyptotek, Copenhagen, suggests a family group). Portraits were used for commemoration on tomb monuments (*stele*) and herms (in the form of a portrait head on a pillar).

A group of mummy portraits survives from Fayum, Egypt (AD 1st–3rd centuries), *see below*. The striking images were painted in encaustic – made from hot wax and pigment – on wooden panels, which were bound into mummy casings prior to burial. The translucent paint created hauntingly vibrant and naturalistic images of the dead. Technical and stylistic similarities between Fayum portraits and 6th-century religious panel paintings from Saint Catherine's Monastery, Mount Sinai, Egypt, suggest a link between portraiture and early depictions of Christ and the Virgin Mary. It is not difficult to imagine that ideas for early Christian imagery would have drawn on Roman portrait traditions.

Christian Emperors

The importance of imperial portraits continued into the Byzantine era (AD 4th–15th centuries), including a period that produced colossal portraits probably measuring several metres high – for example, the metre (3.3ft) high *Head of Constantine I* (c.AD 324–37, Metropolitan Museum of Art, New York).

With the establishment of Christianity as the religion of the Roman Empire by Constantine I during the early 4th century, the emperor's role changed. In the Eastern Empire (retrospectively titled the Byzantine Empire, after the Roman town of Byzantium, which became the eastern capital Constantinople during the 4th century), the emperor's role involved both secular and religious dimensions. The portraits of Emperor Justinian (emperor 527–65) and his empress, Theodora, in two mosaic panels in the sanctuary of the church of San Vitale, Ravenna, show their close involvement in the procession and ceremony of the Eucharist: Justinian is holding the sacramental bread, and Theodora, the chalice for the wine.

In the medieval West, Carolingian and Ottonian kings were also depicted in manuscripts in religious contexts. And the Emperor Charlemagne (742/7–814) went to Rome to be crowned by the Pope on Christmas Day 800, signalling the importance of the Church's endorsement of secular power.

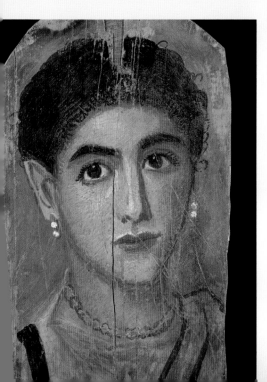

❚ ROMAN

(2nd century BC–AD 4th century)
Mummy Portrait of a Woman AD 2ND century, Musée du Louvre, Paris.

Her large eyes, fine-toned features, elaborate hairstyle and rich attire suggest that the deceased was a wealthy individual. Egypt was part of the Roman Empire at this time, and the tradition of memorialising the dead on grave markers appears to have been adapted for Egyptian mummification.

RELATED TOPICS/ARTISTS
THE CLASSICAL NUDE, PAGES 22–23

Piety & Power

With the rise of the merchant classes, portraits became a popular way of expressing wealth, status and piety. In late-medieval panel paintings, donors were often depicted as small, kneeling figures venerating Christ or the Virgin Mary. During the 15th century, these representations became more naturalistic and individualised as wealthy patrons continued to include themselves in altarpieces and religious paintings.

Donor Portraits

Three generations of the Florentine Strozzi family were represented as the Magi in Gentile da Fabriano's *Adoration of the Magi* (1423). This type of representation brought the family closer to Christ. The ostentatious *Procession of the Magi* (1459), by Benozzo Gozzoli, commissioned to decorate the private Medici Chapel in a newly built palace in Florence, includes many Medici family portraits and the artist's self-portrait. The Medici minimised public signs of opulence, and were often represented by their patron saints, Cosmas and

RELATED WORKS
- **Benozzo Gozzoli** *Procession of the Magi* 1459, Medici Chapel, Palazzo Medici-Riccardi, Florence.
- **Botticelli** *Portrait of a Man With a Medal of Cosimo the Elder* c.1474, Galleria degli Uffizi, Florence.
- **Hans Memling** *Tommaso Portinari and his Wife* c.1470, Metropolitan Museum of Art, New York.

APPRECIATING...

Early and Northern Renaissance portraits were often used to demonstrate the religious credentials of a patron. Placing donors within Christ's Nativity narrative suggested a pious, but privileged, position. Within individual portraits, patrons sought to show their status and wealth, of which wives were another symbol. The profile view, emulating the coin and medallion forms of antiquity, was particularly popular.

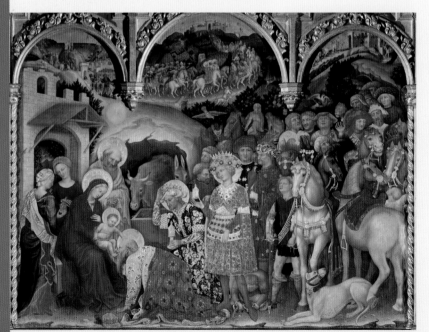

❚ GENTILE DA FABRIANO (c.1370–1427) *Adoration of the Magi (Strozzi Altarpiece)* 1423, Galleria degli Uffizi, Florence.

The Magi group was often used as a vehicle for portraits to emphasise the donor and his family's pious veneration. Some aspects of the painting are naturalistic, for example, the animals, but the costumes have the decorative style of International Gothic, and the cave is reminiscent of Byzantine forms.

RELATED TOPICS/ARTISTS
MASACCIO'S *HOLY TRINITY*, PAGE 56; HUGO VAN DER GOES' *PORTINARI ALTARPIECE*, PAGE 121; AND ANDREA MANTEGNA'S *CAMERA DEGLI SPOSI*, PAGE 141

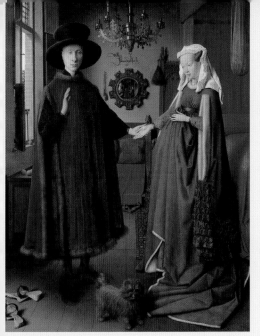

▮ JAN VAN EYCK (1395–1441)
Giovanni Arnolfini and His Wife 1434,
National Gallery, London.

Although untitled, this painting is thought to represent the marriage of Giovanni Arnolfini, a banker based in Bruges, to Giovanna Cenami. The painting includes many symbolic details: the dog (denoting fidelity and love), the rich clothes (wealth and status) and the red bed coverings (the act of procreation).

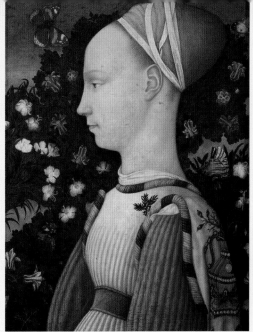

▮ PISANELLO (1395–1455)
Princess of the House of d'Este c.1436–38,
Musée du Louvre, Paris.

During the 15th century, when family alliances could make or break a noble house, wives were important commodities. Her high headdress, bare forehead, opulent dress and the rich embroidery attest to the lady's rank and wealth. Her fashionable style is complemented by the exquisitely painted flowers and butterflies.

Damian, wearing the red robes and hats of doctors, These saints appear, for example, in the altarpiece (1438–40) by Fra Angelico in the monastery of San Marco, a Medici responsibility.

Signs of Status

Individual portraits became increasingly popular with merchants, bankers and the aristocracy, some choosing sculpted bust portraits, echoing the Roman tradition, and others, painted portraits. Jan van Eyck's *Giovanni Arnolfini and His Wife* (1434) demonstrates how one wealthy patron chose to be represented. Although not overtly religious, the painting's details allude to the couple's piety. The central, convex mirror, used to explore an alternative view of the room, notably contains tiny, religious scenes in the roundels of its frame. Van Eyck's exceptional skill is apparent in the precise lighting and perspective of the chandelier.

The identity of Pisanello's lady in *Princess of the House of d'Este* (c.1436–38) poses a problem.

The style links the work to a portrait (c.1441) of Leonello I d'Este, Marquis of Ferrara (1407–50), by Pisanello, indicating possibly a twin sister, Ginevra or Lucia (b.1419), or his wife, Margherita Gonzaga (d.1439). The juniper branch on her shoulder could suggest Ginevra, but the emblematic colours red, green and white (signifying faith, hope and charity) could link her to the Gonzaga family. Current identification favours Margherita Gonzaga.

KEYWORDS

International Gothic a term for a homogeneous style used across Europe in c.1400. It was characterised by decorative detail, such as costumes, and naturalistic modelling of space, figures and animals, but it lacked the Renaissance innovation of single-point perspective. Practitioners included the Limbourg brothers, Gentile da Fabriano, Pisanello and Jacopo Bellini.

What's in a Face?

During the 16th century, portraiture developed more intimate and personal forms. Subjects engaged the viewer in direct eye contact, with communication seeming to take place on many levels. On the one hand, portraits were increasingly used by rulers to objectify their power, and, on the other, individuals from many levels of society sought to be immortalised.

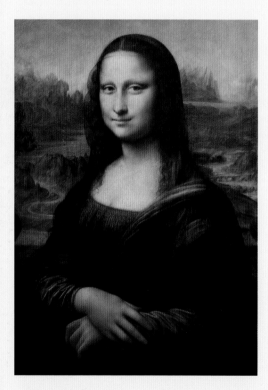

■ LEONARDO DA VINCI (1452–1519)
Mona Lisa (La Gioconda) c.1503–5,
Musée du Louvre, Paris.

Sfumato, *the soft, dark shading and modelling perfected by Leonardo, is used here to create the rich glow of Mona Lisa's costume and background. Her identity has caused endless debate, although Giorgio Vasari claimed that she was the Florentine wife of the Marquese del Giocondo.*

The Enigmatic Smile

Leonardo da Vinci's *Mona Lisa (La Gioconda)* (c.1503–5), famed for her enigmatic smile, is possibly the most reproduced image in art history. What gives this image such power? The three-quarter-length figure has monumentality, her serene, confident gaze is exceptional and the soft tones of her skin and gown are sensuous. The contrast with the harsh, barren landscape behind her is striking. The painting's meaning has been interpreted as a metaphor for time and change.

Equally enticing is the face of the young boy in Titian's *Madonna and Saints with the Pesaro Family* (1519–26). The richly coloured robes, austere, kneeling soldier and the Virgin and Child's sweet countenances recede beside the pensive child's stare. Is Titian asking us to share this momentous experience or a child's boredom? The faces of the family are clearly individual and recognisable, reinforcing their status and piety to the contemporary Venetian viewer. The Venetian Republic discouraged signs of personal aggrandisement, so these portraits would have been doubly significant. The incorporation of donors into a more casual relationship with Christ and the Virgin, in *sacra conversazione*, had developed in 15th-century Florence.

The Face of the Ruler

Princes, doges, kings and emperors alike commissioned imposing portraits to signify their power and majesty. Hans Holbein the Younger, court painter to King Henry VIII of England (ruled 1509–47), established a royal portrait tradition that is followed by his successors even today. Queen Elizabeth I of England (1533–1603) was particularly concerned to control her image. Portrayed in incredibly rich gowns, with symbolic trappings and a mask-like visage throughout her reign, she maintained perceptions of her hegemony despite her gender. Symbolising her wisdom and the peace and prosperity that she brought to her subjects, *Elizabeth I: The Rainbow Portrait* (c.1600) by Isaac Oliver shows eyes and ears (signifying fame or her spy network) embroidered into her cloak.

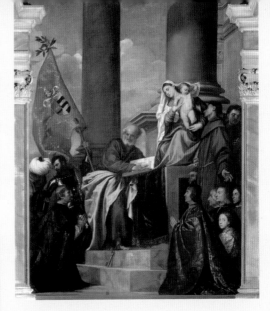

APPRECIATING...

The abundance of 16th-century portraits signifies the ideals of human individuality propagated by the Renaissance. Although many now cannot be identified, portraits were generally symbolic of status in all walks of life. Symbolism was also important within portraits. Cesare Ripa's handbook *Iconologia* (1593) set out the emblems that could be used to signify virtues such as courage and wisdom.

RELATED WORKS

- **Giovanni Bellini** *Doge Leonardo Loredan* 1501, National Gallery, London.
- **Titian** *Equestrian Portrait of Charles V at Mühlberg* 1548, Museo del Prado, Madrid.
- **Isaac Oliver** *Elizabeth I: The Rainbow Portrait* c.1600, Hatfield House, Hatfield.
- **Sofonisba Anguissola** *Portrait of the Artist's Sisters Playing Chess* 1555, Muzeum Narodowe, Poznan.
- Other notable portrait painters of the 16th century include **Lorenzo Lotto, Agnolo Bronzino, Lucas Cranach the Elder, Albrecht Dürer** (including self-portraits), **Raphael, El Greco** and **Tintoretto**.

RELATED TOPICS/ARTISTS
SEE *SACRA CONVERSAZIONE* ON PAGE 57

▌ TITIAN (1489/90–1576)
Madonna and Saints with the Pesaro Family 1519–26, Santa Maria Gloriosa dei Frari, Venice.

Commissioned to celebrate Jacopo Pesaro's victory over the Turks, this painting breaks all the rules of composition. The Virgin and Child are off-centre, balanced by the victor's flag, whilst the saints cluster around, with Saint Francis casually drawing attention to the kneeling family.

▌ HANS HOLBEIN THE YOUNGER (1497–1543)
Henry VIII 1540, Palazzo Barberini, Galleria Nazionale, Rome.

As Court Painter, Holbein painted many portraits of Henry VIII and his wives, including full-length figures. Despite their weight and opulence, the fashionable, jewelled costume, hat, chain and pendant enhance, rather than overwhelm, the king's imposing figure.

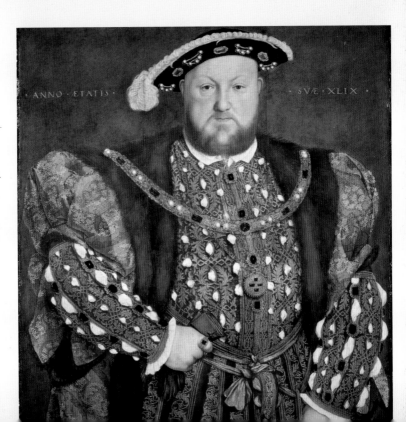

Civic Pride & Personal Duty

Portraiture's popularity continued to grow, and it was rated second in importance to history painting by the academies. In the Dutch Republic, portraiture was used to express civic pride and demonstrated status and financial security. Both Rembrandt van Rijn and Frans Hals' intimate styles represented the personalities of its worthy citizens. Group portraits, in particular, captured the shared civic responsibilities for maintaining and defending the new country's values and aspirations.

The Equestrian Portrait

The equestrian bronze statue of the Roman emperor Marcus Aurelius (AD121–80) had stood in Rome for over a millennium when Renaissance artists sought to revive the form. Donatello's *Gattamelata* (1437), Piazza del Santo, Padua and Andrea del Verrocchio's *Equestrian Statue of Colleoni* (1480s), Campo di Santi Giovanni e Paolo, Venice, were the first equestrian statues of the Renaissance. Equestrian portraits signified power and military achievement, often celebrating mercenary captains, as in Paolo Uccello's *Funerary Monument of Sir John Hawkwood* (1436), in the Duomo, Florence. Titian's *Equestrian Portrait of Charles V at Mühlberg* (1548), in the Museo del Prado, Madrid, shows the Habsburg Holy Roman Emperor and King of Spain (1500–58) in full armour, commemorating his victory at the Battle of Mühlberg (1547).

Used more widely in later centuries, the equestrian portrait typically alluded to individual or ancestral military success – whether actual or symbolic. Rubens' portrait of Giancarlo Doria may have some symbolic connection to his military ancestor's role in re-establishing the Genoese Republic during the 16th century.

▮ PIETER PAUWEL RUBENS (1577–1640)
Equestrian Portrait of Giancarlo Doria c.1606, Palazzo Vecchio, Florence.

Rubens spent eight years in Italy, studying both Classical and Renaissance works. He particularly valued studying ancient statues, but sought to give his works a palpable vitality. Energy and sleek naturalism are apparent in Doria's horse and dog.

APPRECIATING...

By the 17th century, portraits had evolved to reflect the changing requirements of the genre. Although not always mutually exclusive, these characteristics help to explore portraiture:

- idealisation versus likeness
- status and rank versus personality and character
- formal distance versus open intimacy
- public versus personal image
- symbolic allusions versus human naturalism.

Citizens of the Dutch Republic

The 17th century was the Golden Age of Dutch commerce, science and art. Overseas trade made merchants wealthy, and they chose portraits of themselves and their families that celebrated their good fortune. In contrast to the formalised portrayals of courtiers and aristocracy, the Dutch citizen favoured a more natural and informal style. Artists like Rembrandt and Hals responded with open and intimate likenesses for their respective communities, Amsterdam and Haarlem. As Protestants, and predominantly Calvinists, signs of ostentation were generally avoided; black was popular and fashionable, but the rich textures of wool, silk and fur portrayed wealth and rank discreetly.

Rembrandt's precise rendering of old skin on faces and hands celebrated experience without flattery, and his portraits seemed subtly to capture the inner person. Symbols of virtue appeared, but the emphasis was on character, relationships and personality.

Capturing the Community Spirit

Shared civic duty to militia, guards, guilds and charities brought Dutch citizens together. Portraits of these groups were popular, but it was more difficult to match informality and naturalism to the formal requirements of such commissions. The challenge was to avoid a stiff 'row of heads'; to ensure that senior officers stood out; to arrange figures casually around the banqueting table; and to capture individual likenesses. Started by Hals, *The Meagre Company* (1637), in the Rijksmuseum, Amsterdam, portrayed a crossbowmen's militia. It was finished by Pieter Codde, after the patrons got tired of waiting for three years for Hals to return from Haarlem. The result was a painting of two halves: Hals' half, on the left, is vibrant, with powerful brushstrokes, but Codde struggled to match his style.

▌ REMBRANDT VAN RIJN (1606–69)
Johannes Wtenbogaert 1633,
Rijksmuseum, Amsterdam.

Painted early in Rembrandt's career in Amsterdam, this is a portrait of a minister and theologian who campaigned for tolerance in the Church. His clothing suggests a cleric's austerity, but his wise face is illuminated against a white ruff. Rembrandt has captured him as he turns from an open manuscript.

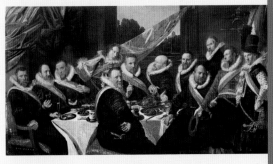

▌ FRANS HALS (c.1582–1666)
Banquet of the Officers of the Saint George Civic Guard
1616, Frans Halsmuseum, Haarlem.

Hals' flamboyant style captures lively personalities with colourful individuality. Members of the Haarlem civic guard served for three years, and this scene, which contains 12 portraits of prominent citizens, harmoniously captures the farewell banquet of 1615. Hals painted these events five times between 1616 and 1639.

RELATED WORKS

- **Rembrandt** *The Nightwatch* 1642, Rijksmuseum, Amsterdam; *Hendrickje Bathing in a River* 1654, National Gallery, London; and numerous others, including self-portraits.
- **Rubens** *Portrait of Anne of Austria* 1621–25, Musée du Louvre, Paris; and *The Artist and His First Wife, Isabella Brant, in the Honeysuckle Bower* 1609–10, Alte Pinakothek, Munich.
- **Frans Hals** *Isaac Massa and Beatrix van der Laen* c.1622, Rijksmuseum, Amsterdam; *Pieter van den Broecke* c.1633, Iveagh Bequest, Kenwood House, London; *Cornelia Claesdr Vooght* 1631, Frans Halsmuseum, Haarlem.

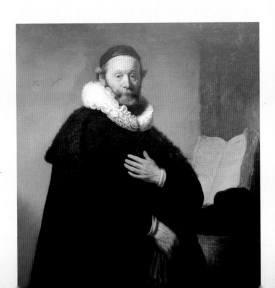

RELATED TOPICS/ARTISTS
THE DUTCH REPUBLIC, PAGES 125–27

The Pope, the Dwarf & the Mistress

Portraits had official functions, especially in capturing the likenesses of rulers, their families and mistresses. Some subjects developed into conventional compositions, which were in vogue for a while until they were challenged by new tastes or fashions. The unusual and exotic provided alternative subjects, reflecting aristocratic interest in curiosities. Court painters held unique positions that matched their skills to the prevailing needs of the palace.

Extremes of Society

Diego Velázquez's *Las Meninas (The Maids of Honour)* (1656–57) is a most unusual composition. The main 'action' is low, with half of the canvas filled with dark walls and ceiling. Although the infanta is central, illuminated by light from a window, her attendants are not arranged around her with any regularity. The right-hand group's informality – the dwarf, boy and dog – contrasts with the Infanta's confident pose and self-assurance. The conceit, however, is that it is not really a portrait of the infanta at all, but of Velázquez painting a portrait of the King and Queen, watched by the child and her companions. The portrayed intimacy of Velázquez's relationship to the Royal Family is matched by the implication that we, the viewer, are seeing the scene through the royal couple's eyes.

Velázquez painted portraits of the dwarves in King Philip IV of Spain's court. His portrait *Don Juan Calabazas, Called Calabacillas* (1640) was

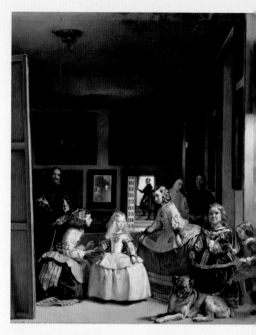

■ DIEGO VELÁZQUEZ (1599–1660)
Las Meninas (The Maids of Honour) 1656–57, Museo del Prado, Madrid.

The small, exquisitely costumed figure of the five-year-old Infanta Margarita Teresa looks directly into the eyes of the viewer. Velázquez's composition places him to the left, apparently painting a fictitious double portrait of King Philip IV and Queen Marianna, just visible in the mirror on the back wall.

painted in a less formal style to that of the royal portraits. The dwarf's physical disabilities are partly concealed by him sitting on the floor, but the subject raises questions about contemporary viewers' responses. Dwarves were celebrated members of the royal court, but despite the warmth and dignity of Velázquez's portraits, the works emphasise a difference that suggests the superiority and curiosity of their royal masters.

The Royal Portrait

Anthony van Dyck's portraits of King Charles I of England, including several equestrian and family portraits, largely followed conventional forms, but their vibrancy and texture brought the subjects to life. *Charles I, King of England, in Three Positions* (1636) (*see pages 8–9*) was commissioned to provide a model for Gian Lorenzo Bernini's marble bust, but its intimacy is a powerful testimony to the king's majesty and belief in the divine right of kings.

KEYWORDS

Pendant portrait a matching pair of portraits produced at the same time representing a husband and wife.

■ CARLO MARATTI (1625–1713)
Portrait of Pope Clement IX Rospigliosi 1669, Pinacoteca Gallery, Vatican Museums, Rome.

An unremarkable pope is here portrayed with subtle textures and lighting. Maratti successfully captures Clement's academic and thoughtful countenance, in the traditional pose and in rich, papal red velvet.

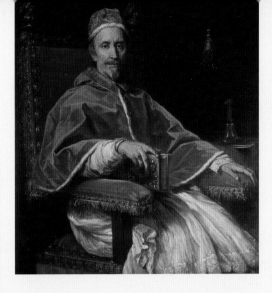

RELATED WORKS
- **Diego Velázquez** *Equestrian Portrait of Conde-Duque de Olivares* 1638, and *Don Juan Calabazas, Called Calabacillas* 1640, both in the Museo del Prado, Madrid.
- **Titian** *Pope Paul III, Cardinal Farnese and Duke Ottavio Farnese* 1546, Galleria Nazionale di Capodimonte, Naples.
- **Thomas Lawrence** *Pope Pius VII* 1819, Royal Collection, Windsor.
- **Anthony van Dyck** *Equestrian Portrait of Charles I, King of England* c.1637–8, National Gallery, London, and *Charles I and Queen Henrietta Maria With Charles, Prince of Wales, and Princess Mary* 1632, Royal Collection, Buckingham Palace, London.

■ FRANÇOIS BOUCHER (1703–70)
Marquise de Pompadour 1756, Alte Pinakothek, Munich.

Mistress to Louis XV of France, the intelligent and highly educated Jeanne-Antoinette d'Etiolles (née Poisson) strongly influenced artistic taste at court. Boucher painted her several times, often portraying her reading or writing, signifying her intellectual and literary interests.

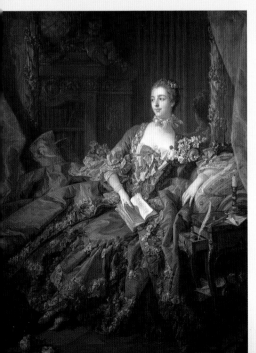

Royal portraiture was not confined to kings and their families. In France particularly, the status of the king's mistresses was of equal importance. Perhaps the most celebrated was Madame de Pompadour (1721–64), mistress to Louis XV. The lavish costumes and posed compositions set a style for future royal portraits (for example, in Élisabeth Vigée-Lebrun's paintings, *see page 49*).

The Papal Portrait
The conventions of papal portraiture were established during the 16th century by such works as Titian's *Pope Paul III, Cardinal Farnese and Duke Ottavio Farnese* (1546). They continued into the 19th century with, for example, Thomas Lawrence's *Pope Pius VII* (1819). Carlo Maratti's *Portrait of Pope Clement IX Rospigliosi* (1669) represents the seated Pope. Such portraits often contrast soft, red, papal robes and the Pope's frail physique with a fierce and knowing intelligence.

APPRECIATING...

The conventions of portraiture offered a validation of the sitter. Although new styles developed, the positioning of the subject in an appropriate setting, with symbolic accoutrements, became the formula for portraiture. Patrons' choices of representation and surroundings determined how they wished to be seen. The artist's success came when his or her skills matched the expectations of the patron.

RELATED TOPICS/ARTISTS
ANTHONY VAN DYCK'S *CHARLES I, KING OF ENGLAND, IN THREE POSITIONS*, PAGES 8–9

The Squire, His Wife & His Property

As Far as the Eye Can See

Gainsborough's skill at landscape painting provides a realistic backdrop to the portrait. The vista follows the property through gates and fields, suggesting a large estate that stretches into the far distance.

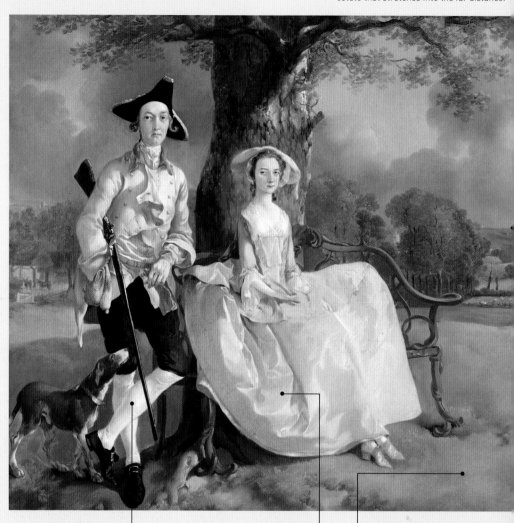

Dressing the Part

Mr Andrews has the trappings of a country gentleman – gun, faithful dog and bags for shot – but his white stockings, polished shoes and cream jacket also suggest that he is playing the part rather than actively being out and about on his land.

Sunday Best

Mrs Andrews particularly is more appropriately dressed for the city or the salon. Her pale-blue silk gown outshines the sky, and her cream satin slippers would never have survived a real walk in the countryside. It is uncertain what the bare area on her lap would have contained – possibly a dog.

Country Estate and Country Park

The agricultural landscape is an income-generating estate, in contrast to the area in which the two are posing. The grassy expanse, the lone, shady tree and the convenient iron bench denote a landscaped country park, a popular possession in the era of the gardener Capability Brown (1716–83). The distant church tower and village further emphasise the size of the estate and the superiority of its owners.

Fertility and Prosperity

The sheaves of corn are piled high, alluding to prosperity, fertility and the cycle of the land. The neat fencing and flock of sheep in the middle distance also suggest well-managed farmland.

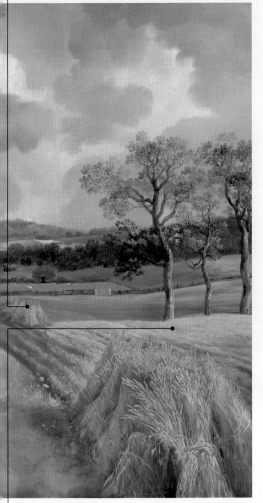

Portraits were in high demand in 18th-century Britain, with the aristocracy, middle classes and politicians commissioning them in large numbers to fill their walls. In his *A History of British Art* (1996), Andrew Graham-Dixon titled his chapter on the 18th century 'My wife, My horse and Myself', in homage to a painting by Alfred Munnings (1878–1959) of the same name. This encapsulates precisely the desire of British patrons for portraits to remind themselves and their peers of their status, possessions and property. Graham-Dixon adds, 'not to mention my country estate, my servants and my dog'. For Mr Andrews, this portrait not only presents his land and estates, but also celebrates his recent marriage and beautiful new wife. Their slightly knowing and satisfied expressions suggest a mutual contentment with both their wealth and their relationship.

▌ THOMAS
GAINSBOROUGH
(1727–88)
Mr and Mrs Andrews
1748–49, National
Gallery, London

And the Farm Workers?

The total absence of any other human presence in the landscape implies that the farm workers are incidental and unimportant to the message of the portrait. It is especially noticeable as the harvest is in full swing and the land is well tended, implying an army of workers. Their omission strengthens the connection between the land and its owners.

RELATED WORKS

- **Thomas Gainsborough** *Mary, Countess of Howe* 1764, Iveagh Bequest, Kenwood House, London; and *Mr and Mrs William Hallett ('The Morning Walk')* 1785, National Gallery, London.
- **Joshua Reynolds** *Lady Elizabeth Delmé and her Children* 1777–80, National Gallery of Art, Washington, DC.
- **Henry Raeburn** *Reverend Robert Walker (1755–1808) Skating on Duddingston Loch* c.1795, National Gallery of Scotland, Edinburgh.
- **Thomas Lawrence** *Portrait of the Children of John Angerstein* 1808, Musée du Louvre, Paris.

RELATED TOPICS/ARTISTS
GEORGE STUBBS' *MARES AND FILLIES*, PAGE 151

Portraiture & the Academy

London's Royal Academy of Arts (RA) was founded in 1768, fulfilling the ambition of the first president, Sir Joshua Reynolds, to establish an artistic tradition in Britain that emulated the standards and ideals of the academies in Rome and Paris. His admiration for Italian Renaissance art led him to turn his portraits into Classical allegories, among them, for example, *Three Ladies Adorning a Term of Hymen: The Montgomery Sisters* (1773).

APPRECIATING...

Signs of the change in artists' self-awareness and status include:

- the establishment of the RA in London, providing recognition and standards

- David's works during the French Revolution, demonstrating an awareness of the messages and role of art far beyond the times

- Goya's imaginative and disturbing paintings in later life, reflecting a growing autonomy of the artist over his subject.

The self-portraits of this period can be seen as another signifier of artistic self-confidence.

The End of an Era

Portraits of King George III of England (1738–1820) demonstrate the continuing popularity of the royal portrait, but in France, the French Revolution set a new direction. In the early years after 1789, Jacques-Louis David, an active revolutionary, captured key moments on canvas. His sketch *The Tennis Court Oath* (1789) portrayed the National Assembly swearing to establish a French constitution. Painted in the year of the execution of King Louis XVI, *The Death of Marat* (1793) was hardly a conventional portrait, yet the heroic and tragic representation of the murder of another revolutionary encapsulated the ideals and horrors of the 'Reign of Terror'.

Women Painting Women

The Swiss artist Angelica Kauffmann was a founder member of the RA and a friend of Reynolds. Élisabeth Vigée-Lebrun, elected to the French Academy in 1783, was popular at the French court until she fled the revolution, working later at the Russian court of Catherine the Great (1729–96). Both artists painted self-portraits and female aristocrats. Vigée-Lebrun's portraits of Marie Antoinette, her *Portrait of Grand Duchess Elisabeth Alekseyevna* (1795), the future Empress of Russia, or Kauffmann's *Portrait of Eleanor, Countess of Lauderdale* (c.1780–81), show that they largely worked within the conventions

▌ ALLAN RAMSAY, studio of (1713–84)
George III 1761-72, Private Collection.

Royal portraits in Britain typically represented the monarch in official regalia made from the richest materials and colours, such as ermine, silk, gold and red. The robes were often associated with a ceremonial event, for example, the coronation or an investiture, or with one of the noble orders.

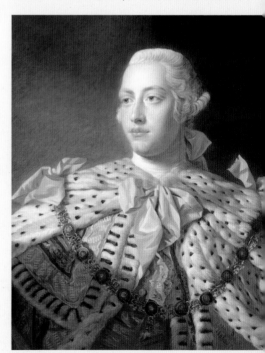

RELATED TOPICS/ARTISTS
FRANCISCO DE GOYA Y LUCIENTES: OTHER WORKS, PAGE 81

of contemporary portraiture. Their popularity with powerful female patrons, including Marie Antoinette and Catherine the Great, suggests, however, a special empathy between these women artists and their sitters.

The Self-portrait

The self-portraits of Vigée-Lebrun (1790), Kauffmann (c.1770–75) and Francisco de Goya y Lucientes (1790–95) follow a tradition dating back at least to Lorenzo Ghiberti's bronze self-portrait head on the Florence Baptistery doors, *The Gates of Paradise* (1425–52). In these 18th-century self-portraits, the artists portray themselves employed in their trade – at least one is painting a portrait. The artists are well dressed, and their clothes were probably not entirely suitable for the messiness of painting. The works show the artists' self-confidence and the self-promotion of their art; their direct gaze seems to be saying, 'This is who I am – this is what I do'.

On the founding of the RA, Johann Zoffany painted the academicians attending a life class (1771–72), with the two female members (who were excluded from life classes) represented by portraits. Surrounded by Classical sculptures, the painting celebrates the ideals of the new RA. These individual and group self-portraits demonstrate both the growing self-awareness of artists and the status that they had achieved by the end of the 18th century.

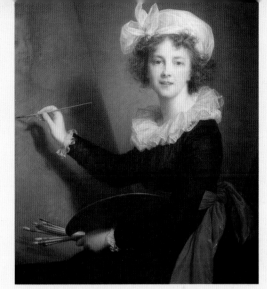

❚ **ÉLISABETH VIGÉE-LEBRUN** (1755–1842)
Self-portrait 1790, Galleria degli Uffizi, Florence.

Vigée-Lebrun painted herself many times in different guises, often in fashionable dress. This one was commissioned by the Uffizi to add to its collection of female self-portraits.

❚ **FRANCISCO DE GOYA Y LUCIENTES** (1746–1828)
Self-portrait 1790–95, Museo de la Real Academia de Bellas Artes San Fernando, Madrid.

Goya's early success was as a portrait painter, including commissions for King Charles VI of Spain. This self-portrait demonstrates his skills, notably in the softly lit window, sketchy, vibrant costume detail and gaze that is full of character. The hat contains candle-holders so that he could finish works by artificial light.

RELATED WORKS

- **Joshua Reynolds** *Three Ladies Adorning a Term of Hymen: The Montgomery Sisters* 1773, Tate Britain, London.
- **Élisabeth Vigée-Lebrun** *Self-portrait in a Straw Hat* after 1782, National Gallery, London, *Marie Antoinette* 1778, Kunsthistorisches Museum, Vienna, and *Portrait of Grand Duchess Elisabeth Alekseyevna* 1795, State Hermitage Museum, Saint Petersburg.
- **Angelica Kauffmann** *Self-portrait* c.1770–75, National Portrait Gallery, London, and *Portrait of Eleanor, Countess of Lauderdale* c.1780–81, Rienzi Collection, Museum of Fine Arts, Houston, Texas.
- **Jacques-Louis David** *The Death of Marat* 1793, Musée du Louvre, Paris.
- **Johann Zoffany** *Academicians of the Royal Academy* 1771–72, Royal Collection, Windsor.

The End of the Grand Portrait

The 19th century saw many innovations in western European art, but the essentials of portrait painting continued to be practised until the end of the century. The political changes in France after the Revolution continued to provide new patrons, particularly Napoleon Bonaparte, and in the United States, a new élite sought to be immortalised. The Impressionists' interest in painting contemporary life introduced a new, casual intimacy to portraiture.

APPRECIATING...

By the end of the 19th century, the extremes of grandiose portraiture had been transformed into the self-portraits of a traumatised Vincent van Gogh. The composition, style and function of portraits had altered completely. Instead of the focus on status and self-promotion, artists had begun to use portraits to explore intimate emotions and artistic forms in more personally expressive ways.

Emperors and Citizens

Napoleon Bonaparte (1769–1821) established the first French Empire in 1804. His many grandiose portraits symbolised his towering ambitions: as a general (Jean-Antoine Gros, c.1801); crossing the Alps (Jacques-Louis David painted several versions, 1801); as first consul (Gros, c.1802, Jean-Auguste-Dominique Ingres, 1804); at his consecration as emperor (David, 1805–7); on the imperial throne (Ingres, 1806); and in his study (David, 1812). His portraits incorporated symbols of Roman imperial portraiture, for example, the laurel-wreath crown.

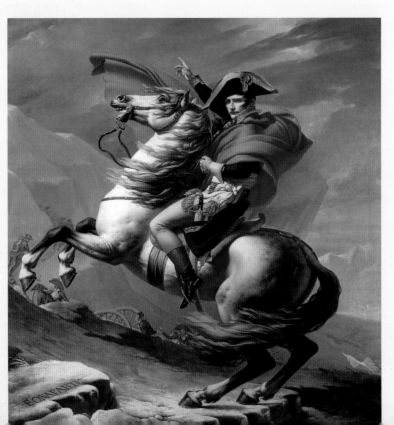

▌ **JACQUES-LOUIS DAVID** (1748–1825) *Napoleon at the Saint Bernard Pass* 1801, Kunsthistorisches Museum, Vienna.

David and Ingres painted many representations of Napoleon, portraying his magnificence and power. This image, with its references to Hannibal crossing the Alps and Charlemagne, is impossibly posed – the precariously balanced horse reinforces a sense of extreme drama and Napoleon's heroic achievements.

■ JEAN-AUGUSTE-DOMINIQUE INGRES (1780–1867)
Monsieur Bertin 1832, Musée du Louvre, Paris.

Ingres' style is almost photographic in its rendering of flawlessly smooth brushwork. Louis-François Bertin was a leading journalist in the years after Napoleon, and is shown here as a stern and imposing figure who is clearly not afraid to express his opinions.

■ JOHN SINGER SARGENT (1856–1925)
Lady Agnew 1892, National Gallery of Scotland, Edinburgh.

Sargent's skill was partly in the bold, vibrant brushstrokes used to capture the rich fabrics of the sitter's dress and setting (he always selected what sitters wore). More compelling were the hauntingly intense faces of people with real emotions and desires – not the remote, formal expressions painted by his predecessors.

RELATED TOPICS/ARTISTS
JAMES MCNEILL WHISTLER'S *ARRANGEMENT IN GREY AND BLACK: PORTRAIT OF THE ARTIST'S MOTHER*, PAGE 7, AND *MODERNITY*, PAGES 134–35

Through the political upheavals after Napoleon's ultimate exile, portraiture fluctuated between past royal traditions and more intense and sober portraits, for instance, Ingres' *Monsieur Bertin* (1832).

New World: *nouveaux riches*

Few of the Impressionists painted conventional portraits as such, except for Pierre-Auguste Renoir; instead they painted their acquaintances informally. Berthe Morisot and Edgar Degas, for example, portrayed people going about their lives, but they were often more interested in capturing the fleeting effects of light and colour than in conforming to the conventions of portraiture.

John Singer Sargent was perhaps the last grand-portrait artist working in Britain and the United States at the turn of the century. His soft, delicate style captured the mood of rising wealthy Americans and British society. James McNeill Whistler heralded a new dynamic in portraiture with the representation of his mother (*see page 7*). Challenging all norms of portrait composition, allegory and function, the dark, grey and white areas show an interest in form that would become the focus of 20th-century painting.

KEYWORDS

Modernity in mid-19th-century Paris, writers and artists, such as Charles Baudelaire, Émile Zola and Édouard Manet were concerned that art and literature should address contemporary subjects. The redevelopment of Paris, the advent of the railway, industrialisation and the desire of the *bourgeoisie* for fashion and leisure all became subjects for paintings.

RELATED WORKS

• **Berthe Morisot** *The Artist's Sister at a Window* 1869, National Gallery of Art, Washington, DC.
• **Edgar Degas** *Place de la Concorde (Vicomte Lepic, his Daughters and his Dogs)* 1875, State Hermitage Museum, Saint Petersburg.
• **Pierre-Auguste Renoir** *Madame Charpentier and her Children* 1878, Metropolitan Museum of Art, New York.
• **Vincent van Gogh** *Self-Portrait With Bandaged Ear* 1889, Courtauld Institute Galleries, London.

Religious Painting

'I shut my eyes in order to see.'

PAUL GAUGUIN (1848–1903)

QUICK ARTISTS REFERENCE

15th century Fra Angelico, Giovanni and Gentile Bellini, Hieronymus Bosch, Sandro Botticelli, Carlo Crivelli, Jan van Eyck, Gentile da Fabriano, Piero della Francesca, Domenico Ghirlandaio, Hugo van der Goes, Andrea Mantegna, Masaccio, Masolino, Hans Memling, Antonello da Messina, Luca Signorelli, Domenico Veneziano, Rogier van der Weyden, Leonardo da Vinci

16th century Annibale Carracci, Correggio, Lucas Cranach the Elder, Giorgione, Michelangelo, Parmigianino, Raphael, Andrea del Sarto, Tintoretto, Titian, Paolo Veronese

17th century Caravaggio, Pietro da Cortona, Artemisia Gentileschi, El Greco, Guercino, Bartolomé Murillo, Rembrandt, Guido Reni, Pieter Pauwel Rubens

18th century William Blake, Gianantonio Guardi, Franz Anton Maulbertsch, Giovanni Battista Piazzetta, Sebastiano Ricci, Giovanni Battista Tiepolo

19th century Peter von Cornelius, Josef von Führich, Paul Gauguin, William Holman Hunt, John Martin, John Everett Millais, Johann Friedrich Overbeck, Dante Gabriel Rossetti, Paul Sérusier

Religious art serves a framework based on theology. It may operate on many levels, but its role is determined by religious doctrine. Over time, original functions may become obscured, but the place occupied by art within religious dogma can never be taken for granted. Periods of iconoclasm – meaning, literally, 'image-breaking' – when imagery's role was reassessed or rejected, demonstrate its centrality to religion. Christian art has a long history in which its function has been periodically questioned by Church leaders. Its forms have also changed as the needs of Christianity have evolved.

Religions across the world have sought different ways to define or explore the human relationship with a higher power – natural or spiritual law, or transcendent being(s) or god(s). Each religion has its own perception of the nature of this power, and its own systems for defining the human engagement. Judaeo–Christian religions and the Islamic faith, for instance, assert a single God – monotheism – whereas others, such as Hinduism and the pre-Christian Greek and Roman belief systems, perceive a pantheon of many gods – polytheism. Clearly, these different religions make use of imagery in a variety of ways. For example, the Islamic faith rejects the representation of any God-made beings, such as humans, so its imagery uses the words of the Prophet Muhammad and highly elaborate calligraphy to create visually inspiring forms.

Christian imagery has struggled with the second commandment, which states: 'Thou shalt not make thee any graven image or any likeness …' (Deut. 5:8). Since the time of the first Christian wall paintings of around the 3rd century, Church authorities have sought to explain and justify imagery in terms that avoided accusations of idolatry (image worship). For this reason, Christian imagery is said to perform such functions as intercession between humans and God; didacticism (teaching people the story and message of Christ); or acting as vehicles for venerating Christ, the Virgin Mary or saints. Images thus became a route to God rather than separate idols.

However, even within the Christian community, there is little agreement across Roman Catholic, Orthodox and Protestant faiths on the role of imagery. Indeed, division between their doctrines has often involved imagery; for example, the Protestant Reformation led to iconoclasm, highlighting the importance of imagery to Christianity.

Imaging the Transcendent

Christian imagery existed for a millennium before Renaissance innovations changed the forms of religious painting. Its functions, subjects, symbols and conventions were formulated over the previous centuries, remaining in some ways unaltered through to today. They centre on the fundamental belief that Christ, the son of God, came to earth and died for the redemption of sins so that humans could achieve eternal life.

Early Functions of Christian Imagery

Early Christian art represented the story of Christ and various symbolic subjects and signs, for example, Christ as a shepherd, often in a funerary context. In some cases, such forms as the enthroned Christ appear to have drawn on pre-Christian imagery. Symbolic motifs, like the cross, fish, peacock and vine, were used for decoration. Imagery was used to present the scenes and messages of Christian redemption.

By the 6th century, subjects included Christ and the Virgin Mary; scenes from Christ's life, including the Baptism; and Old Testament scenes, such as Abraham about to sacrifice Isaac. Churches were highly decorated with scenes and symbols in mosaics. Pope Gregory the Great (c.540–604) argued in favour of the role of images in educating the illiterate in the Christian narrative. From this time, images of Christ and the Virgin Mary began to appear on panels in the East and in Rome, sometimes associated with relics. Images developed allegorical significance, for example, the Crucifixion symbolised redemption, but the form of representation – Christ dead or alive on the cross, dressed in a long robe or loincloth – remained divergent.

The periods of iconoclasm (726/30–787 and 815–42) in the Eastern Church, led by the Patriarch and Emperor in Constantinople, were divisive, raising fundamental questions about the validity of Christian imagery. Their outcome reinforced and codified Christian imagery in the East, whilst the Western Church, which had rejected iconoclastic doctrines, developed other forms of imagery. Although there was interaction between East and West, the Orthodox (Byzantine) and Roman Catholic Churches largely pursued different forms of Christian imagery and iconography.

▌ **BYZANTINE** Empire (AD 4th–15th centuries)
Deësis 1261?, Hagia Sophia, Constantinople (Istanbul).

This large mosaic was probably made after the Byzantine Empire recaptured Constantinople from the Latin Empire in 1261. Christ's hauntingly direct gaze is delicately detailed, demonstrating the characteristics of late Byzantine art. The Deësis symbolises a prayer or petition made to Christ by the Virgin Mary and Saint John the Baptist on behalf of the worshipper.

■ GIOTTO DI BONDONE (c.1277–1337)
Ognissanti Madonna c.1310, Galleria degli
Uffizi, Florence.

*The image is remote and stylised; the angels are much
smaller than the Virgin Mary; the gold background raises the
subject above the earthly world. Giotto's more naturalistic
style can be seen in the Virgin's face, and in the apparent
depth of the covered throne. His naturalistic style is often
heralded as a forerunner to that of the Renaissance.*

■ UNKNOWN ARTIST (14th century)
Buddha Bodnath Stupa (wall painting),
Kathmandu, Nepal.

*Buddhism, which originated in Asia in the 6th or 5th centuries
BC, is not theistic (without a god), but is concerned with
achieving nirvana (enlightenment). Representations of
Buddha carry a mystical presence, and he can be depicted
seated or standing. Here, Buddha wears monk's robes and is
surrounded by important symbols: the peach and lotus flower.*

From Icons to Altarpieces

In medieval churches, religious imagery took
many forms, including mosaics, frescoes,
carvings, stained-glass windows, reliquaries,
altars, funerary monuments, manuscript
illuminations and private devotional objects.
Imagery helped worshippers to understand and
contemplate the Christian message in the pursuit
of eternal life. In the Byzantine Church, icons –
panel paintings – were central to the worshipper's
communication with Christ, the Virgin Mary or the
saints. The icon was perceived as representing a
holy figure, both visually and spiritually, allowing
veneration through the image. In the *Deësis*
mosaic, Hagia Sophia, Constantinople (Istanbul)
(1261?), Christ holds the Bible, blesses with his
right hand and is flanked by the Virgin Mary and
Saint John the Baptist, who ask for intercession
on behalf of the viewer.

The altar was central to the ceremonies of
the sacraments, and, in Western churches, was
decorated with painted altar frontals, ornate
retables (screens behind the altar) or, later,
multi-panelled altarpieces. From the 13th century,
such artists as Cimabue, Duccio di Buoninsegna
and Giotto di Bondone drew on the forms and
spiritual presence of Byzantine imagery to paint
panels for altarpieces. Giotto's *Ognissanti Madonna*
(c.1310) presents the Virgin Mary enthroned with
the Christ Child on her knee and surrounded by
angels – the Madonna in majesty known as the
Maestà. Painted in ethereal colours and decorated
with gold, both the *Maestà* and the Crucifixion
were popular subjects of early panel paintings
because they symbolised forgiveness of sins and
redemption. These images emphasised Christ's
role and sacrifice, moving beyond a simple
narrative of his life.

Christ Comes Down to Earth

Changes in painting style and forms in early 15th-century Florence humanised Christian imagery. The development of more naturalistic styles of representing the human form, and the use of single-point perspective, placed the viewer at the centre of Christian imagery. The increasing use of contemporary settings and costumes made the message of salvation more relevant and personal.

Close to God

In Masaccio's *Holy Trinity* (c.1425–28), Christ's Crucifixion is attended by the Virgin Mary and Saint John with the kneeling donors – probably Domenico Lenzi, whose tomb is under the floor below, and his wife. Christ's death and the Trinity symbolise the redemption of sins and the route to heaven. Mary directly engages the viewer, raising her hand to present Christ's sacrifice. Below, a skeleton lies on a tomb; the inscription warns of the viewer's fate and of the need for penitence: 'I was once what you are, and what I am, you also will be'.

The scene's immediacy is reinforced by soft colours, naturalistic figures and the vaulted chapel's perspective. The overall effect – called *trompe l'oeil*, French for 'something that deceives the eye' – creates a reality that engages directly with the penitent viewer. The eye is led first to the vanishing point at the foot of the cross and the tomb, then up to the body of Christ, by the gestures of the attending figures. The Classical architectural elements – Corinthian and Ionic capitals and a coffered ceiling resembling the Pantheon in Rome – demonstrate renewed interest in and engagement with antiquity.

Piety and Patronage

The contemporary reality is also represented in Fra Angelico's *Crucifixion* (1438–40) and Rogier van der Weyden's *Saint Columba Altarpiece* (c.1455). Compared to Gentile da Fabriano's *Strozzi Altarpiece* (1423, see page 38), these scenes bring the Christian message directly into the world of the donor and viewer. The wealthy Renaissance families – the Medici, the Strozzi, the Brancacci, the Lenzi and the Portinari – commissioned religious works to gain merit for the salvation of their souls and a place in paradise.

▌ MASACCIO (1401–28)
Holy Trinity c.1425–28, Santa Maria Novella, Florence.

The characteristics of this scene marked out Masaccio as a key innovator of the Early Renaissance. They are also present in Scenes From the Life of Saint Peter *painted by Masaccio and Masolino (1383–1440s) in the Brancacci Chapel (mid-1420s), Santa Maria del Carmine, Florence.*

FRA ANGELICO
(c.1400–55)
Crucifixion 1438–40,
Chapter House, San Marco
Monastery, Florence.

*Fra Angelico painted frescoes
throughout the San Marco
Monastery, a Dominican house,
during its renovation, which was
paid for by Cosimo de' Medici,
reputedly to atone for sins in
his financial dealings. This
Crucifixion is attended by saints
representing both the Medici
and the Dominican order.*

APPRECIATING...

The forms and naturalism of antiquity were applied
to religious painting, bringing the Christian message
closer to contemporary donors and viewers. Single-
point perspective especially brought the painting's
subject into the viewer's reality, effectively centring
the holy events on their personal experience.

RELATED WORKS

- **Jan van Eyck** *The Ghent Altarpiece* 1426–27,
 Cathedral of Saint Bavo, Ghent.
- **Fra Angelico** *San Marco Altarpiece* 1438–40,
 San Marco Monastery, Florence.

KEYWORDS

Fresco a technique used for wall paintings, such
as *Holy Trinity*. Paint is applied to wet plaster in daily
sections (*giornata* in Italian, plural *giornate*), to be
completed before the plaster dries.

Sacra conversazione (Italian for 'holy conversation')
saints and donors are depicted in an informal
audience with the Virgin Mary, for example, Domenico
Veneziano's *Madonna and Child with Saints* (see page
6). The intimacy reflects a perceived closer human
relationship with Mary and Christ.

ROGIER VAN DER WEYDEN (c.1400–64)
Saint Columba Altarpiece c.1455,
Alte Pinakothek, Munich.

*Commissioned for the church of Saint Columba in Cologne,
Germany, this work follows the traditional, three-panelled
design of the triptych. The naturalistic figures and
architectural spaces create a contemporary resonance,
however. Painted in oil, the costumes' textures and colours
typify painting in 15th-century northern Europe.*

RELATED TOPICS/ARTISTS
DOMENICO VENEZIANO'S *THE MADONNA AND CHILD WITH SAINTS*, PAGE 6; GENTILE DA FABRIANO'S *STROZZI ALTARPIECE*, PAGE
38; SINGLE-POINT PERSPECTIVE AND HUGO VAN DER GOES' *THE PORTINARI ALTARPIECE*, PAGE 121

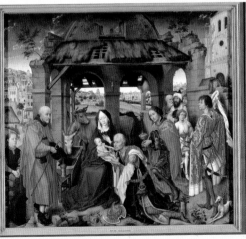

Christ's Human Experience

Piero della Francesca was one of the second generation of Renaissance artists who employed greater naturalism and three-dimensional physicality than their predecessors. Apprenticed to Domenico Veneziano (*see page 6*) in Florence, he worked across Tuscany, and his soft colours and delicate handling of light and tone drew on his master's style. He was particularly concerned with mathematical relationships in composition, and perfected the requirements for painting naturalistic perspective. Piero's compositions for traditional Christian subjects were often innovative. In this painting of Christ's Baptism, the centre of a triptych for the abbey in Sansepolcro, he unifies the symbols of baptism with the natural landscape. Instead of a symbolic and stylised River Jordan, there is a shallow stream flowing through Tuscan countryside; formalised angels are replaced with a simple, Classical group; and the dove is echoed in the clouds. Christ's Baptism, symbolic of the first of the seven sacraments that absolve sin, is no longer a distant ideal, but a real event happening in the local landscape.

RELATED WORKS

- **Piero della Francesca** *Flagellation of Christ* 1450s?, Galleria Nazionale delle Marche, Palazzo Ducale, Urbino; and *Resurrection* c.1458, Museo Civico, Sansepolcro.
- **Botticelli** *Adoration of the Magi* c.1481–82, Mellon Collection, National Gallery of Art, Washington, DC.
- **Carlo Crivelli** (1430/35–94) *The Annunciation, with Saint Emidius* 1486, National Gallery, London.

KEYWORDS

Tempera this traditional medium for panel painting was made by mixing pigment with egg yolk. It dried quickly and produced lasting colour, but was difficult to blend into more subtle colours and tones. Botticelli added a little oil to achieve softer effects. Until the early 15th century, panel paintings were often enhanced with gilding applied to backgrounds or costumes.

The Natural Landscape

The trees and plants are painted in great naturalistic detail, whilst the landscape is drawn from Piero's native Tuscany. The town of Sansepolcro is represented in the distance, in the gap between Christ's hip and the tree. Christ stands in the river in which the sky, hillside and figures are reflected.

Religious Harmony

Piero wrote treatises on mathematics, including On Perspective in Painting. He used geometry to arrange harmonious compositions. In the Baptism of Christ, the position of the dove divides the panel so that the height above (a) and below (b) follow the rules of the golden mean – a:b equals b:a+b. Additionally, the angles of John's bent arm and leg are equal, centred on the axis of Christ's body.

The Sacrament of Baptism

Scenes from the lives of Christ, the Virgin Mary and the saints were popular subjects for painting. Some have particular significance for the salvation of the human soul – the Annunciation, Baptism, Crucifixion, Resurrection and saints' martyrdoms – each symbolising aspects of the central Christian message of redemption.

Balancing the Composition

The subtle lights and shadows give a real sense of the figures and their bodies. Colours are harmonised across the composition, linking Christ, the tree, the angels and the man preparing for baptism in the background. The trees, sky, land and figures are carefully balanced, with Christ at the centre.

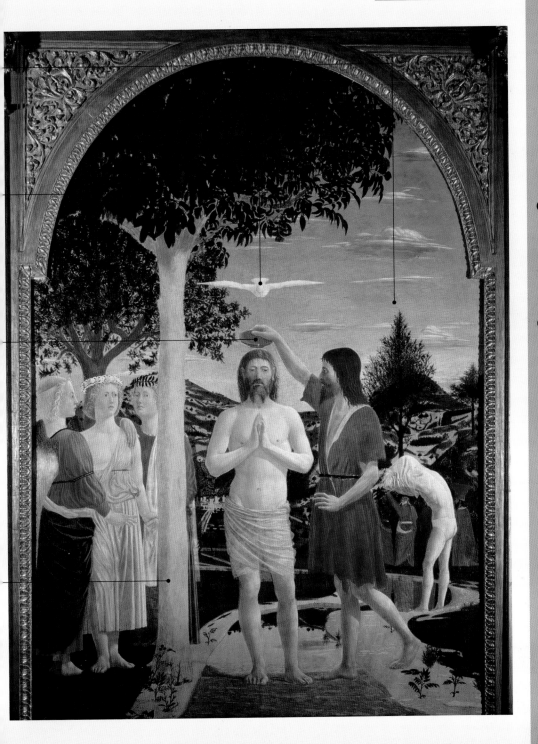

Heaven & Hell

The Church exhorted people to seek forgiveness for their sins or to risk eternal damnation in hell. The Church judged every aspect of life, and the wages of sin would never have been far from people's minds. During the 13th century, the Church developed the concept of purgatory, where the soul would go after death. Virtuous acts and prayers in life could improve an individual soul's chance of reaching heaven and lessen its time in purgatory.

The Sins of the World

Virtuous and pious acts included donating to charities and the Church, which could encompass adorning religious establishments with frescoes and altarpieces. Rogier van der Weyden's *Altarpiece of the Seven Sacraments* (c.1441) shows how individuals could be absolved of sin: through baptism, confirmation, confession, receiving the Eucharist, ordination, marriage and extreme unction on the deathbed. The final weighing of the soul would take place at the Last Judgement, when it would be reunited with the body. Representations of the Last Judgement, for example, by Hans Memling (1467–71) and Fra Angelico (1431), show Christ enthroned, passing judgement on the throng. To his right, the virtuous are led into paradise, whilst to his left, the condemned suffer the horrors of hell.

RELATED WORKS

- **Rogier van der Weyden** *Altarpiece of the Seven Sacraments* c.1441, Koninklijk Museum voor Schone Kunsten, Antwerp.
- **Hans Memling** *Last Judgement* 1467–71, Muzeum Narodowe, Gdansk.
- **Fra Angelico** *Last Judgement* 1431, Museo di San Marco, Florence.
- **Hieronymus Bosch** *Triptych of Temptation of Saint Anthony* 1505–6, Museu Nacional de Arte Antiga, Lisbon.

▮ HIERONYMUS BOSCH (c.1450–1516)
Garden of Earthly Delights (right panel) after 1466, Museo del Prado, Madrid.

Each motif within the scene shows the punishment of sin: giant instruments inflict torture, animals have power over humans, grotesque forms parade around and the fires of hell burn in the distance. There is a tyranny of nightmarish monsters.

GIOVANNI BELLINI (early 1430s–1516)
Pietà 1460, Pinacoteca di Brera, Milan.

The subject of this painting offers great potential to explore the tragedy of Christ's death. The half-length representation brings the emotions close to the viewer, reinforcing Mary's anguish and Saint John's dazed horror. Bellini captures death in Christ's limp arm resting impotently on the marble shelf.

APPRECIATING...

As the 15th century progressed, artists in Italy and northern Europe increasingly represented the humanity in the Christian message. Such artists as Bosch and Mantegna had the freedom to develop their own aesthetic.

Hieronymus Bosch painted several triptychs that graphically portrayed human sins and virtues and their consequences. Following no artistic precedent, Bosch painted highly individual scenes of sins and virtues, pleasure and torture, angels and monsters, to represent the moral values of a Christian society. The seven deadly sins – anger (or wrath), envy, gluttony, greed (or avarice), lust, pride and sloth (or despair) – and their many subsidiary manifestations were symbolically or actually represented. In Bosch's *Garden of Earthly Delights* (after 1466), the central panel shows humans enjoying sensual and sexual pleasures; the left panel alludes to the Garden of Eden and the origins of sin; whilst the right panel depicts hell as a monstrous landscape of deformity, torture and pain – the wages of sin.

The Passion of Christ

In northern Italy, artists explored new styles and forms to represent the Christian message. The Bellinis – Jacopo and sons Giovanni and Gentile – brought greater naturalism, emotion and scale to Venetian art. The emotional intensity of Giovanni's *Pietà* (1460) is captured in its pose and facial expressions. Gentile painted immense miracle scenes of Venice, symbolising the city's unity and piety, for example, *The Procession of the True Cross* (1496, Gallerie dell'Accademia, Venice). Their brother-in-law, Andrea Mantegna, became court painter to the duke of Mantua and painted the *San Zeno Altarpiece* (1458–59) for a church in Verona. An opulent *sacra conversazione*, with rich garlands and drapes, takes place in a large, open enclosure.

ANDREA MANTEGNA (c.1430/1–1506)
San Zeno Altarpiece (central panel) 1458–59, San Zeno, Verona.

This early work by Mantegna demonstrates his skill at capturing the nuances of pose, personality and activity. The Classical elements in the frame and background add complexity and vibrancy, whilst the emphasis on abundant goodness is overwhelming.

KEYWORDS

Disegno [Italian for 'drawing'] this style emphasised drawing and lines with which to capture an image; applied to artists like Mantegna and (Florentine) Michelangelo.

Colore [Italian for 'colour'] this style created images using colour and tone without drawing; applied to such Venetian artists as Giovanni Bellini and Titian.

The Rise of Rome

The 16th century saw significant change for the Church, and artists responded with increasingly human representations. Division between the Roman Catholic and Protestant faiths, which began with protests by Martin Luther (1483–1546) in 1517, eventually led to many northern European countries rejecting religious art. Meanwhile, the papacy's power grew, and artists were drawn to Rome by its patronage and the city's renewal. The innovations of Leonardo da Vinci laid the foundations for the High Renaissance.

■ LEONARDO DA VINCI (1452–1519)
Annunciation 1472–75, Galleria degli Uffizi, Florence.

There are many sophisticated and complex elements in this painting, including the precise capturing of the folds in Mary's robe; the carefully gradated haziness of the receding landscape; and the fine shadowing of the faces and figures to give beauty and volume.

The Human Family of Christ

Leonardo, a true polymath, was unique for his range of interests, and his artistic legacy, though small, created a new paradigm. His writings show how closely he studied the requirements of painting perfect form. His paintings show a deep understanding of the natural world and his skill at capturing visually intense and emotional images. The study of human anatomy by both Leonardo and Michelangelo brought a new power to the human form, most strongly demonstrated in Michelangelo's *Sistine Chapel* (1508–12, see page 25).

Early 16th-century Rome was dominated by the patronage of Pope Julius II, who initiated many building projects and commissioned Raphael to paint his Vatican apartments (the *Stanze, see page 92*). The scheme combined Classical subjects and philosophical ideas from ancient Greece with key moments in papal history.

Leonardo's perfect form, Michelangelo's monumental physicality and Raphael's emotional intensity, unsurpassed in Vasari's opinion, influenced the next generation of artists. The choice of subject often involved the personal and human aspects of the Christian story. Correggio and Parmigianino explored the emotional relationships in the Christian narrative, capturing moments of high drama and passion.

Giorgio Vasari (1511–74)

Giorgio Vasari is generally described as the first art historian. His book *Lives of the Most Excellent Painters, Sculptors and Architects (Lives of the Artists)*, published in 1550, then revised and enlarged in 1568, extolled the virtues of Renaissance artists (especially Florentine ones) and established their canonical status which has dominated study of the period until relatively recently.

APPRECIATING...

The demonstrable scale of the works and the human intensity of art in the first 25 years of the 16th century were highly innovative. Rome became the centre of an artistic powerhouse. In Venice, too, Titian's rich colours and heightened humanity elevated religious painting to a new level (*see pages 41, 75–77*). Religious subjects became the context within which artists and patrons explored the nature of the human condition.

KEYWORDS

High Renaissance (c.1490s–1527) this term describes the perceived culmination of the artistic developments of the 15th century. It encompasses Leonardo, Michelangelo and Raphael in Florence and Rome, and Titian in Venice.

Oil painting perfected in northern Europe during the 15th century, and demonstrated by the works of Jan van Eyck (*see page 39*), Rogier van der Weyden (*see page 57*), Hans Memling (*see page 106*) and Hugo van der Goes (*see page 121*). Italian artists, especially Antonello da Messina (c.1430–79), studied the technique, and it had spread to Italy by 1500.

RELATED WORKS

- Works by **Domenico Ghirlandaio, Luca Signorelli, Andrea del Sarto** and **Parmigianino**.
- Works in Venice by **Giovanni Bellini, Giorgione, Titian, Paolo Veronese** and **Tintoretto**.

RELATED TOPICS/ARTISTS MICHELANGELO'S *SISTINE CHAPEL*, PAGES 24–25; RAPHAEL, PAGES 92–93; GIORGIONE, PAGE 122; AND LUCAS CRANACH THE ELDER, PAGE 26

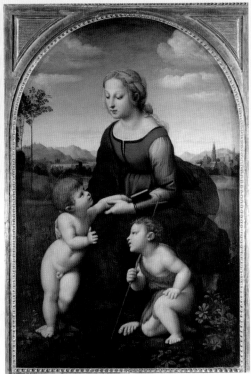

▌ RAPHAEL (1483–1520)
The Virgin and Child with Saint John the Baptist (La Belle Jardinière) 1507, Musée du Louvre, Paris.

Raphael's Madonna is not a remote, divine figure, but a beautiful young mother. As she carefully holds Christ, she seems aware of the infant John the Baptist, and we see her recognition of what the future holds.

▌ CORREGGIO (c.1489–1534)
Noli me Tangere c.1525, Museo del Prado, Madrid.

Mary Magdalene's discovery of Christ after His Resurrection, a pivotal moment for Christianity, is represented here as an emotionally charged encounter. Christ's words, 'Touch me not' (John 20:17), have become a metaphor for all-too-human unrequited passion.

In Heaven Above & on Earth Beneath

The precedent set in the early 16th century for filling vast chambers with paintings continued into the 17th century. These offered the potential for enormous compositions, with elaborate and extensive subjects. In contrast, normal-sized paintings became more intimate, with the viewer brought close to events. Caravaggio's intense tonal contrasts emphasised the closeness and drama of the Christian narrative.

RELATED WORKS

- **Tintoretto** *Paradise* after 1588, Palazzo Ducale, Venice, *The Slaughter of the Innocents* 1582–87, Scuola di San Rocco, Venice.
- **El Greco** *The Burial of Count Orgaz* 1586–88, Santo Tomé, Toledo.
- **Caravaggio** *Supper at Emmaus* 1601–2, National Gallery, London.
- Works by **Annibale Carracci, Guido Reni, Pieter Pauwel Rubens** and **Rembrandt**.

APPRECIATING...

The Council of Trent, which convened three times between 1545 and 1563 in the Italian city of Trent (modern-day Trento or Trentino), addressed accusations of corruption and criticism by Protestant reformers. It decreed that religious imagery should follow doctrine and communicate to the faithful. The archbishop of Bologna wrote that artists should 'teach, delight and move' (1582). Whilst painting styles during this period became increasingly flamboyant, expressive and melodramatic, in many ways, the religious message, presented on a human level, did meet these criteria.

The Pain and the Passion

Visual interpretations of the Christian story moved beyond the traditional scenes and compositions. Individual interpretations explored many different elements: emotional, dramatic or violent moments in the Christian narrative or saints' lives, or important events in Church history. Compositions depended on the overall visual impact, employing light and colour to add drama and richness. Bodies were contorted, faces caught in horror or bliss, shock or serenity. In smaller paintings, the viewer was close to the action, but in the largest paintings, each scene or vignette of action might capture the attention. The viewer's eye was drawn through the painting, often being unable to focus on the whole subject at once.

■ CARAVAGGIO
(c.1571–1610)
The Taking of Christ c.1598, National Gallery of Ireland, Dublin.

Caravaggio's extremes of light and dark give his works intensity and vibrancy. Portrayed in contemporary costume, the moment of Christ's betrayal contrasts the movement, drama and shock of the arrest with Christ's unresisting calm.

RELATED TOPICS/ARTISTS
PAOLO VERONESE'S *THE APOTHEOSIS OF VENICE*, PAGE 78;
ANNIBALE CARRACCI'S FRESCOES FOR THE PALAZZO FARNESE, ROME, PAGE 93

KEYWORDS

Mannerism (from the Italian word *maniera*, 'manner' or 'style') a term applied retrospectively during the 20th century to describe art and culture between the High Renaissance and c.1610. It is usually associated with an exaggerated foreshortening, unusual compositions and elongated figures.

Baroque a term coined retrospectively during the 19th century, it covers the period from c.1580 to the early 18th century. Its style was florid and decorative, with dramatic poses and passionate expressions, often combining painting, sculpture, decorative effects and architecture to create impact.

◼ **EL GRECO** (1541–1614)
Adoration of the Shepherds 1612,
Museo del Prado, Madrid.

El Greco drew on the spirituality and light of his Byzantine Cretan heritage and the colours of a Venetian training to produce uniquely expressive religious imagery. He settled in Toledo, Spain, in 1577. His paintings visually explored the relationship between heaven and earth.

Painting the Heavens

The popularity of huge ceiling and wall paintings stretched across Europe, from Michelangelo's Sistine Chapel through the hall of the Great Council, Palazzo Ducale, Venice (Paolo Veronese and Tintoretto, 1585–90, *see page 78*), and the Palazzo Barberini, Rome (Pietro da Cortona, 1633–39), to the Banqueting Hall, Whitehall, London (Pieter Pauwel Rubens, installed 1635). Subjects were often triumphal allegories, but many contained underlying religious symbolism, not least representations of heaven.

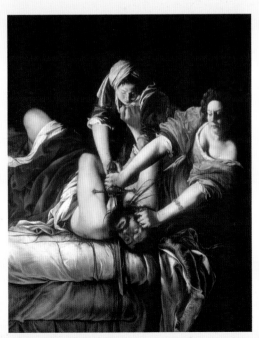

◼ **ARTEMISIA GENTILESCHI** (1593–1652)
Judith Beheading Holofernes 1611–12,
Galleria degli Uffizi, Florence.

The gruesome moment of murder draws on Caravaggio's intense contrasts of light and dark to reveal the faces: Judith's detached and focused, her handmaid's determined and Holofernes' gasping his last breath. Hailed by some as a proto-feminist artist, Gentileschi painted many female subjects, including Judith and her handmaid several times.

Raising the Madonna

As the 17th century slipped into the 18th, demand for religious art declined and the days of grand religious painting were numbered. New subjects dominated, and the Enlightenment proposed philosophies that placed humankind at the centre of the world order. The Christian message still had resonance, however, and at the end of the 18th century artists began to paint radically individual visual interpretations.

APPRECIATING...

By the end of the 18th century, few artists were being asked to fill churches with Christian imagery as patrons looked to other subjects for visual inspiration. The Christian message would continue to draw artists to explore its spirituality, however, and the symbolism and forms of religious imagery remained powerful models for artists.

RELATED WORKS

- **Guercino** *The Flagellation of Christ* 1657, Galleria Nazionale d'Arte Antica, Rome.
- **Sebastiano Ricci** *Saint Pius, Saint Thomas of Aquino and Saint Peter Martyr* 1730–33, San Maria del Rosario (Gesuati), Venice.
- **Franz Anton Maulbertsch** *Crucifixion* 1758, Parish Church, Sümeg, Hungary.
- **John Martin** *Great Day of His Wrath* 1851–53, Tate Britain, London.

▌ BARTOLOMÉ MURILLO (1617–82)
Immaculate Conception of the Escorial c.1678,
Museo del Prado, Madrid.

The Virgin Mary and the doctrine of the Immaculate Conception suited Murillo's skill at capturing pathos, and he painted several versions of the theme. Completely free from sin, the Virgin is represented as a gentle young girl of stainless virtue floating to heaven accompanied by cherubs on a crescent moon.

▌ GIOVANNI BATTISTA TIEPOLO (1696–1770)
The Virgin with Six Saints 1737–40,
Museum of Fine Arts, Budapest.

Tiepolo's soft colours, flowing forms and billowing silks classify his style as Rococo. All pretence that the Virgin Mary is in the real world is abandoned as she floats on clouds above the attending saints. Tiepolo's dramatic and colourful style was popular beyond Venice, but he was one of the last artists to paint religious imagery on a grand scale.

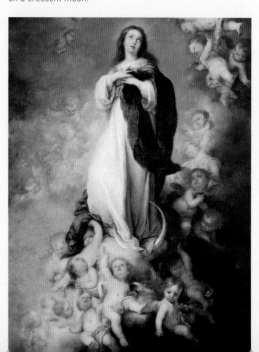

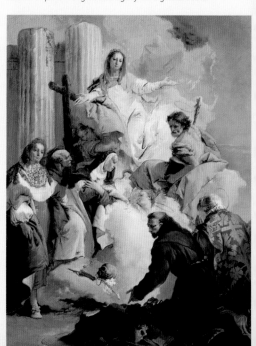

The Gentle and Loving Mother

The cult of the Blessed Virgin Mary – the Madonna – dates back at least to the 5th century, when the Church declared her the Mother of God. As Christ's mother, she brought salvation to the world and acted as an intercessor on behalf of supplicants. Scenes from her life were depicted in art: the *Annunciation* (Leonardo da Vinci, *see pages 62–63*); the *Nativity* (Caravaggio, 1609); *The Virgin and Child with Saint John the Baptist* (Raphael, *see page 63*); *The Miracle of the Wedding at Cana* (Paolo Veronese, 1563); *Pietà* (Giovanni Bellini, *see page 61*); *Her Assumption into Heaven* (Titian, 1516–18); and *Her Coronation* (El Greco, 1591). The doctrine of her Immaculate Conception, ratified as dogma during the 19th century, held that she was born without sin and remained so throughout her life.

By the Fading Light

By the 18th century, the traditions of Christian painting continued in only a few places. In Venice, artists continued to paint large frescoes and altarpieces, including Sebastiano Ricci, Giovanni Battista Piazzetta, Giovanni Battista Tiepolo and Gianantonio Guardi. In Austria and Hungary, Franz Anton Maulbertsch maintained the tradition until the end of the century. Styles were soft, using delicate or muted colours, and compositions often involved figures floating on clouds into bright, ethereal skies.

KEYWORDS

The Enlightenment an era of scientific study from the 17th century, pioneered by Galileo Galilei (1564–1642) and Isaac Newton (1643–1727), that developed rational explanations for the natural world. Philosophers of the 18th century explored experiences of the mind and senses and the source of knowledge. Denis Diderot (1713–84) published the *Encyclopédie* from 1751: 'a systematic dictionary of the sciences, arts and crafts'. Many Enlightenment philosophers rejected religion as superstition, believing only in the power of the rational human mind.

Ideals of the Christian Message

In England, William Blake (1757–1827) and John Martin (1789–1854) presented deeply personal interpretations of the Christian ideals. Blake's visionary poetry and art contained religious messages – he was inspired by the Bible, and his paintings and prints have a mystical and dream-like quality. He believed that he could communicate with the prophets and his dead brother. John Martin's paintings and prints explore apocalyptic visions of heaven and hell. Like Blake, his works had no precedent, and they presented a dark world in the throes of turmoil and destruction, offering only glimpses of salvation.

RELATED TOPICS/ARTISTS
ROCOCO, PAGE 31

▌ WILLIAM BLAKE
(1757–1827)
The Book of Job 1820, Pierpont Morgan Library, New York.

Blake's Christianity was a personal and spiritual belief that radically rejected the established Church. His illustrations for the Book of Job *and Milton's* Paradise Lost *present a unique and individual interpretation of religious subjects. Drawing on his own disturbed and visionary experience, he created powerful and original conceptions of the transcendent.*

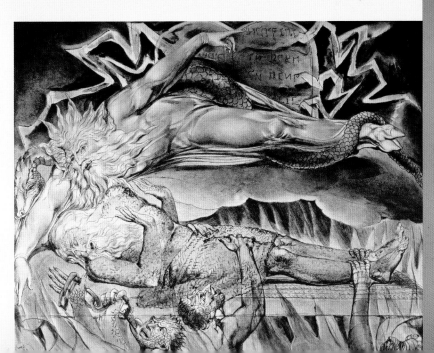

Renewing the Faith

Several groups explored new interpretations of the Christian subject during the 19th century. The Nazarenes were German Romantic artists working early in the century; the Pre-Raphaelite Brotherhood, founded in 1848, revived artistic styles from the 15th century; and Paul Gauguin and *Les Nabis* explored religious experience and symbolism in rural France during the 1880s and 1890s.

APPRECIATING...

Artists continued to explore Christian imagery throughout the 19th century. The Nazarenes revived traditional forms and techniques to recapture the spirituality of the past. Others applied innovative styles to traditional subjects, creating newly powerful imagery for the expression of Christian beliefs. Running through these works was a continuing engagement with the manifestation of a transcendent being on earth.

The Nazarene Movement

Founded initially as the Brotherhood of Saint Luke in Vienna, Austria, following the medieval guild tradition, the group later adopted the title 'Nazarenes' and moved to Rome (from 1810 to c.1830). The Nazarenes revived monumental Church fresco painting and, inspired by Albrecht Dürer, rejected Neo-Classicism in order to paint traditional Christian themes. Josef von Führich's *Jacob Encountering Rachel with her Father's Herds* (1836) is typical of their style. The Nazarenes, including Johann Friedrich Overbeck and Peter von Cornelius, were popular in Germany. Cornelius' murals in the Ludwigskirche, Munich (1836–39), demonstrate their strong affinity with traditional Christian imagery.

RELATED WORKS

- **Peter von Cornelius** *The Last Judgement* 1836–39, Ludwigskirche, Munich.
- **John Everett Millais** *Christ in the House of His Parents* 1850, Tate Britain, London.
- **Paul Sérusier** *Incantation or the Sacred Forest* c.1891–92, Musée des Beaux-Arts, Quimper, France.

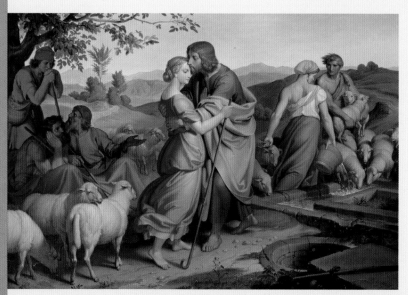

▌ JOSEF VON FÜHRICH (1800–76)
Jacob Encountering Rachel with her Father's Herds 1836, Österreichische Galerie, Vienna.

This painting may seem dull and formulaic to us today, but the revival of Christian subjects and earlier styles would have been a dramatic contrast to the hard rationality of Neo-Classicism at the time it was painted. The romanticism of the representation dominates in the gentle faces, soft colours, rounded forms and the idyllic pastoral landscape.

The Pre-Raphaelite Brotherhood

In England, the Pre-Raphaelite Brotherhood (PRB) sought to revive the Early Renaissance style of artists like Fra Angelico. Dante Gabriel Rossetti came closest to this goal in *The Girlhood of Mary Virgin* (1848–49, Tate Britain, London) and *Ecce Ancilla Domini (Annunciation)* (1850, Tate Britain, London), which employed the soft colours and forms of fresco painting. Although this stylistic revival was not universally adopted by the group, many PRB artists and their associates painted religious subjects and themes. John Everett Millais' *Christ in the House of His Parents* (1850) was hugely controversial because of its realistic and menial setting. William Holman Hunt's *The Light of the World* (1853–54) combined a highly naturalistic style with the symbolism of Christian salvation.

Synthetism and *Les Nabis*

Paul Gauguin developed the theory – termed Synthetism – that art is a visual expression of the synthesis of nature viewed through the prism of the artist's experience and sensibilities. By foregrounding the artist's expression in the art-making process, Gauguin was no longer limited to naturalistic representation, but instead painted flat, simplified forms in non-naturalistic colours and tones. Working at Pont-Aven, in Brittany, during the 1880s, Gauguin followed these principles to represent visually the local peasants' strong, traditional Christian beliefs juxtaposed with their imagery and symbolism. Led by Paul Sérusier, *Les Nabis* (the French and Hebrew term for 'The Prophets') followed Gauguin's artistic ideals, focusing on artistic expression and symbolism. Members of *Les Nabis*, who became well known, included Pierre Bonnard, Édouard Vuillard, Maurice Denis and Émile Bernard.

▌ **WILLIAM HOLMAN HUNT** (1827–1910)
The Light of the World 1853–54, Keble College, Oxford.

This work's rich colours and symbolism have made it one of the most popular images of the 19th century. Christ knocks on a woodland door, symbolising the human soul, long closed and overgrown, his bright halo and lantern illuminating the dark night (taken from Revelation 3:20).

▌ **PAUL GAUGUIN** (1848–1903)
The Yellow Christ
1889, Albright-Knox Art Gallery, Buffalo, New York.

As in Vision After the Sermon: Jacob Wrestling the Angel *(1888, National Gallery of Scotland, Edinburgh), Gauguin represents peasants wearing traditional costume experiencing a vision. By harmonising the rich reds and golds of the landscape with the crucified Christ, Gauguin centralises the Christian message within the rural world of the peasants.*

RELATED TOPICS/ARTISTS
NEO-CLASSICISM, PAGES 98–99; ROMANTICISM, PAGE 81; SYMBOLISM, PAGE 85; AND POST-IMPRESSIONISM, PAGE 115

Myth & Allegory

'Art is the aesthetic ordering of experience

to express meanings in symbolic terms.'

DANIEL BELL (1919–)

Myths are narratives that reinforce a society's cultural values. Throughout history, societies have narrated, written or visualised mythologies – groups of connected myths – that underlie and articulate their cultural identity. Western Europeans are most familiar with Greek mythology, but different mythologies exist across the world. For example, the Scandinavian people have Norse mythology, and the Indian subcontinent has the *Mahabharata*, a Sanskrit epic poem of 90,000 verses, relating ancient Hindu myths, dating back to around the 5th century BC. Many of these mythologies are very old, and their origins obscure, but they share a continued interest for, or relevance to, the societies that they serve.

The characters and events in Greek mythology were drawn from ancient Greek texts. Central to these were Hesiod's *Theogony*, which described the origins of the earth, heaven and gods, and the Homeric poems the *Iliad* and the *Odyssey*, all dating back to about the 8th century BC. Many of these myths narrated heroic exploits; some provided the narrative for rituals and worship; and others were allegories of Greek civic values, customs and concerns.

Studies of Greek myths show that many were based on real events. For example, the discovery of the site of Troy by the archaeologist Heinrich Schliemann (1822–90) supported the reality of the Trojan War in Homer's *Iliad*. More recently, based on geological evidence, scholars have proposed that Odysseus' island of Ithaca in the *Odyssey* was part of Cephalonia, in the Ionian Sea. Myths may have been based on real events, but their telling and retelling through history transformed them to the point where reality and myth were indistinguishable.

The boundary between mythical and religious narratives can appear thin. The gods of Greek mythology were worshipped in ancient Greece and Rome (Roman mythology substituted names and added characters, but basically followed Greek narratives). The revival of interest in Greek and Roman myths during the Renaissance demonstrated their continued significance to western European Christian society. The myths of gods, goddesses, heroes and heroines told of basic human experiences and values – love, loss, seduction, fertility, pleasure, fear, life, death, heroism, sacrifice and power – that appealed to the Renaissance mind. Whether the myths were based on real events or not, their survival is a testament to their lasting relevance.

The Heritage of Greece & Rome

With the establishment of Christianity as the religion of the Roman Empire at the start of the 4th century AD, pre-Christian (pagan) religions declined. Although Christian theology drew on Classical Greek philosophy, knowledge of Greek and Roman mythology fell into obscurity in western Europe. The texts preserved in the Greek language, including those of Plato, could no longer be translated. As Byzantine power in Constantinople declined during the 14th century, however, greater interaction between East and West brought Greek scholars to Italy. The renewed interest in Graeco–Roman philosophy and mythology initiated the rediscovery and translation of many Greek and Roman manuscripts.

▮ HIERONYMUS BOSCH (c.1450–1516)
The Ship of Fools 1490–1500, Musée du Louvre, Paris.

Bosch was preoccupied with representing moral subjects, choosing both religious and secular contexts. His unique style was particularly well suited to capturing the grotesque details of humanity's deepest sins and vices.

Petrarch and Boccaccio

Francesco Petrarch (1304–74) was one of the first Renaissance scholars to study Classical texts and manuscripts. Although he could not read Greek, he had a copy of Homer's works, and, with his fellow literary scholar, the author of the *Decameron* Giovanni Boccaccio (1313–75), Petrarch promoted the study of ancient Greek in Italy. The renewed interest in ancient Greek and Roman philosophy and texts laid the foundation for humanism during the Renaissance. By 1400, educated individuals were turning to Classical sources to explore ideas of human potential and control over destiny. In 1397, for example, the Byzantine scholar Manuel Chysolarus (c.1355–1415) came to teach Greek at the University of Florence. His pupil, the historian Leonardo Bruni (c.1370–1444), translated Plato and Aristotle's works and, as chancellor of Florence, witnessed the artistic innovations of the Early Renaissance.

What is an Allegory?

Graeco–Roman mythology provided many of the narratives and characters used in mythological painting. The humanist interest in these myths centred on their symbolic – or allegorical – meanings. An allegory is an image or narrative that has a symbolic meaning. For example, Rosalba Carriera's *Flora* (1730s) represents the Roman goddess of flowers and spring (Greek: Chloris). Flora was a popular subject because she symbolised the renewal of life, fertility and abundance. She was often depicted as a beautiful woman decked in flowers, symbolic of the feminine qualities valued by male patrons, who were concerned with love, procreation and prosperity.

Mythical and Allegorical Subjects

Mythical and allegorical subjects alluded to a wide range of values, good and bad, designed to encourage virtuous behaviour. These might condemn sins and pillory stupidity, as in Hieronymus Bosch's *The Ship of Fools* (1490–1500). A group of grotesque individuals, representing humanity, sit in a boat that clearly cannot sail and will probably sink. They enjoy the pleasures of the flesh while the boat goes nowhere. The imagery is a moral allegory on how these pleasures distract humanity from a virtuous and productive life. Bosch was particularly concerned with the seven deadly sins (*see pages 60–61*), and painted a panel depicting them early in his career (c.1480, Museo del Prado, Madrid).

The relationship between men and women was frequently the subject of allegorical painting. Viewed largely from the male perspective, such paintings dealt with many values: wifely virtues; beauty; fertility and procreation; ideal and erotic love; conquest and submission; and the tensions and problems inherent in male and female attraction. Graeco–Roman goddesses and heroines – particularly Venus (Greek: Aphrodite) – were employed to symbolise these desires and concerns. Agnolo Bronzino's *Allegory of Venus and Cupid* (mid-1540s) was probably a gift from Duke Cosimo de' Medici to King Francis I of France. It displays a complex range of imagery alluding to the pleasures and pitfalls of erotic love. Venus, holding a golden apple and Cupid's arrow, is being titillated by Cupid. Old Father Time holds up a drape, whilst other figures symbolise foolish pleasure (the child scattering rose petals and ignoring the thorn in his foot); deceit (the beautiful girl hiding a monster under her skirt); jealousy (or possibly syphilis, contorted in the background); and oblivion (shielded by the drape to the left). The allusions to sexual pleasure and its negative connotations provide insights into 16th-century morality.

RELATED TOPICS/ARTISTS
THE SEVEN DEADLY SINS, PAGES 60 – 61; PIETER PAUWEL RUBENS, PAGES 28–29

▌ ROSALBA CARRIERA (1675–1757)
Flora 1730s, Galleria degli Uffizi, Florence.

Rosalba Carriera is renowned for her pastel painting. Based in Venice, she was popular with British Grand Tourists. Carriera painted portraits and sexually alluring subjects, such as this Flora, with her soft, textured expanse of flesh and seductive expression. Flora's symbolism of fertility and renewal overlies a contemporary representation of women.

▌ AGNOLO BRONZINO (1503–72)
Allegory of Venus and Cupid mid-1540s, National Gallery, London.

The smooth skin and opulent blue drape are rich and sensuous. The allegorical allusions would have offered an intellectual puzzle to the viewer, flattering their knowledge of mythical subjects and symbolism. The image presents the ideals of erotic love from an entirely male perspective.

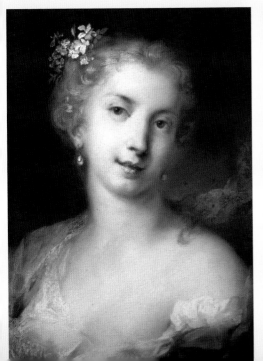
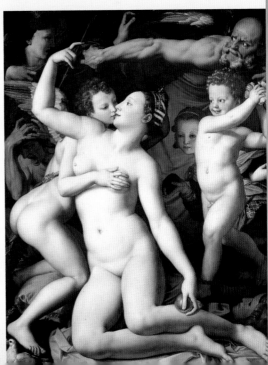

The Renaissance Ideal

Marsilio Ficino (1433–99) and Lorenzo de' Medici ('The Magnificent', 1449–92) explored the ideas within Greek philosophy. Ficino was a theologian, and he sought to combine Greek philosophical values, especially those of Plato, with Christian theology. Lorenzo collected Classical manuscripts and supported and encouraged Ficino's work. He also supported many artists, including Sandro Botticelli, Leonardo da Vinci and Michelangelo.

APPRECIATING...

The mythological subjects used in 15th-century works set the precedent for the future. They operated on three levels:

- the mythical characters provided allegories for contemporary human interests, such as love, virtue and moral values

- their representation was concerned with the ideal – the Platonic concept of a version of reality that is higher and more perfect than everyday reality

- the myths provided new secular subjects and compositions in which ideas aligned to humanist thinking could be expressed.

RELATED WORKS

- **Paolo Uccello** *Faith, Fortitude and Hope* c.1435, Duomo, Prato.
- **Hieronymus Bosch** *Seven Deadly Sins* c.1480, Museo del Prado, Madrid.
- **Botticelli** *Venus and Mars* c.1483, National Gallery, London.

▌ SANDRO BOTTICELLI (1445–1510)
Primavera c.1482, Galleria degli Uffizi, Florence.

The dark woodland sets off the willowy female figures. The pose of the Three Graces follows Classical sculptures, whilst Flora's dress is abundantly decorated with delicate flowers, symbolising renewal and fertility. The predominant colours of silvery grey and red are carefully balanced around Venus to highlight the goddess.

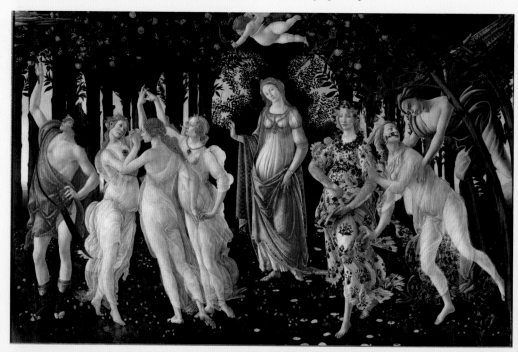

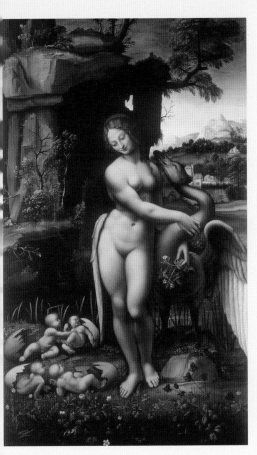

LEONARDO DA VINCI (1452–1519)
Leda and the Swan 1505–10,
Galleria degli Uffizi, Florence.

Both Zeus' seduction of Leda and the hatching of two sets of twins are represented here. Leonardo's curvaceous Leda embraces the swan in a lush landscape. The swan's grey wings frame the warmer tones of Leda and the infants.

Leda and the Swan

A popular allegory of love and sexual fulfilment was Zeus' (Roman: Jupiter's) conquests. The king of the gods would take various forms to deceive and seduce his chosen paramour. Leda was the wife of the king of Sparta, and Zeus, disguised as a swan, pretended to seek her protection from an eagle. Leda bore four children – Helen of Troy, Clytemnestra, Castor and Pollux – but which were Zeus' offspring and therefore half-immortal varies in different versions of the myth.

GIORGIONE (c.1477–1510), or TITIAN (1489/90–1576),
Pastoral Concert (Fête Champêtre) 1508–9,
Musée du Louvre, Paris.

Ideal feminine virtues are set within the context of a pastoral idyll. The nude women contrast to the clothed men in a harmony of pleasure, feminine beauty and music.

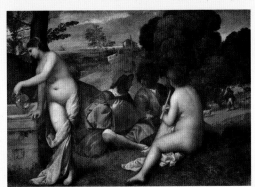

Venus and Mythical Love

Sandro Botticelli's *Primavera* (c.1482) was one of the first works since antiquity to represent the subject of a Classical myth in visual form. Inventories and contemporary letters suggest that it was painted for the teenage Lorenzo di Pierfrancesco de' Medici, a second cousin of Lorenzo ('The Magnificent'), and that it may allude to marriage. The painting combines mythological elements to create allegories of the ideals of love and feminine virtue. To the left, Mercury (Greek: Hermes), the Roman messenger god, holds back the clouds with his caduceus; the Three Graces – beauty, charm and joy – dance in diaphanous gowns; and an ideal Venus stands in the centre, with Cupid above her aiming his arrow. To the right, Zephyrus blows on the nymph Chloris as she is transformed into Flora (Spring). A letter from Ficino to Lorenzo di Pierfrancesco describes Venus' virtues as those of the ideal wife and parallels many aspects of the painting.

KEYWORDS

Renaissance Neo-Platonism the translation from the Greek of the works of Plato (428/7–348/7BC) was a core development of the Renaissance. Platonic idealism held that the reality that we experience is only a shadow of a higher ideal. The ideal, separate from flawed reality, was an influential concept for Renaissance humanists.

RELATED TOPICS/ARTISTS
SANDRO BOTTICELLI'S *THE BIRTH OF VENUS*, PAGE 24, AND GIORGIONE'S *TEMPEST*, PAGE 122

Heroes & Heroines

The Greek myths contain many stories of heroes faced with challenges and monsters that needed to be overcome in order to reach home or to save heroines. Selfless acts and mighty deeds against the odds provided ideal subjects for paintings. Both the superhuman endeavours of the heroes and the beauty and vulnerability of the heroines were popular elements in these myths.

APPRECIATING...

The selection of Classical subjects by patrons during the 16th century demonstrates the spread of knowledge of Greek myths and philosophy across Italy and beyond. The popular choice of mythical heroes and heroines *in extremis* reflects the patrons' desire for stimulation, excitement and even titillation. Decorating private rooms in palazzos with a series of connected Classical themes allowed patrons to share their visual pleasure and display their erudition to their peers. It is important to remember that the vast majority of these patrons were aristocratic men, and that the subjects reflected their pleasures and preferences.

■ ALBRECHT DÜRER (1471–1528)
Knight, Death and the Devil 1513,
Staatliche Kunsthalle, Karlsruhe.

This work shows the detail and intensity that Dürer achieved in his engravings. The different textures of the armour, the horse's flank, the dog's fur and the landscape create depth and vibrancy. The expressions of all the characters, including the horse and dog, emphasise the image's symbolic messages.

MYTHOLOGICAL COUPLES

Along with Perseus and Andromeda, other heroes and heroines from Graeco–Roman mythology that were often depicted in paintings include:

• Venus (Greek: Aphrodite) and Adonis
• Diana (Greek: Artemis) and Actaeon
• Tarquin and Lucretia (from a Roman legend of rape and suicide)
• Paris and Helen of Troy
• Ulysses (Greek: Odysseus) and Penelope
• Apollo and Diana
• Orpheus and Eurydice.

Life and Death

Allegorical works did not always draw on mythical subjects; some explored fundamental conditions of life more directly. Albrecht Dürer's *Knight, Death and the Devil* (1513) can probably be interpreted as part of a group of three works, including *Saint Jerome in his Study* and *Melencolia I* (1514). *Knight, Death and the Devil* is an allegory of Christian redemption, with the knight riding purposefully forwards, despite Time with his hourglass, and the Devil on his heels. The dog at his feet symbolises faithfulness, the lizard alludes to religious zeal and God is represented by the castle on the hill. The knight symbolises the ideal of a devoted life of religious fervour – an important model for the Arthurian legends.

PIERO DI COSIMO
(1462–1521)
Perseus Frees Andromeda
c.1510, Galleria degli Uffizi, Florence.

This work presents the narrative of the myth at the point when Perseus rescues Andromeda. We see him flying on winged feet towards the sea monster and then killing it as it threatens Andromeda. The people of the town, dressed in Eastern and exotic costumes, cower on the shore.

Perseus and Andromeda
Perseus, the first mythical Greek hero, was the son of Danaë and Zeus. The gods gave him magical weapons and armour, which he used to defeat the Gorgon Medusa. On his return, he killed a sea monster that was terrorising a Phoenician kingdom and saved Andromeda, who had been tied to a rock to appease the monster. They established the Perseid Dynasty of Mycenae. Perseus is sometimes represented with winged feet or riding the winged horse Pegasus.

RELATED WORKS
- **Giovanni Bellini** and **Titian** *The Feast of the Gods* 1514, National Gallery of Art, Washington, DC.
- **Paris Bordone** *Allegory With Lovers* 1550, Kunsthistorisches Museum, Vienna.
- **Lucas Cranach the Elder** *The Judgement of Paris* c.1528, Metropolitan Museum of Art, New York.
- **Raphael** *The Triumph of Galatea* 1511, Villa Farnesina, Rome.

RELATED TOPICS/ARTISTS
CORREGGIO'S *JUPITER AND IO*, PAGE 26; AGNOLO BRONZINO'S *ALLEGORY OF VENUS AND CUPID*, PAGE 73; DOSSO DOSSI'S *DIANA AND CALISTO*, PAGE 123

TITIAN (1489/90–1576)
Bacchus and Ariadne
1523–24, National Gallery, London.

Painted for Alfonso d'Este's palazzo, this work was to be hung with a series of Classical paintings, including The Feast of the Gods, in the Camerino d'Alabastro. It shows Bacchus finding Ariadne, who was abandoned on the island of Naxos by Theseus, mythical king of Athens. Ariadne had helped Theseus evade the Minotaur in the Labyrinth on Crete using a ball of thread, but he deserted her to return to Athens. Ariadne leads a procession of revellers as Theseus' boat sails away and Bacchus arrives to take her as his lover.

Adorned in Splendour

Allegorical painting developed beyond the confines of Greek myth to encompass a broader range of symbolism. Since Classical times, the concept of personification had allowed cities and countries to allegorise their qualities and values. Cities were represented by a female figure (*tyche*) that governed their fortunes, and the concept was revived in the Renaissance. The power and status of individuals were also represented as allegories.

APPRECIATING...

Mythological and allegorical paintings were still concerned with representing the ideal – to symbolise the perfect goal, to celebrate perceived achievements and to portray the symbols of power. Painting during the Baroque period (*see page 65*) was well suited to creating large-scale, flamboyant allegories that could include all manner of symbolic elements. Large wall paintings and ceilings were covered with numerous figures (especially *putti*) from extensive narratives, while opulent, rich textures and forms emphasised the triumphal messages.

RELATED WORKS

- **Pietro da Cortona** *The Rape of the Sabine Women* 1627–29, Pinacoteca Capitolina, Rome.
- **Rembrandt** *Danaë* 1636–47, State Hermitage Museum, Saint Petersburg.
- **Diego Velázquez** *The Fable of Arachne* c.1657, Museo del Prado, Madrid.

▌ PAOLO VERONESE (1528–88)
The Apotheosis of Venice 1585, Palazzo Ducale, Venice.

The Palazzo Ducale was at the centre of Venice's strategy to promote its status and history. Fire destroyed earlier decorations in 1577, and Veronese's ceiling crowned the new programme. The personification of the city rises through the clouds, surrounded by regal attendants.

Power and Polity

Personifications were used to highlight civic status and national ideals. For example, drawing on the ancient Roman title, Britannia is the personification of Britain. She is represented as a Classical warrior, with a lion and, since the 19th century, Poseidon's (Roman: Neptune's) trident, symbolising sea power. In Paolo Veronese's *The Apotheosis of Venice* (1585), Venice is adorned as a queen about to be crowned, in a scene comparable to the Virgin Mary's coronation. During the 15th century, Venice promoted its own myths of equality with Rome, apostolic foundation, social unity and democracy. The imagery used included a horn of plenty, the winged lion of Saint Mark (Venice's patron saint and legendary founder), allusions to the Doge's rule and military achievements.

▌ CAESAR BOETIUS VAN EVERDINGEN (c.1617–78)
Allegory of the Birth of Frederik Hendrik c.1650.
Huis ten Bosch, The Hague.

Commissioned after his death, this painting allegorises the life of Frederik Hendrik (head of state, 1625–47), He presided over the Dutch Republic's 'Golden Age', and is symbolised by baskets of riches, the Republic's lion and military success.

KEYWORDS

Apotheosis deification, becoming a god, symbolic of glorification. A Roman concept applied to emperors, such as Augustus Caesar, who were usually represented ascending into heaven.

Muses nine goddesses (daughters of Zeus) of the liberal arts, for example, Calliope (epic poetry), Erato (love poetry) and Terpsichore (dancing).

Allegories for all Occasions

Artists were asked to paint more generalised allegories, using motifs of myths, but without specific characters or narrative. A broader range of heroic subjects was represented, including, from the Bible, Samson and Delilah and Solomon and Bathsheba. Allegorical paintings made use of more mundane subjects, too, for example: the seasons and times of day symbolising the cycle of life; the Muses and personifications celebrating the liberal arts; the ages of humankind; truth; and a whole range of ideas and ideals, such as religion, faith, vanity, painting and free trade. The symbolism in these paintings was designed to present uplifting narratives which either advocated or celebrated the qualities of an ideal world.

RELATED TOPICS/ARTISTS
CARAVAGGIO'S *VICTORIOUS CUPID*, PAGE 27; PIETER PAUWEL RUBENS' *JUDGEMENT OF PARIS*, PAGES 28–29; ANNIBALE CARRACCI'S *TRIUMPH OF BACCHUS AND ARIADNE*, PAGE 93; WORKS BY NICOLAS POUSSIN AND CLAUDE (LORRAINE), PAGES 124–25

▌ GUIDO RENI
(1575–1642)
Abduction of Helen 1631,
Musée du Louvre, Paris.

The epic poem the Iliad tells of the love of Paris, prince of Troy, and Helen, wife of Menelaus, king of Sparta. Paris abducts Helen, and returns with her to Troy. Menelaus calls up a Greek army that attacks and destroys Troy through the ruse of the wooden horse. Representations of Helen and Paris explore the passion and tensions of their encounter. Reni represents a dignified descent to the awaiting ships with Helen acquiescent. Other artists show seduction, passion or rape in one of history's greatest love stories.

Decoration & Melodrama

In Venice, the demand for traditional allegorical paintings continued, and Giovanni Battista Tiepolo's style was well suited to fulfil this. The French court sought the more personal and lyrical representations of Jean-Antoine Watteau, François Boucher and Jean-Honoré Fragonard, in contrast to the grand forms of the previous century. At the end of the 18th century, Romantic artists created a completely new repertoire of symbolic subjects and messages for paintings.

RELATED WORKS

- **Jean-Antoine Watteau** *The Embarkation for Cythera* 1717, Musée du Louvre, Paris.
- **Giovanni Battista Tiepolo** *Apollo and the Continents* 1752–53, Residenz, Würzburg.
- **Francisco de Goya y Lucientes** *Los Caprichos* 1797–99; *Disaster of War* 1810–15; and *The Black Paintings* 1820–23, Museo del Prado, Madrid.

APPRECIATING...

Through the 18th century, the subjects of allegorical painting became increasingly personal. From the intimacies of the French court to the horrors of Goya and Fuseli's work, artists explored new subjects to express and symbolise the experience of life. They no longer relied on the narrative and visual formulae of Greek myths, but instead drew on their own imagination and the world around them to construct allegories. By moving from the grand to the personal, these allegories also changed from representing and celebrating social and cultural ideals to symbolising and highlighting the new realities of life.

Courtly Allegories

Jean-Antoine Watteau developed the form of allegory known as *fête galante* (see page 148), which symbolised pleasure and courtly love. He painted several versions of a scene known as *The Embarkation for Cythera* (or *Pilgrimage to Cythera*) (1717). A group of revellers appears to be embarking (or possibly disembarking) for the mythical island of love. Figures in contemporary costume, alluding to Watteau's aristocratic patrons, are engaged in romantic trysts as they walk through the idyllic landscape.

Tiepolo worked outside Venice for Prince–Bishop Carl Phillip von Greiffenclau, painting a series of large allegorical paintings in his new palace at Würzburg, Germany. Of particular interest are the stairwell paintings that allegorise the four continents of Europe, America, Asia and Africa with Apollo. At a time when the world beyond Europe was only just becoming known, the prince–bishop used these allegories to suggest his international status.

■ GIOVANNI BATTISTA TIEPOLO (1696–1770)
Bellerophon on Pegasus 1746–47, Palazzo Labia, Venice.

The representation of an open ceiling to heaven was a particularly Venetian form. The viewer looks up at the winged horse, Pegasus, and the mythical Greek hero Bellerophon flying into the heavens. They are awaited by the personification of Glory, dressed in a golden gown.

❚ ANGELICA KAUFFMANN
(1741–1807)
Venus Convinces Helen to Go with Paris
1790, State Hermitage Museum, Saint Petersburg.

In this version of the story, Venus, the Roman goddess of love, is persuading Helen to go with Paris to Troy. Cupid encourages Paris to come forward, and the lovers' apparent hesitation is a more gentle interpretation than that seen in some other extant versions.

RELATED TOPICS/ARTISTS
ROCOCO, PAGE 31; THE ENLIGHTENMENT, PAGE 67; NEO-CLASSICISM, PAGE 98; FÊTE GALANTE, PAGE 148

Dreams and Nightmares

The artists categorised as Romantics rejected the rationalism of the Enlightenment (*see page 67*) and turned to their own experiences, imagination and emotions for inspiration. Their work, in general, contrasts with the hard-edged pragmatism of Neo-Classicism (*see page 98*). Francisco de Goya y Lucientes and Henry Fuseli particularly explored the mind's darker side, painting subjects that symbolised life's horrors and terrors. Goya's etchings *Los Caprichos* (1797–99), *Disaster of War* (1810–15) and *The Black Paintings* (1820–23) were his response to the hypocrisies, genocide and personal sufferings that he witnessed in his life. Fuseli explored more intimate nightmares, portraying monsters and terrified figures in such works as *Lady Macbeth Seizing the Daggers* (1812, Tate Britain, London) and *Silence* (1799–1801, Kunsthaus, Zürich).

❚ HENRY FUSELI (1741–1825)
The Nightmare 1781, Institute of Arts, Detroit.

Fuseli painted several disturbing subjects drawn from dark and tortured dreams. The monster sitting on the girl's body and her abandoned pose have decidedly erotic connotations. The dark setting, with its indistinct figures – typical of Fuseli's style – adds to the sense of horror threatening the vulnerable girl.

KEYWORDS

Romanticism a style of art and literature that drew on the imagination rather than rationalism. Artists include Francesco de Goya y Lucientes (*see pages 49, 101 and 114*), Henry Fuseli, William Blake (*see pages 67 and 82–83*), Caspar David Friedrich (*see pages 130–31*), Eugène Delacroix (*see pages 12–13*), John Constable (*see pages 118–19*), Joseph Mallord William Turner (*see page 100*) and Samuel Palmer (*see page 9*). Their subjects and styles varied but they shared a rejection of the forms of Neo-classicism and the values of the Enlightenment.

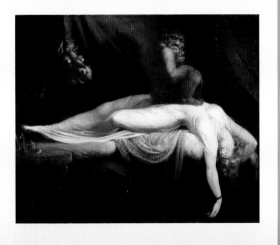

William Blake's Personal Vision

William Blake trained as an engraver and many of his works combined relief etching with watercolour painting. He attended the Royal Academy in London (*see page 48*) from 1778, but eventually rejected its artistic values. He strongly criticised Joshua Reynolds, the first president, for his attitude to art, and pursued an entirely individual aesthetic. Blake's art and writing are described as the works of a genius or eccentric, but are primarily the expression of a radical visionary. *Reason* or *Isaac Newton* (1795) is an allegory of Blake's criticism of the Enlightenment's instrumental reasoning and, as he saw it, the attempt to emulate God.

Although believing in a sense of the transcendent, Blake rejected organised religion, relying on his own interpretation of the Bible. On the periphery of the political upheavals of the period, he addressed social issues – for example, in the poems and illustrations of *Songs of Innocence and Experience* (1789–94) – such as child chimney sweeps, social deprivation, exploitation and poverty. He illustrated a number of books, including Milton's *Paradise Lost* (1808), *The Book of Job* (1823–26, *see page 67*) and Dante's *The Divine Comedy* (1826–27, unfinished). The illustrations give an insight into Blake's vision of heaven and hell, good and evil. Throughout his life, he claimed to have visions that directed his work, and this may explain his unique symbolic language.

RELATED WORKS
- **William Blake** *The Marriage of Heaven and Hell* 1790–93 and *The Ancient of Days (God as an Architect)* 1794, Whitworth Art Gallery, Manchester.

Painting and Print

Blake developed a technique of relief etching by applying acid to a copper plate and leaving the image raised – as opposed to indented, as in normal etching. After he had printed the image, he would colour it with watercolour. The soft tones and transparent colours gave his works luminosity.

Man in the World

The image represents a man (Isaac Newton) almost at one with the rocks at the bottom of the sea, bent over and measuring the world. The human thirst for knowledge is represented as being at odds with his position as part of the world.

Measuring the World

Isaac Newton, who established the principles of empirical study and science, is symbolic of the Enlightenment. The figure holds compasses for measuring, which Blake had earlier represented in the hands of the God-like figure of The Ancient of Days. *Newton's (and the Enlightenment's) obsession with measuring is blinding him to an intuitive engagement with the natural world.*

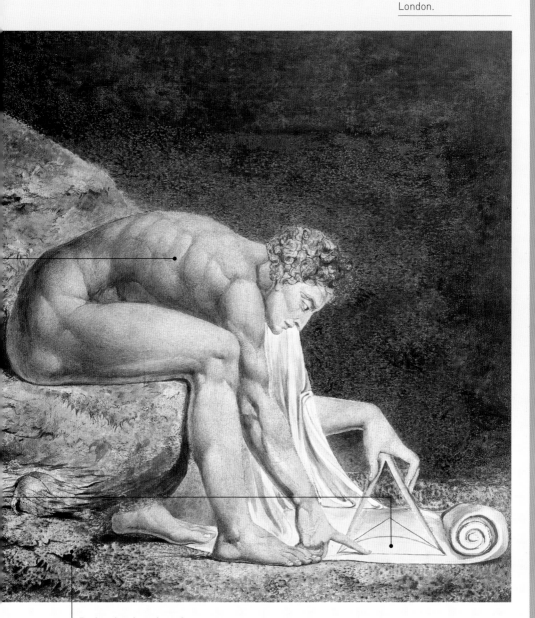

■ WILLIAM BLAKE
(1757–1827)
Reason or *Isaac Newton*
1795, Tate Britain,
London.

RELATED TOPICS/ARTISTS
BLAKE'S *THE BOOK OF JOB*, PAGE 67

Rational or Imaginary?

*Blake's work visually explores the dilemma faced by
Enlightenment philosophers concerning the source of
knowledge. On the one hand is the physical world known
through measurement and, on the other, are the intuition,
senses and imagination known through the experience
of the world. Blake believed that the latter were the
only authentic path to understanding.*

The Personal Ideal

Allegorical painting during the 19th century continued to represent ideals through artists' individual expression rather than standard forms. Whereas artists in earlier centuries had used mythologies to express civic values, they now developed a more personal vocabulary. In general, however, many of the ideals expressed continued to concern love, beauty, the cycle of life and the human condition. The Pre-Raphaelite Brotherhood and Symbolists were prominent in using allegory, but Classical themes were revived by other artists towards the end of the century.

Medieval and Classical Ideals

The Pre-Raphaelite Brotherhood (PRB, *see pages 68–69*) drew on medieval and Shakespearean narratives to express ideals of love and the relationship between men and women. PRB artists, including William Holman Hunt (*see page 69*), John Everett Millais, Arthur Hughes and Ford Madox Brown, created powerful imagery which explored Victorian England's personal and moral values. Dante Gabriel Rossetti pursued an individual vision of ideal feminine beauty. More broadly, Victorian painting was heavily involved in expressing moral codes, for example, Leopold Augustus Egg's trilogy on the consequences of adultery, *Past and Present* (1858, Tate Britain, London). Two artists returned to themes from antiquity – Frederic Leighton and Lawrence Alma–Tadema – recreating lavish Classical contexts for allegorical subjects.

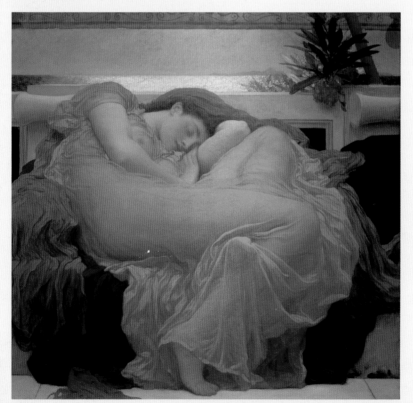

❚ **FREDERIC LEIGHTON** (1830–96) *Flaming June* c.1895, Museo de Arte, San Juan, Puerto Rico.

Frederic Leighton and Lawrence Alma-Tadema used Classical forms to represent moral values and ideals of feminine beauty. Although clothed, the curves of this languid figure are clearly visible through the diaphanous gown. The astonishing orange, the arrangement of the gown and the woman's sleeping pose encourage the viewer's voyeurism, making this painting almost a nude.

■ DANTE GABRIEL ROSSETTI (1828–82)
The Beloved 1865–66, Tate Britain, London.

Dante Gabriel Rossetti used his models, Elizabeth Siddal and Jane Burden (later married to William Morris), to reference lovers from the past, including Dante's Beatrice, Queen Guinevere, an Eastern goddess of love and characters in his own poetry. Rossetti explored a very personal, vibrant and intense ideal of beauty in this work, within an Oriental context.

Beyond Imagination

Realist and Impressionist artists, active in France through the mid-19th century, were concerned with capturing the immediacy of modern life and the natural world. Within the broad group of Post-Impressionist artists, the Symbolists, such as Gauguin, sought to use symbolic imagery to express inner ideas and emotional responses to the world. Covering a huge range of subjects, forms, themes and imagery, Symbolist artists worked across Europe, each pursuing individual visions of beauty, dreams, nightmares, the natural and human world and the transcendent.

■ PAUL GAUGUIN (1848–1903)
The Lost Virginity 1891,
Chrysler Museum of Art, Norfolk, Virginia.

The fox lying close to the woman's face and mouth, and the flower in her hand, symbolise perseverance, sexual power, rebirth and the lost virginity of the title. The figures in the background are peasants from Pont-Aven, Brittany. The unsettling symbolism could be referencing rural sexual rites or could more generally be alluding to dreams of sexual desire and conquest.

APPRECIATING...

By the end of the 19th century, individual symbolic expression had replaced generalised allegories. The decline of formulaic subjects and compositions, governed by the academies, enabled wide-ranging freedoms of expression, manifested particularly by the Symbolists. This laid the foundations for such 20th-century art movements as Dada and Surrealism (*see pages 162–63*).

KEYWORDS

Symbolism a term applied to the work of artists active in the late 19th and early 20th centuries who explored personal expression through symbolic imagery, for example, from dreams. It encompassed the 'Pont-Aven' group and *Les Nabis* ('The Prophets', *see page 69*) associated with Gauguin and Paul Sérusier; Pierre-Cécile Puvis de Chavannes, Odilon Redon, Auguste Rodin, Gustav Klimt and Edvard Munch.

RELATED WORKS

- **John Everett Millais** *Ophelia* 1851–52, Tate Britain, London, and *Saint Isumbras at the Ford* 1857, Lady Lever Art Gallery, Port Sunlight.
- **Arthur Hughes** *April Love* 1855–56, Tate Britain, London.
- **Gustav Klimt** *The Beethoven Frieze* 1902, Österreichische Galerie, Vienna.
- **Edvard Munch** *The Scream* 1893, Nasjonalgalleriet, Oslo.

Historical Themes

'Any form of art is a form of power; it has

impact, it can affect change – it can not

only move us, it makes us move.'

OSSIE DAVIS (1917–2005)

QUICK ARTISTS REFERENCE

15th century Gentile Bellini,
Vittore Carpaccio, Domenico Ghirlandaio,
Andrea Mantegna, Paolo Uccello

16th century Annibale Carracci, Raphael,
Andrea del Sarto, Paolo Veronese,
Cornelis Claesz. van Wieringen Abraham Willaerts

17th century Charles Le Brun, Anthony van Dyck,
Nicolas Poussin, Rembrandt van Rijn

18th century Jacques-Louis David, William Hogarth,
Giovanni Battista Tiepolo, Benjamin West

19th century Thomas Couture, Eugène Delacroix,
Paul Delaroche Théodore Géricault,
Francisco de Goya y Lucientes,
Édouard Manet, Joseph Mallord William Turner

History painting was the highest in the hierarchy of genres defined by the French Academy during the 17th century because it conveyed intellectual and moral messages. Until the 19th century, academy-trained artists in Rome, Paris and later London sought to achieve fame and patronage through this genre. The academic category of history painting included religious, mythological and allegorical subjects (*see chapters 3 and 4*), as well as subjects drawn from actual events in history. These latter historical themes enabled artists and patrons to visualise characters, events and ideals in a way that had contemporary relevance.

Historical themes in painting could include contemporary events, often wars or battles; critical moments in time, perhaps a particular turning point or success; or characters and highlights from Classical history that provided inspiration or role models. Whether representing a recent event or one from Classical antiquity (Darius' surrender to Alexander the Great, for example), the precise action, characters, composition, costume and setting needed to be visualised and selected. Historical subjects, possibly more than religious or mythological ones, offered the greatest potential for interpretation and artistic innovation.

The choice of subject and its form of representation reflected the political, intellectual or social objectives of the patron or artist. More broadly, civic or co-operative commissions could support propaganda, whether stated or implicit. Although such aims might apply to art in other categories, to religious painting, for example, it is perhaps when art seeks to represent actual events that the underlying power plays or self-perceptions are most obviously revealed.

The reasons for, and purpose of, historical paintings varied. Representations of battles frequently commemorated military successes, reinforcing perceptions of power and status. Other subjects were chosen to symbolise a political, intellectual or social ideal. From the 17th century, the motivations for artists to choose historical subjects were strong because recognition by the academy and prizes brought commissions. Paintings rarely, if ever, represented anything but success, heroism and power, but during the 18th century, especially in England, political satire became popular. As artists gained greater autonomy over their work, more controversial subjects were represented, and the historical painting became a vehicle for political criticism and challenge.

Victory & Triumph

In antiquity, commemorating victories was popular. The Parthenon's sculptural reliefs (440s–430s BC) celebrate victory over the Persians, for example, as well as the battles of the Lapiths and the Centaurs and the ceremonial procession of the Athenians. In Imperial Rome, monuments commemorated victories and military achievements, for instance, the *Ara Pacis Augustae* (Latin for 'Altar of Augustan Peace') (9–13BC), the columns of Trajan (c.AD110–13) and Marcus Aurelius (c.AD180–92), and the Arch of Titus (AD81) contained sculptural decorations representing battles or victory celebrations.

▌ CLASSICAL ROME (8th century BC–4th century AD)
'Alexander Mosaic' c.100BC, House of the Faun, Pompeii.

Measuring more than 3 x 5m (around 10 x 16ft), this floor mosaic captures the chaos and violence of battle with its precise detail and naturalism. Clues to the identity of the subject are the trousers worn by the Persians (which were not worn by Greeks) and the curved hat of their leader. Alexander's armour, on the other hand, is typically Macedonian.

The Heritage of Rome

The Romans were particularly concerned with maintaining their dominance in Europe. They drew on the artistic and military legacy of Greece to reinforce perceptions of their political values and unassailable hegemony. They brought sculptures from Greece (the Greek Riace bronzes, dating from 460 to 430BC, were found in a harbour in southern Italy, probably as the result of an ancient shipwreck) and copied Greek art extensively. The so-called 'Alexander Mosaic' (c.100BC) was found in Pompeii in 1831. Showing a pivotal moment in battle, the figure on horseback to the left is thought to be Alexander, whilst the charioteer in the centre represents the Persian king Darius. The mosaic may originally have been Greek, later being transported and reassembled in Pompeii; or it may have been a faithful Roman copy of a Greek painting; or an original Roman rendering of the subject. Whatever its origins, its location in Pompeii during the 1st century AD demonstrates the importance of Alexander the Great as a military role model for Rome.

Image was extremely important, and the representation of historical characters and events was used to legitimate power and continuity. On the Arch of Constantine (c.312–15), sculpted panels from the reigns of three 'successful'

emperors – Trajan, Marcus Aurelius and Hadrian – containing representations of historic events were positioned beside contemporary panels of Constantine. Having defeated his co-emperors and assumed sole rule after a long period of instability, Constantine probably used these panels to legitimise his position and affirm a positive imperial heritage.

Artistic Models from Antiquity

The *Laocoon* (possibly a Roman copy of a 3rd-/2nd-century BC original) was found in Rome in 1506, only two years before Michelangelo started painting the Sistine Chapel ceiling (*see page 25*). Placed in the new Belvedere Courtyard in the Vatican by Pope Julius II, the *Laocoon* was perceived to be a tangible artistic link to antiquity through a reference by Pliny (1st century AD). Its contorted figures and muscular detail symbolised the art of ancient Rome for Renaissance artists, and for many that followed. Its fame transcended the uncertainty about its date and provenance, and during the 18th century it became an icon of artistic perfection.

Narrating History

Narrative histories have been written for millennia, and it is possible that early mythologies are in part such records. The tradition of Classical historians like Herodotus (5th century BC), Suetonius (1st/2nd century AD) and Tacitus (c.AD56–117) continued through the Byzantine and medieval eras. Visual representations of historical chronicles – the sequential record of historical events – were less common. The Bayeux Tapestry (1066/82) is unique in its scale and execution. Probably commissioned by a member of William the Conqueror's family or a close political associate, its vibrant detail follows the characters and events in England and France surrounding the Norman conquest of England. Although some sections appear to be missing, and some people have discerned secret, anti-Norman messages in its words and images, it was probably a piece of propaganda supporting William's claim to the English throne. What better way to consolidate his position than to create a visual record of the events that achieved it? History, after all, is written (or embroidered or painted) by the victors.

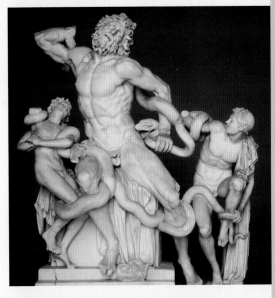

▌ **CLASSICAL ROME** (8th century BC–4th century AD)
Laocoon possibly a Roman copy of a 3rd-/2nd-century BC original, Museo Pio-Clemente, Vatican City.

Another work with an uncertain history, this sculpture represents the Trojan priest and his sons being killed by sea snakes. In Virgil's Aeneid, Laocoon tried to warn the Trojans about the wooden horse, but was executed by the gods, who favoured a Greek victory.

▌ **MEDIEVAL** (5th–14th centuries)
Bayeux Tapestry 1066/82,
Musée de la Tapisserie, Bayeux.

The Bayeux Tapestry is an embroidery measuring 70m (230ft) in length depicting the events leading up to the Battle of Hastings in 1066, in which William the Conqueror defeated the Anglo-Saxon king, Harold. Although the patron and location of its production is disputed, the narrative of the tapestry can be seen as a commemoration of William's victory, legitimising his right to rule England.

Establishing the Historical Tradition

In the republics of Florence and Venice, the desire to maintain hegemony and represent a historical legacy was central. In Florence, the Medici used subtle and discreet means to underpin their control of the city, whereas in Venice, where individual promotion was rigorously discouraged, the government commissioned art that reinforced the city's heritage. Across Italy, princes of the city-states – Rimini, Urbino, Mantua and Ferrara – used paintings, some on historical themes, to establish and promote their status.

The Battle Scene

Italy was not a unified country in the 15th century, and political power rested with the city-states. Rivalry often resulted in short wars, usually fought between mercenary armies. Paolo Uccello's three large paintings of *The Battle of San Romano* (c.1438–50s) commemorate the battle between Florence and Siena of 1432. Commissioned by Bartolini Salimbeni, who was involved in the hostilities, the panels were acquired by Lorenzo de' Medici, possibly forcibly, to be hung in the Palazzo Medici. Uccello represents three points in the battle that emphasise Florentine dominance, but seem staged. The second panel, in the Uffizi, Florence, depicts more violence, but none captures the horror and gore of real battle. Perhaps mercenaries settled matters with short skirmishes, or maybe the battle was to be remembered as a noble victory rather than a bloodbath. Curiously, Florence and Siena both claimed victory, suggesting that the two armies returned to their cities largely intact. Lorenzo's desire to display the paintings demonstrates their symbolic meaning – depicting both a Florentine triumph and Medici hegemony.

APPRECIATING...

Paintings of historical events provided patrons with the means to represent their achievements and status for their own ends. An apparently simple visual record of a battle or the signing of a treaty could be manipulated to emphasise one person or side over another. Placing ancient historical or religious events in contemporary settings associated the place with the event. Representing the people and places of a contemporary historical event redrew them as they should be remembered.

PAOLO UCCELLO (1397–1475)
Niccolò da Tolentino at the Battle of San Romano
1438–40?, National Gallery, London.

*Uccello was obsessed with single-point perspective
(see page 121), whilst painting in the decorative style
of International Gothic (see page 39). His drawing of
Tolentino's hat is rendered in precise perspective, but the
fallen soldier is famously foreshortened in reverse.*

'The Myth of Venice'

Narrative paintings, popular in Venice in around
1500, were typically large panels containing a
central event surrounded by subsidiary scenes.
Often capturing the cityscapes of Venice, they
contributed to perceptions of Venetian unity. Vittore
Carpaccio produced many narrative paintings,
including the *Legend of Saint Ursula* (1490s): nine
paintings of the saint's life and martyrdom. Most
scenes were set in imaginary locations, but many
echoed vistas of Venice.

 Frescoes in the Palazzo Ducale were repainted
by Gentile and Giovanni Bellini, Carpaccio and
Titian from 1474. They contained paintings of
important events in Venetian history, which
reinforced Venice's status and promoted its 'myth'
(*see page 78*). In particular, the idea of Venice's
status being equal to, or higher than, Rome's was
symbolised by a narrative painting cycle of Doge
Ziani brokering a peace treaty between Pope
Alexander III and Emperor Frederick Barbarossa
in Venice in 1177.

RELATED TOPICS/ARTISTS
ANDREA MANTEGNA'S *CAMERA DEGLI SPOSI*, PAGES 140–41

VITTORE CARPACCIO (c.1460/66–1525/26)
The Legend of Saint Ursula Cycle (Panel) 1490s,
Gallerie dell'Accademia, Venice.

*The legend of Saint Ursula told of a Christian princess who
travelled through Europe before her marriage, but was
massacred, with 11,000 virgins, by Huns. Three scenes
are represented here as the ambassadors arrive to broker
the marriage. The contemporary costumes, seafront and
buildings are redolent of Venice.*

War & Peace

Pope Julius II held the papacy for only a decade (1503–13), but during that time he re-established control over the Papal States and founded the Swiss Guard. He attempted to free Italy from foreign occupying forces by first defeating Venice with the League of Cambrai, and then joining forces with the Holy League of 1511 against France. His artistic patronage reflected his drive to cement the hegemony of the papacy, and of Rome (*see pages 24–25 and 62–63*).

■ RAPHAEL (1483–1520)
The School of Athens 1510–11,
Stanza della Segnatura, Palazzi Pontifici, Vatican City.

The Classical architectural background echoes the contemporary buildings of Donato Bramante (1444–1514). The depth of space, the precisely worked relationships between, and within, the groups of philosophers, and the poses, colourings, flowing robes and figural detail create a completely harmonious and naturalistic scene. Classical antiquity had returned to Rome.

The Classical Heritage

Julius commissioned Raphael to paint the Vatican apartments, starting with the Stanza della Segnatura in 1509. The themes portrayed in the four large lunettes represented the ideals of Julius' papacy, including poetry, philosophy and theology. The fresco featuring philosophical disputation, known as *The School of Athens* (1510–11), represented the ancient academy centred on Plato and Aristotle. Debate, writing and contemplation take place inside the vast, Classical edifice, with such figures as Socrates, Pythagoras and Ptolemy being depicted. This imagined meeting of minds symbolised the Classical legacy with which Julius wished to be aligned. Set against representations of great moments and figures in Church history, the fresco suggested continuity between philosophical and religious ideals.

Large, decorative schemes proliferated in palaces across Italy, typified by Annibale Carracci's frescoes in the Palazzo Farnese (built between 1515 and 1589 in Rome). Designed originally by Antonio da Sangallo the Younger (1484–1546) for Alessandro Farnese (1468–1549), the future Pope Paul III, the palace involved Michelangelo in its later building stages. Carracci's paintings on the 'Galleria Farnese' ceiling were begun shortly after the *Accademia di San Luca* (the academy of artists) was founded in Rome (1593).

■ CORNELISZ CLAESZ. VAN WIERINGEN (c.1580–1663)
The Explosion of the Spanish Flagship during the Battle of Gibraltar, 25 April 1607 c.1621,
Rijksmuseum, Amsterdam.

The explosion of the Spanish flagship during the battle marked a turning point in the war between Spain and the Dutch Republic. It is represented in horrifying detail here as the fire engulfs the ship and the sailors are hurled to their deaths.

Commemoration and Honour

The tradition of representing naval engagements developed in the Dutch Republic during the early 17th century. The republic was involved in many sea battles during the Eighty Years' War with Spain (1568–1648). *The Explosion of the Spanish Flagship During the Battle of Gibraltar, 25 April 1607* (c.1621), by Cornelisz Claesz. van Wieringen, commemorated the first major Dutch naval victory in 1607. The genre continued to be popular, with works, for example, by the Willaerts family – Adam (1577–1644) and sons Abraham (c.1603–69) and Isaac (1620–93) – Hendrick Cornelisz Vroom (c.1563–1640) and Aert Anthonisz (1579/80–1620).

APPRECIATING...

Historical subjects were important as a means of referencing past events that symbolised individual or civic aims, achievements and ideals. In Raphael's frescoes, historical figures were assembled in imaginary settings to represent a set of ideas. Similarly, representations of sea battles, reconstructed from the record of events, sought to show the drama and sacrifice of critical moments in the struggles of a nation.

KEYWORDS

Genre the type or subject matter of art. Although the hierarchy specified five important genres – history painting, portraiture, landscape, still-life and 'genre' painting – there were also sub-genres, such as the nude and sea battles.

RELATED WORKS

- **Raphael** *Poetry, Theology (Disputà) and other Scenes* 1509–11, Stanza della Segnatura, Palazzi Pontifici, Vatican City.
- **Andrea del Sarto** *Triumph of Caesar* c.1520, Villa Medici, Poggio a Caiano, Florence.
- **Paolo Veronese** *Battle of Lepanto* c.1572, Gallerie dell'Accademia, Venice.
- **Adam Willaerts** *Embarkation of the Elector Palatine in the 'Prince Royal' at Dover, 25 April 1613* c.1622, National Maritime Museum, London.

❚ ANNIBALE CARRACCI (1560–1609)
Triumph of Bacchus and Ariadne 1597–1601, Palazzo Farnese, Rome.

Carracci studied works by Michelangelo and Raphael when he came to Rome, and these frescoes are a Baroque response to those artists' High Renaissance style (see pages 62–63). They also reference the Classical sculptures in the Farnese Collection, including the Farnese (Weary) Hercules, *found in the Baths of Caracalla, Rome, in 1546.*

Great Moments in History

Why represent a particular event in history? Paintings often focused on moments when it was perceived that the tide of history turned. Representations would not always visualise or emphasise the dénouement, but rather some smaller event that underpinned the greater outcome. Conveying atmosphere, emotion, psychological reactions or melodrama offered more nuanced challenges than just action and violence.

■ CHARLES LE BRUN (1619–90)
The Triumphal Entry of Alexander the Great into Babylon
1662–68, Musée du Louvre, Paris.

Alexander is dressed in gold and is riding a decorated chariot pulled by an elephant. His soldiers collect the spoils of war, but there is an air of welcome rather than fear. The citizens and temples of ancient Babylon greet the benevolent conqueror.

Royal and State Commissions

The selection of a painting's subject lay with individual or civic patrons in the 17th century. Charles Le Brun's *The Triumphal Entry of Alexander the Great into Babylon* (1662–68) was one of four vast canvases of Alexander commissioned by King Louis XIV of France. The king wished to be seen as a great, magnanimous ruler, and perceived Alexander as his role model. The French Academy, *L'Académie de Peinture et de Sculpture*, was founded in 1648 during the reign of Louis XIV. It had great power and influence over training and standards of art in France under the directorship of Le Brun, from 1663 until his death in 1690.

Rembrandt's *The Conspiracy of the Batavians under Claudius Civilis* (1661–62) was commissioned for the town hall in Amsterdam, but was rejected by the city council. Depicting an uprising against Rome drawn from the Netherlands' history, it represented the Dutch Republic's independence and nationalism.

These works offer contrasting perspectives on the relationship between artist, patron and on the artistic outcomes.

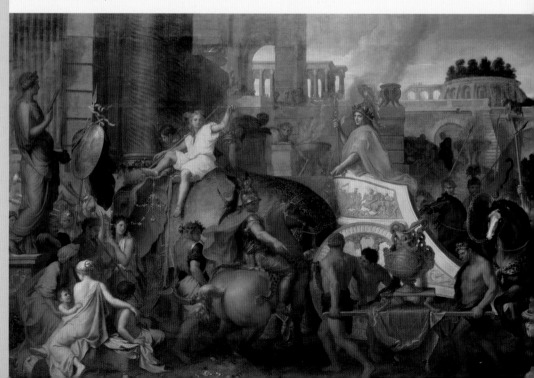

▮ **REMBRANDT VAN RIJN** (1606–69)
The Conspiracy of the Batavians under Claudius Civilis 1661–62, Nationalmuseum, Stockholm.

The scene of Batavian rebellion against the Romans, described by Tacitus, is dark and brooding. It was perhaps not the heroic scene that the Amsterdam burghers had expected.

▮ **NICOLAS POUSSIN** (1594–1665)
Death of Germanicus 1627, Minneapolis Institute of Art, Minneapolis.

The dying Roman general is attended by his distraught captains, swearing vengeance, as well as his weeping wife. Poussin's Classical context is matched by the frieze-like arrangement of the scene. The vivid red, blue and gold contrast the grey of the dying hero.

The Wealthy Patron's Taste

Nicolas Poussin's *Death of Germanicus* (1627) was his second commission from the Barberini family of Rome. Drawn from the work of the Roman historian Tacitus, the story of this suspicious death would have flattered the patron's intellect. Germanicus was the adopted son of Emperor Tiberius, and the grandson of Mark Antony. His death caused unrest, and, according to Tacitus, symbolised the end of a virtuous era – it was a moment when the tide of history turned.

RELATED WORKS

• **Anthony van Dyck** *Emperor Theodosius Forbidden by Saint Ambrose to Enter Milan Cathedral* 1619–20, National Gallery, London.

APPRECIATING...

As with paintings taken from myths, historical subjects were often drawn from Classical antiquity and symbolised heroic ideals to viewers. Contemporary patrons were fascinated by Alexander the Great and the heroes of Roman history.

KEYWORDS

The Academy the institutions in Rome, Paris and London set the standards for fine art – painting and sculpture – and trained the leading artists. Artists aspired to membership and the academies effectively defined how art was to be valued from the 17th to the mid-19th centuries.

New Histories

As with religious and mythological subjects (*see chapters 3 and 4*), the popularity of Classical historical themes declined during the 18th century. Artists turned increasingly to recent contemporary events, which commemorated military milestones and, in some cases, symbolised achievements in new colonial enterprises. In England, William Hogarth created satirical scenes and narratives that directly attacked contemporary social morals. Later in the century, a revival of Classical forms brought new impetus to historical painting.

KEY FIGURES

Johann Joachim Winckelmann (1717–68) a fierce ambition drove Winckelmann to seek recognition, and he wrote polemically on the merits of Greek art above all other forms. He was the first to study systematically the history of art, and his work *History of Art of Antiquity* (1764) laid the foundations for subsequent art history.

APPRECIATING...

Although an idealised Classical history was replaced by contemporary events, the representation of historical themes remained dependent on symbolism. The incorporation of accurate details drawn from archaeological remains or contemporary accounts could still be visually manipulated to present a viewpoint or message. The revival of interest in Classical art not only changed the style of painting, but also initiated the first developments in art-historical study.

Political Satire

William Hogarth's paintings, and the prints made from them, engaged with many contemporary scandals and moral issues in English society, although the artist was tied through patronage to the dominant class of the day. He satirised disasters, such as the South Sea Bubble (1720), a trade monopoly that overheated and lost many investors a lot of money. His moralising cycles, including *A Harlot's Progress* (1731) and *A Rake's Progress* (1735), visually represented the slow fall into destitution and madness of morally bankrupt figures. His later work, *An Election* (1754–55), captured the corruption in the election system in four paintings that plot the bribery and manipulation involved in electioneering.

A New Colonial History

Benjamin West was an American artist who settled in England in 1763 and gained the patronage of King George III. He was involved in the founding of the Royal Academy (*see page 48*), and became its second president (1792–1805). He sought to recreate accurately the details of historical scenes, drawing on archaeological evidence, for example, in *Agrippina Landing at Brundisium with the Ashes of Germanicus* (1768, Yale University Art Gallery, New Haven). He also painted scenes from the British campaigns in North America – *The Death of General Wolfe (1727–59) on 13th September 1759* (c.1770) and *The Treaty of Penn with the Indians* (1771–72) – in which contemporary dress and settings created a new paradigm for historical representation. These paintings reconstructed British colonial events with a subtle attention to detail that reinforced perceptions of a noble, imperial enterprise.

RELATED WORKS

- **William Hogarth** *A Harlot's Progress* 1731 (paintings destroyed 1755), and *A Rake's Progress* 1735, Sir John Soane's Museum, London.
- **Benjamin West** *The Treaty of Penn with the Indians* 1771–72, Pennsylvania Academy of Fine Arts, Philadelphia.

■ **GIOVANNI BATTISTA TIEPOLO** (1696–1770)
The Banquet of Cleopatra
c.1742–43, Musée Cognacq-Jay, Paris.

The meeting of Cleopatra and Mark Antony enabled Tiepolo to create a sumptuous setting, emulating Paolo Veronese, with the characters dressed in rich, contemporary costume. The representation is a decorative scene of 18th-century manners in which the historical subject is secondary.

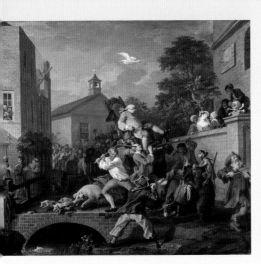

■ **WILLIAM HOGARTH** (1697–1764)
Chairing the Member 1755 (one of four plates), Sir John Soane's Museum, London.

The final painting of the An Election *series (1754–55) shows the newly elected Member of Parliament being carried through the streets of his constituency. Around him, thugs fight, the wealthy continue revelling, an adulterer flees, ordinary people protest and pigs run wild. The 'democratic' process may have been successful, but society's ills remain.*

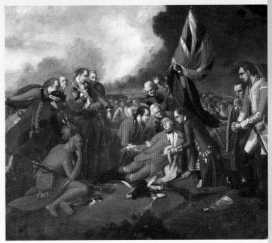

■ **BENJAMIN WEST** (1738–1820)
The Death of General Wolfe (1727–59) on 13th September 1759
(detail) c.1770, National Army Museum, London.

General James Wolfe was considered the first British hero of the 18th century, dying after successfully defeating the French at Quebec. West's representation of his dying moments recreates the battle, but adds a number of figures that would not have been present, including the Native American.

Imaging the Revolution

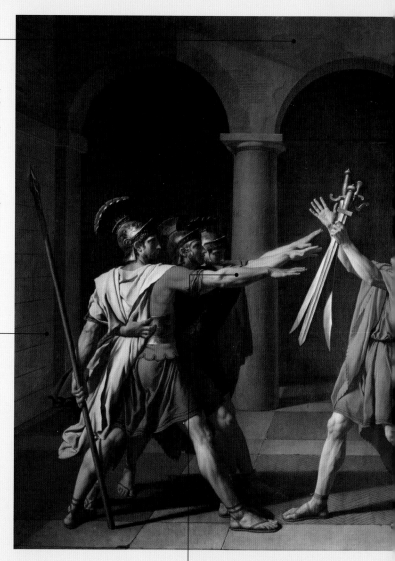

Neo-Classicism

The discovery of Classical antiquities, including the excavations at Pompeii (started in 1748), renewed intellectual interest in the Classical world, and the rationalism of the Enlightenment (see pages 66–67) underlaid the artistic style of Neo-Classicism. Neo-Classicism rejected the frivolous excesses of the Rococo and Baroque styles (see pages 31 and 65), Neo-Classical artists sought to emulate more closely the forms and values of Classical antiquity.

Liberté, Égalité, Fraternité

Commissioned originally by the minister of fine arts for Louis XVI, this painting was adopted by the revolutionaries as symbolic of the ideals of the French Revolution. It was considered to embody the moral values of brotherhood, duty and community that closely equated to those of the Revolution: liberty, equality, brotherhood, or death!

The Horatii and the Curatii

The nuances of this narrative are captured in the stances and expressions of the figures. The three Horatii brothers swear to fight for the honour and victory of Rome against the Curatii of Alba. But the events will spell tragedy for both families: to the right is a Horatii sister who is married to a Curatii. On the victory of the Horatii, the sister will curse her brother and then be murdered by him.

RELATED WORKS

- **Jacques-Louis David** *The Loves of Paris and Helen* 1788, *The Death of Marat* 1793, *The Intervention of the Sabine Women* 1799 and *Consecration of the Emperor Napoleon I and Coronation of the Empress Josephine* 1805–7, all Musée du Louvre, Paris.

Classical Composition

The balanced composition is divided into three distinct areas by the Classical architectural background. Each area contains elements important to the narrative: the brothers, the patriarch and the women.

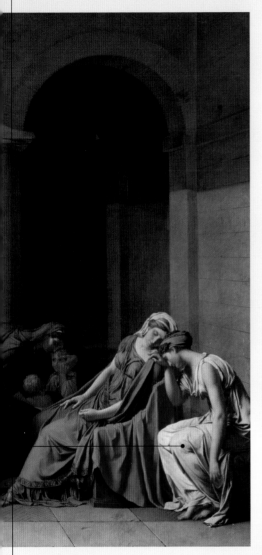

Jacques-Louis David went to Rome to study Classical art and to seek inspiration for this work. Completed in Rome, the *Oath of the Horatii* was later displayed at the Salon, in Paris, to great acclaim. Although it was a royal commission, after 1789 it became an icon of the French Revolution. Art-historical debate has questioned whether David intended it as a republican image, or whether its adoption by the revolutionaries reflected a changed interpretation. David's Neo-Classical style was admired first by the court of King Louis XVI, then by the revolutionary authorities, and finally by Napoleon Bonaparte. David's portraits of Napoleon (*see page 50*), and the huge representation of his coronation, aligned the ideals of Neo-Classicism with the emperor's ambition to emulate Imperial Rome through European domination.

The *Oath of the Horatii* draws on the narrative of a 7th-century BC war between Rome and its neighbour, Alba. The cities decided to settle their dispute through combat between the cities' champions: the Horatii for Rome and the Curatii for Alba. The connections between the two families meant that whichever won, there would still be tragedy for both. David's representation draws on Roman sculptural forms and costumes to represent the Horatii as they swear their oath.

▌ JACQUES-LOUIS DAVID
(1748–1825)
Oath of the Horatii 1785,
Musée du Louvre, Paris.

Gender Differences

The men and women are separated by more than just the visual structuring of the painting. The men are depicted in vibrant colours, with strong musculature, dominant, confident poses and military bearing, whereas the women are pale, languid and slumped in despair. These contrasts underpin the heroism and tragedy of the brothers' oath, whilst reinforcing gender stereotypes.

KEYWORDS

The Salon the regular art exhibition organised by the French Academy in Paris that was first instigated in 1673. Initially held biannually, it was the forum in which artists displayed their works and gained recognition. During the 19th century, first the Realists – Gustave Courbet and Édouard Manet – and then the Impressionists, set up rival exhibitions that challenged and rejected the Salon's artistic values.

The Political Challenge

Historical subjects during the 19th century were increasingly taken from contemporary events, and especially those with political resonance. Some artists in Britain and France painted controversial events in order to raise awareness of political issues. Others painted emotive representations of battles, massacres and victories to inspire nationalism; and yet others followed the *juste milieu*, or 'the middle way'. The Realists, in particular, rejected the idealised forms and subjects of the academy.

■ JOSEPH MALLORD WILLIAM TURNER (1775–1851)
Slave Ship (Slavers Throwing Overboard the Dead and Dying – Typhon Coming on) 1840,
Museum of Fine Arts, Boston.

Turner painted this work to highlight the plight of slaves thrown overboard in bad weather to enable insurance claims. The violence of the sea and storm that is captured by Turner's glowing colours is heightened by the horrifying sight of shackled slaves drowning in the foreground.

Horror and Tragedy

Théodore Géricault's *Raft of the Medusa* (1818–19) set a new precedent for depicting historical events without idealism or heroism, but engaging with the realities of a horrifying situation. A few years later, J M W Turner's *Slave Ship (Slavers Throwing Overboard the Dead and Dying – Typhon Coming on)* (1840) captured a similarly grim subject. In both paintings, the artists used their skills to highlight the real circumstances of the events.

▮ THÉODORE GÉRICAULT (1791–1824)

Raft of the Medusa
1818–19, Musée du Louvre, Paris.

Basing the work on a notoriously gruesome event, Géricault painted the horror of the shipwrecked without compromise or idealism. Some of the people, the last of 149 sailors from the original ship, are clearly dead or dying, and the living are represented at the moment of their rescue.

Several other artists sought to use painting to make political comments during the early 19th century. Francisco de Goya y Lucientes' *The Second of May, 1808: The Charge of the Mamelukes* and *The Third of May, 1808: The Execution of the Defenders of Madrid* (1814), along with his print series *Disasters of War* (1810–15), depicted the horrors of France's war with Spain. Eugène Delacroix, though tending more towards melodrama, explored the plight of Greece in its struggles for independence in several paintings, including *The Massacre at Chios* (1824). He also commemorated the July revolution of 1830 *(see pages 12–13)* with *Liberty Leading the People (28th July 1830)*. Other artists represented Classical or medieval subjects with melodramatic or romantic themes, for example, Paul Delaroche, in his *The Execution of Lady Jane Grey* (1833).

Realism and Censorship

Édouard Manet's *The Execution of the Emperor Maximilian of Mexico* (1867–68) took historical realism to the next stage. Drawing on Goya's *Third of May, 1808*, Manet painted the execution as the news of it broke in France. The Habsburg Archduke Maximilian had been offered the Mexican crown to further European interests, encouraged by the French emperor, Napoleon III. When the nationalists revolted, Napoleon abandoned Maximilian, who was shot with his generals. Manet blamed the French emperor for the execution.

RELATED WORKS

- **Francisco de Goya y Lucientes** *The Second of May, 1808: The Charge of the Mamelukes* and *The Third of May, 1808: The Execution of the Defenders of Madrid* 1814, Museo del Prado, Madrid.
- **Eugène Delacroix** *The Massacre at Chios* 1824, Musée du Louvre, Paris.
- **Paul Delaroche** *The Execution of Lady Jane Grey* 1833, National Gallery, London.
- **Thomas Couture** *Romans of the Decadence* 1847, Musée du Louvre, Paris.

APPRECIATING...

Paintings of historical themes developed a political edge during the 19th century. Although more heroic and romantic subjects were represented, artists like Manet broke entirely with tradition and laid the foundations of modern representations, which would eventually lead to Pablo Picasso's *Guernica* (*see page 165*).

KEYWORDS

Realism the style adopted by a group of artists in France who chose to represent contemporary subjects in realistic ways. Prominent in this group were Gustave Courbet (*see page 152*) and Édouard Manet.

▮ ÉDOUARD MANET (1832–83)

The Execution of the Emperor Maximilian of Mexico
1867–68, Staatliche Kunsthalle, Mannheim.

Manet painted three versions of this event. He altered the uniform of the firing squad to emphasise France's involvement in Maximilian's fate. The French government censored the painting, and none of the three versions was displayed in Paris.

RELATED TOPICS/ARTISTS
EUGÈNE DELACROIX'S LIBERTY LEADING THE PEOPLE, PAGES 12–13

Still Life

'Until I saw Chardin's painting, I never

realised how much beauty lay around me

in my parents' house, in the half-cleared

table, in the corner of a tablecloth left awry,

in the knife beside the empty oyster shell.'

MARCEL PROUST (1871–1922)

Still life was the lowest-rated genre of the academies in Paris, Rome and London, but was highly valued in the Dutch Republic from the early 17th century. As academic hegemony declined during the mid-19th century, still life acquired increasing importance as a vehicle for representing the form of objects, for example, in works by Paul Cézanne and Pablo Picasso, which laid the foundations of Modernism. Still life is concerned with representing objects of everyday life – flowers, fruit, raw or cooked foods and domestic objects often associated with eating or drinking. Common to all still-life paintings is the exclusion of the human form, although human agency is often implied.

Still life can represent domestic interiors with casually or formally arranged objects, often on a table. Until recently, the choice of objects was interpreted allegorically. For example, a dying flower might allude to the transience of life, or an oyster, to fertility. Viewed like this, still-life paintings had a complex interweaving of meanings that revealed the concerns and anxieties of the societies that made them. An alternative viewpoint, championed by the art historian Svetlana Alpers, is that the still life is concerned with description without layers of allegory. Alpers perceives a difference between the narratives of academic history painting and the descriptive forms of 17th-century Dutch still-life, landscape (see pages 126–27) and genre paintings (see pages 144–47). Her interpretation focuses on the form and content of Dutch still life, which would later concern Cézanne and 20th-century Cubist and abstract artists (see pages 158–61).

Still-life painting is also concerned with the representation of 'reality'. It spans the range of representation from simulating 'reality' so carefully that it deceives the eye into thinking that the object actually exists – sometimes called trompe l'oeil or hyper-reality – to Cubist still-life paintings and collages that fragment 'reality' until the objects are only partly represented or are elided altogether. The way that a tulip or a plum, a glass of wine or broken bread, a translucent shell or a folded cloth is represented underlies its descriptive or symbolic power. Whether representing signs of affluence, the abundance of nature or humankind's control of the natural environment, the still-life painting is centred on the object.

Bountiful Nature

Still-life painting represents a number of opposites: food from raw nature versus food provided by human agency; abundance versus dearth; reality versus illusion. A small number of wall paintings survive from the Roman period that appear to have comparable characteristics to those of more recent still-life painting. A few contemporary commentaries and texts on the subject provide insights into how Roman society perceived these works.

Illusion and Reality

The first narrative, possibly one of the most recounted texts on art from antiquity, was written by Pliny the Elder in *Natural History* (Book 35:65, c.AD77). It describes a competition between two artists to paint the most realistic still life. The first, Zeuxis, displayed a painting of a bunch of grapes that birds tried to eat. Despite Zeuxis' evident

success, the second artist, Parrhasios, presented his painting of a linen curtain. In his enthusiasm to see his rival's painting, Zeuxis attempted to draw the curtain to reveal the picture beneath before realising that he had been fooled. He conceded victory to Parrhasios. It is not difficult to picture the successful deceit of these paintings, and as the competition takes place on a stage, the issue of reality versus illusion is heightened.

A later text, written by Philostratus in the 3rd century AD, describes two paintings in an art collection, possibly imaginary, called *xenia*, a Roman term derived from the Greek word *xenos*, meaning 'host' or 'guest'. It refers to still-life paintings similar to the one pictured here from Herculaneum, near Naples. (Herculaneum, like Pompeii, was engulfed by volcanic ash from Vesuvius in AD79, which preserved many of its houses and their decorations intact.) Philostratus describes two *xenia* paintings that represent food provided by nature and by human agency. In the first, figs burst with ripeness, some oozing juice, others, still ripening, while grapes hang off the vine and honey awaits extraction from the comb. The emphasis is on the bounty of nature that is simply waiting to be enjoyed. In the second, fowl and game hang plucked or skinned, ready for cooking; bread is nearby and medlars need peeling and cooking. Here the emphasis is on the work of hunting, harvesting and cooking that is required to prepare food – human agency is necessary and dominates nature.

These two *xenia* are the extremes on the scale of nature versus human agency (Bryson, 1990). *Xenia* were often arranged in a sequence of panels displaying food on a simulated shelf or in a cupboard, with the items depicted representing various stages on this scale. In the panel from

▋ HERCULANEUM

Still Life, Hare Eating Grapes 1st century AD, Museo Archeologico Nazionale, Naples.

This painting is probably 2000 years old, but the feathers on the duck, the round, ripe, red apple, the grapes, and the representation of the munching hare, are sharp and convincing. The shadows on the niche where the apple sits, and the painted frame, offer the illusion of a real space, whilst acknowledging the theatricality of the display.

▌ PAUL CÉZANNE
(1839–1906)
Still Life With Apples 1895,
Musée d'Orsay, Paris.

Some of Cézanne's early still-life paintings followed a more traditional composition, with distinct components – bottles, dishes, glasses – and fruit on a table. In others he concentrated on perfecting the representation of the essential shapes and colours of fruit. In this painting, the display is stripped down to the minimum of detail, with the apples, cloth, dishes and backdrop arranged on a flat, but uneven, plane.

Herculaneum, a duck is being hung, an apple sits on a shelf and a live hare greedily eats the grapes. Perhaps the animal is being intentionally fattened up for the pot or, alternatively, the *xenia* is amusingly registering how potential food is eating potential food.

Painting the Object

These texts and surviving *xenia* from Pompeii, Herculaneum and Boscoreale (a villa outside Naples whose wall paintings are now preserved in the Metropolitan Museum, New York) demonstrate Roman society's concern with food and how it signifies both bountiful nature and the fruits of labour. The use of the term *xenia* for these paintings denotes the gifts that pass between host and guest and, in the second description, the gifts that nature provides to humans. The precise descriptions of food by Philostratus, and the illusions seen within the surviving *xenia*, reveal the Roman artist and viewer's interest in the realistic depiction of the object. Nearly 1900 years later, Paul Cézanne (1839–1906) also used still life to explore the representation of the object.

Cézanne, who is usually described as a Post-Impressionist, was involved with, but detached from, the Impressionists. He exhibited with them, and was a close friend of Camille Pissarro (*see pages 134–35*), but his concern was not to capture the fleeting impressions of a subject, rather to

explore its solidity and composition. Cézanne started to paint still-life subjects early in his career, depicting fruit, and especially apples. The works produced in his last years demonstrate the attention that he paid to the elements of form captured in, for instance, apples, a folded cloth, dishes and a jug, and the logic and balance of the composition. Accents of colour – blue and green; red, orange and yellow – flow around the painting, both unifying and separating the elements.

Exploring Still Life

These works demonstrate the powerful fascination exerted by the everyday object, and especially the importance of food as a painting subject or symbol. The art historian Norman Bryson articulates the centrality of food to existence – its abundance in times of wealth and its dearth in times of famine – and how the still-life painting engages with the cycles of pre-industrial production. In Dutch still life particularly, the tension between frugality and affluence provided the context for the fascination with the genre.

So the still-life painting can be interpreted on many levels. The precise rendering of the object and the illusions of reality are balanced by the symbolic or fundamental meanings within the image. The imagery of still-life painting, perhaps more than that of any other genre, explores the boundary between reality, illusion and symbolism.

Incidental Details

Between antiquity and the early 17th century, there were few paintings that could be described as still life. The representation of natural and human-made objects was incorporated into other paintings, however. In these incidental representations of flowers, animals, vases and other details, which often had symbolic meanings, it is possible to see the artist's fascination with the illusion and reality of painting objects.

▌ HANS MEMLING (c.1440–94)
Flower Still Life c.1490,
Thyssen-Bornemisza Collection, Madrid.

Although this painting is effectively a Christian allegory, it anticipates the rise of the still life in the Dutch Republic a century later. The patterned carpet and darkened recess reinforce the illusion of space, and the careful detail of the lily, iris and columbine petals and leaves creates an almost tangible reality.

The Vase of Symbolic Flowers

In 15th-century religious paintings, flowers were used symbolically and, as the desire for naturalistic representations grew, these were placed in vases. The precise rendering of flower petals and forms, and the illusion of the three-dimensional vase – sometimes of glass, containing water – challenged artists' skills. For example, Fra Filippo Lippi's *Annunciation* (c.1445) insets a bulbous glass vase into the floor, whilst Gabriel kneels with a lily before the Virgin Mary. Hans Memling's *Flower Still Life* (c.1490), painted on the back of a portrait, has removed the vase from the religious scene, but has kept the symbolism. The pottery vase is given form with shadows and highlights, and has Christ's monogram inscribed into the design: IHS (*Iesus Hominum Salvator*, Latin for 'Jesus, the Saviour of Men').

Floral Symbolism

The flowers in Memling's vase – the lily, iris and columbine – were a popular selection used in northern Europe for religious symbolism. These were also precisely rendered in the foreground of Hugo van der Goes' *The Portinari Altarpiece* (1476–79, *see page 121*), with the violet and carnation (or pink). Such flowers had the following meanings:

- *lily:* the Virgin Mary's purity
- *iris:* the Virgin Mary's purity or sorrow, sometimes substituting for the lily
- *columbine (aquilegia):* resembling the flying dove of the Holy Ghost, seven flowers (as in van der Goes' painting) symbolise its seven gifts of wisdom, understanding, counsel, fortitude, knowledge, piety and fear of the Lord (Isaiah 11:1–2)
- *violet:* Christ's humility on earth, often as a child, hence associated with the Adoration of the Shepherds
- *carnation (or pink):* often red, to symbolise the blood of Christian martyrs
- *rose:* white for innocence, purity, chastity; red for charity and martyrdom (the red rose was said to have grown from the blood of Christ on Calvary)
- *daisy:* innocence and purity.

■ **VITTORE CARPACCIO** (c.1460/66–1525/26)
Two Venetian Ladies 1490–95,
Museo Civico Correr, Venice.

This panel is only the bottom of the original painting: the top part (in the Getty Center, Los Angeles) depicts a cormorant hunt on the Venetian Lagoon and contains the lily head on the stem seen in the jug on the balustrade. Even in this casual scene, there are symbolic elements: the lily (signifying purity), two doves (love), a pomegranate (eternal life) and a dog (fidelity).

The Birds and the Beasts

Vittore Carpaccio enthusiastically represented animals, birds and other objects in his paintings. In *Two Venetian Ladies* (1490–95), he included two dogs, various birds (a parrot, doves and a peacock), a pomegranate and a jug. Many of his narrative paintings (*see pages 90–91*) have incidental objects and details that simulate reality. In *The Vision of Saint Augustine* (1502, Scuola di San Giorgio degli Schiavoni, Venice) and *Dream of Saint Ursula* (1495, Gallerie dell'Academia, Venice) especially, he renders the interiors precisely, with many relevant and contemporary details. These include objects on Saint Augustine's desk and shelves, bottle-glass windows and ornaments in Saint Ursula's room and particularly a little white dog sitting to attention before Saint Augustine.

APPRECIATING...

Naturalistic representations of religious subjects during the 15th century brought the Christian message to a human level and encouraged artists, especially in northern Europe, to include precise images of still-life objects. These incidental details of flowers, birds and animals were often vehicles for symbolism, but they also added to the illusion of reality in these paintings.

■ **GIUSEPPE ARCIMBOLDO** (c.1530–93)
Spring 1573, Musée du Louvre, Paris.

Painted as satirical portraits or personifications for the court in Prague, Arcimboldo produced many examples of these curious, sometimes grotesque, images. His arrangements of objects included flowers, vegetables and fruits, and even fish, books and cannon. Despite the individuality of these images, the precise painting of fruits, flowers and objects echoes still-life painting.

RELATED WORKS

- **Hugo van der Goes** detail of flowers at the front of *The Portinari Altarpiece, The Adoration of the Shepherds* 1476–79, Galleria degli Uffizi, Florence.
- **Fra Filippo Lippi** detail of the vase at the front of *Annunciation* c.1445, San Lorenzo, Florence.
- **Vittore Carpaccio** *Hunting on the Lagoon* (recto) and *Letter Rack* (verso), upper part of *Two Venetian Ladies* 1490–95, Getty Center, Los Angeles.

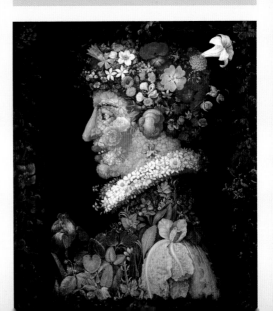

Dutch Still-life Painting

Dutch society bore few similarities to that of Italy or France during the 17th century, and its paintings reflect different artistic interests. Its economic success was built on maritime and foreign trade, but its wealth was not confined to an aristocratic court, as in France, or lavished on a grateful Church, as in Italy. The largely Protestant population, including strict Calvinists who abhorred signs of ostentation, sought different aesthetic pleasures.

The Profusion of Flowers

A popular subject for Dutch still-life painters was bouquets of exotic, cultivated flowers, rendered in precise and vibrant detail. Ambrosius Bosschaert the Elder's *Bouquet in an Arched Window* (c.1618) typifies more symmetrical and formalised compositions. Evidently painted from prior sketches, the arrangement contains flowers from across the seasons – spring tulips, narcissi and lilies of the valley; summer irises, roses, marigolds and carnations – that could not have bloomed at the same time. The initial impression of exotic and perfect blooms changes as signs of decay and predatory insect life become apparent. Note the holey leaves on the right, the caterpillar on the left and the housefly crossing the windowsill.

❚ AMBROSIUS BOSSCHAERT THE ELDER (1573–1621)
Bouquet in an Arched Window c.1618,
Mauritshuis, The Hague.

The four exotic tulip flowers may represent highly priced tulip varieties traded in the Netherlands (the red-and-white-striped one to the right is possibly the highly prized Semper Augustus). Although accounts vary, a period called 'Tulipomania' spanned the early 17th-century, with prices reaching thousands of florins a bulb until the market crashed in 1637.

Abundance and Abstinence

Willem van Aelst produced many still-life paintings in more asymmetrical compositions. The flowers in his works are arranged more casually, with co-ordinated colour schemes and dark backdrops to emphasis blooms. In *Still Life With Peaches* (1672), a bowl of ripe peaches stands out against dark-green leaves and grapes. The peaches' pale-yellow and soft, orange, furred surfaces contrast with the grey bloom on the grapes, creating a tempting display that is only partly offset by the optimistic snail. Signs of decay, blight and predation suggest life's transience and moralise against the sins of greed, vanity (*vanitas* in Latin), ostentation and excessive consumption.

The popularity of still-life painting spread to Flanders and Spain, where artists emulated the Dutch style. The principles of Dutch painting can be seen in Juan de Espinosa's *Still Life With Grapes* (1630–37), with its careful detail and assembly of objects: flowers, birds, shells and an ornate jug. The seasons are again mixed up, with ripe autumn grapes being juxtaposed with daffodils and cornflowers.

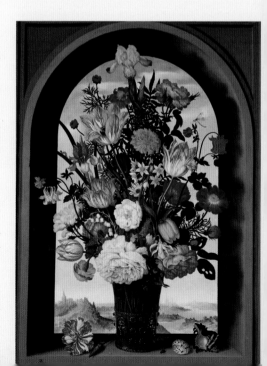

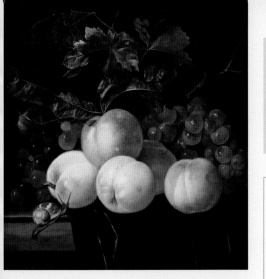

WILLEM VAN AELST (1627–c.1683)
Still Life With Peaches 1672, Private Collection.

Van Aelst's attention to detail is seen in the signs that the grapes have been touched; in the grey bloom of the fruit, shiny patches show where something has brushed it. The perfection of the fruit is disturbed by marks on the peaches, which may remind the viewer of human imperfections.

JUAN DE ESPINOSA (documented 1628–59)
Still Life With Grapes 1630–37, Musée du Louvre, Paris.

The flowers and birds are more rigid but the pink shell, and the glistening grapes, are very convincing. The suspended grapes were a popular trick used by Juan Sánchez Cotán, and allude to human presence and absence.

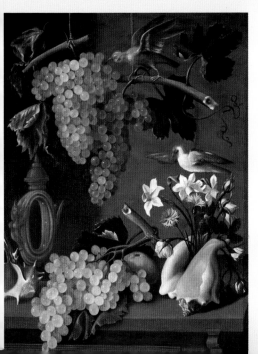

RELATED TOPICS/ARTISTS
DUTCH REPUBLIC, PAGE 126

RELATED WORKS

- Other 17th-century Dutch, Flemish, Italian and Spanish still-life painters include: **Juan Sánchez Cotán, Caravaggio, Tommaso Salini, Frans Snyders, Willem Claesz. Heda, Francisco de Zurbarán, Jan Davidsz. de Heem, Evaristo Baschenis, Willem Kalf** and **Giovanni Battista Ruoppolo.**

APPRECIATING...

During the 17th-century, still-life painting became a popular and prominent genre, particularly in the Dutch Republic. Artists developed elaborate compositions and painted precisely rendered detail to create images of the perfect flower, the ripest fruits, the shiniest shells, the most realistic insects and many other intricate instruments and objects. The balance between illusion and reality, and between allusions to abundance and moralising messages, was also carefully maintained.

Moral Allegory or Detailed Description?

Traditional interpretations of Dutch still-life consider that the represented objects – whether overblown, exotic flowers or ripe fruits with insects, wine, instruments or skulls – offered viewers a salutary reminder of life's limits. The high moral tone implied was at odds with the care and precision seen in these paintings. It was acceptable to enjoy the visual pleasures of the displayed bounty, and the expenditure on it, as long as it had underlying moral symbolism. It is hard not to interpret these images, as Svetlana Alpers suggests, as a reflection of a fascination with describing the seen world, a passion that is apparent in earlier Northern Renaissance painting and that spans landscape and genre painting. Illusion, reality and symbolism vied for precedence.

KEYWORDS

Vanitas a Latin word used to describe a particular form of still life in which all of the objects appear to make allegorical references to the transience of life. These might include a skull, a watch, an overturned glass, a dying candle or an empty pipe.

Visual Voluptuary or *Vanitas Vanitatum*?

Pieter Claesz painted some of the most discussed *vanitas* still-life paintings, in which the objects alluded to a powerful, symbolic message, including *Vanitas Still Life* (1630). Natural objects often emphasised human achievements and the results of successful toil. For instance, perfect blooms represented horticultural success; plump, ripe fruit emphasised the rewards of trade and agriculture (and even the insects have a healthy appearance). Human-made objects and other inclusions also stressed fine craftsmanship, the exotic, and rich materials. Intricate vessels like a nautilus cup, gold and silverware, Chinese porcelain, fruits from distant countries and expensive items, such as salt, reflected Dutch prosperity. In Claesz's work, a variety of fine and rich objects seem to allude to the senses: taste (the pie, sweetmeats, bread and wine), hearing (the viols and mandolin), touch (the smooth surfaces) and smell (the hot brazier to the left, with its smoking taper), with sight being encompassed by the whole painting.

The deception of Claesz's still life is the casual display of apparently everyday objects associated with a meal and the relaxing pleasures of smoking or music. However, the display is more ordered, with the broken pie and spoon, plates of bread and sweets clearly arranged. The providers of the pleasures of music and reading lie ready for use, but the timepiece, glinting in the soft light, is precisely in the centre of the image, ensuring that the viewer does not forget that all these things will pass.

The Wine Glass and its Reflection

The rich, red wine glows in a fine and delicately decorated glass setting the colour palette for the painting. Its reflection balances the display of food, appearing richer than the original, possibly reminding the viewer of the uncertainties in life.

RELATED WORKS

- **Pieter Claesz** *Vanitas Still Life* 1630, Mauritshuis, The Hague, *Still Life* 1647 and *Tobacco Pipes and a Brazier* 1636, The Hermitage, Saint Petersburg.
- **Willem Claesz. Heda** *Breakfast Piece* 1637, Musée Mayer van den Burgh, Antwerp.
- **Jan Davidsz. de Heem** *A Table of Desserts* 1640, Musée du Louvre, Paris.
- **Willem Kalf** *Still Life with Nautilus Cup* 1662, Thyssen-Bornemisza Collection, Lugano, and *Still Life with a Late Ming Ginger Jar* 1669, Museum of Art, Indianapolis.

The Pile of Books

The pile of books props up the mirror and alludes to knowledge. Set beside the other diversions – musical instruments and the pipe – the books suggest the pleasures of study and contemplation.

▌ PIETER CLAESZ (1597–1661)
Still Life With Musical Instruments 1623, Musée du Louvre, Paris.

The Abundance of Food

The arrangement of food references the fruits of nature (in the pie) and cooking (the bread and pie), whilst more exotic foods (olives, almonds and sweets on the third plate) and fine-wine bottles emphasise more expensive pleasures. All are laid out on a crisp linen cloth, with a lace edging just visible. The tortoise may allude to fecundity, or it may be a collector's item to be studied, like the books.

The Timepiece

This particular timepiece, with its pale-blue silk ribbon, appears in many of Claesz's works, and is a constant reminder of the transience of life. Without it at the centre of the painting, the still life could be interpreted as simply a pleasurable spread. Instead, the painting stresses the effects of the passage of time on these pleasures.

Musical Instruments

Three instruments are displayed. A viol in the foreground dominates the whole scene, with its bow laid, waiting to be used. A similar instrument stands in the background and, with the mandolin, suggests a trio of players. The mandolin lies on its face, showing off its elegant lines and workmanship, but recedes behind the timepiece resting on its back.

Fantasy & Reality in France

Still-life painting continued on a reduced scale in the Dutch Republic, Spain and Italy through the 18th century. At the court of King Louis XV of France, the Rococo style of Jean-Antoine Watteau, François Boucher and Jean-Honoré Fragonard (*see pages 30–31*) was popular, but still-life paintings by Jean-Baptiste-Siméon Chardin were also in demand. In contrast to the frivolity of Rococo subjects, Chardin's paintings presented more down-to-earth, still-life and genre scenes (*see pages 148–49*).

▌ JAN VAN HUYSUM (1682–1749)
Still Life With Fruit c.1720, Musée Fabre, Montpellier.

The subject is in an indeterminate, Classical setting on a stone plinth or balustrade. The fruits have been chosen to complement each other – blue and green against yellow, orange and red. Cream carnations and a sandstone backdrop provide a neutral foil for this rich, decorative display.

KEYWORDS

Trompe l'oeil French for 'something that fools the eye'. The technique was used extensively in wall paintings from the 15th century to create imitation architectural details (from Masaccio's *Holy Trinity*, *see page 56*, to Annibale Carracci's decoration of the Palazzo Farnese, *see page 93*).

Later Dutch Still Life

During the early 18th century, still-life paintings in the Dutch Republic mostly represented flowers and fruit in quite overblown compositions. The emphasis was more on the decorative qualities of the subject, and less on the signs of decay and predation. The tumbling exotica of perfect blooms and ripe fruits were chosen for their colourful relationships, and the illusion of reality was taken to extremes. Although insects are sometimes present, as in Rachel Ruysch's *A Vase of Flowers* (1706), they, too, appear to be adding to the decoration rather than eating or spoiling the display.

▌ GIUSEPPE MARIA CRESPI (1665–1747)
Bookshelves c.1725,
Civico Museo Bibliografico Musicale, Bologna.

Note in particular the shadows where the books overhang the shelves; the highlights of the polished wooden edge of the casing; the pieces of paper stuck between the books; the shadows and patina on the parchment and book covers; and the untidy arrangement of books and papers.

Chardin's Reality

Chardin believed that still life was as important and challenging as history painting, and concentrated his career on this subject and genre painting. He exhibited *The Skate (The Ray)* (c.1728) at the French Academy in 1728, and – exceptionally – was accepted into the institution immediately. The ordered composition, the graphic representation of the skate's gutted body and the startled kitten contrast with the traditional elements of cloth, bottle, jug and pans.

Although Chardin's later work did not contain such dramatic subjects, the emphasis on presenting the simple 'realities' of the subject was a central theme. With Chardin, we return to the issue of illusion and reality. The plain settings of his still-life paintings, with their carefully chosen and arranged objects, present an austere and apparently humble subject. His loose, almost impressionistic, style captures the textures, colours, depth and volume of each object and adds to the feeling of rustic simplicity. His paintings, however, were popular with élite society across Europe; he was admired by Diderot (editor of the *Encyclopédie, see page 67*); he sold works to Louis XV, and was granted a salary and lodgings at the Louvre. In this context, his paintings can be seen as presenting an idealised simplicity that few of his patrons would have experienced directly.

Hyper-reality

Since the time of Zeuxis and Parrhasios, one form of still-life painting – *trompe l'oeil* – has sought to simulate reality so precisely that the eye is completely taken in and the hand stretches out to touch the painted objects before realising the deception. Artists created hyper-real letter racks (Vittore Carpaccio, 1490–95, Getty Center, Los Angeles, and Wallerant Vaillant, 1658, Gemäldegalerie, Dresden), the back of a painting (Cornelius Gijsbrechts, c.1670, Statens Museum for Kunst, Copenhagen), or an assembly of knick-knacks (Samuel van Hoogstraten, 1666–68, Kunsthalle, Karlsruhe). Giuseppe Maria Crespi's *Bookshelves* (c.1725) demonstrates convincing features: shadows and highlights, a simulated frame and an emphasis on realistic details like torn pages, disordered objects and writing. The detail is so carefully captured that it is hard to believe that it is not real.

RELATED WORKS

- **Rachel Ruysch** *A Vase of Flowers* 1706, Kunsthistorisches Museum, Vienna.
- **Luis Meléndez** *Still Life with Oranges and Walnuts* 1772, National Gallery, London.
- **Jan-Baptist Bosschaert** *Flower Piece* n.d., Groeninge Museum, Bruges.
- **Jean-Baptiste-Siméon Chardin** *The Skate (The Ray)* c.1728, Musée du Louvre, Paris.

JEAN-BAPTISTE-SIMÉON CHARDIN (1699–1779)
Still Life With Dead Pheasant and Hunting Bag 1760, Staatliche Museen, Berlin.

This late work demonstrates simplicity of subject and composition: just a bag, powder horn and bird, and yet the viewer is drawn into a different world. The leather's soft colours and textures contrast in tone with the dark pheasant, which is hardly more than an impression of feathers, feet and beak.

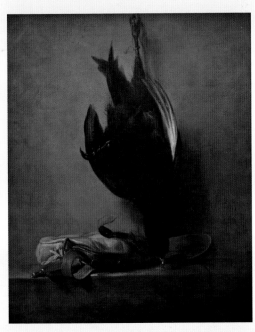

The Object & Modernity

At the beginning of the 19th century, Goya painted still-life subjects with a harsh reality. Few other artists painted the genre until Édouard Manet and the Impressionists began to undermine the value systems of the academy in the middle of the century. Most of the artists who were involved with the Impressionists were concerned with capturing the essence of modern life and were not attracted to the formalities of still life. Manet, Gustave Caillebotte and Paul Cézanne, however, painted still-life subjects, which explored modernity (*see page 51*) in different ways.

The Butcher's Knife

Francisco de Goya y Lucientes' descent into a dark world was manifest in his art in several ways, including in still-life painting. His *Still Life: A Butcher's Counter* (1810–12) represents the joints of a sheep's carcass. Its bloody head and ribs, with the kidneys still attached, are visceral and shocking. The creamy fat and red meat seem innocuous until you see the sheep's head, with its clouded eye and parted lips. More shocking was a painting (c.1818–19) by Théodore Géricault of dismembered human limbs – an arm severed at the shoulder and two legs (it is, perhaps, bizarrely appropriate to call this a still life). Eugène Delacroix painted more typical subjects: a bouquet of flowers and a still life with fish and game.

The Modern Still Life

Manet painted many still-life subjects, including vases of flowers and displays of fruit, fish and

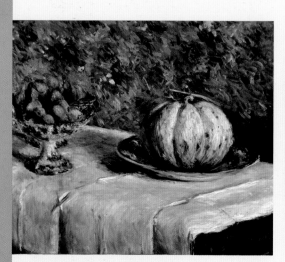

❚ GUSTAVE CAILLEBOTTE (1848–94)
Melon and Fruit Bowl With Figs 1880–82,
Private Collection.

Caillebotte's paintings of Parisian streets accentuate the details of modernity – wide boulevards, iron bridges, the flâneur and technology – with sharp and naturalistic detail. By contrast, his still-life paintings of fruit have a looseness and sensitivity to colour, texture and form that echoes Dutch still-life painting.

❚ FRANCISCO DE GOYA Y LUCIENTES (1746–1828)
Still Life: A Butcher's Counter 1810–12,
Musée du Louvre, Paris.

The Spanish term for still life was bodegones, and Goya painted several. This work was possibly painted at the time of the Madrid famine of 1811–12; it may allude to starvation or may be associated with the Disasters of War prints (1810–15) that refer to famine.

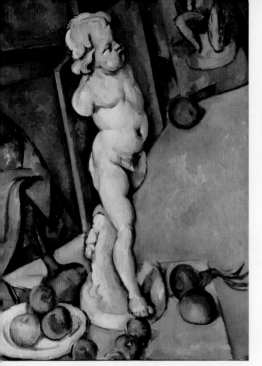

KEYWORDS

Post-Impressionism the term 'Post-Impressionism' was coined in the context of the first collaborative exhibition of late-19th-century French artists, including Manet and Cézanne, in Britain in 1910. It was subsequently used by the British art critic Roger Fry to encompass artists who came after the Impressionists, including Cézanne, Georges Seurat, Paul Gauguin, Vincent van Gogh and Henri de Toulouse-Lautrec.

▌ **PAUL CÉZANNE** (1839–1906)
Still Life With Plaster Cupid c.1894,
Courtauld Institute Galleries, London.

The composition of apples, onions and a plaster Cupid set against a jumble of canvases is inspired. Whilst the logic of the space seems clear, Cézanne distorts it with tones and colours. The orange of the apples is used on the floor in the middle distance, on the Cupid, on the table, and on the onions and canvases in the background. As the eye follows these visual references, the composition dissolves.

vegetables. An emphasis on colour and tone predominated, as with many of his works, and the light brushstrokes, flat forms and sketchy details create a new paradigm for still-life painting. Instead of elaborate compositions, Manet focused on the simple juxtaposition of elements: two or three fruits, a vase of two flowers, a tossed rose and, famously, one errant asparagus spear. He used minimal tonal gradation to create texture and shape, especially using bold strokes of white and grey to capture flowers and cloths. Manet also used such forms in incidental details in his larger works, for example, the bouquet of flowers in *Olympia* (*see page 32*) and *Le Déjeuner sur l'Herbe*.

The subject matter of Cézanne's still life is very much in the tradition of the genre in its content and arrangement of objects. Fruit, vegetables, a backdrop and ornaments are typical elements from the past. Where Cézanne is innovative is in taking the objects beyond their physical context to create integrated and monumental images. Scale is lost as he connects objects and surroundings with colours and brushstrokes; yet the solidity of the objects is never lost. His later still-life paintings border on the abstract, and fragmentation of the image is only a few brushstrokes away. His works are rightly described as the foundation of modern art.

RELATED WORKS

- **Théodore Géricault** *Study of Truncated Limbs* c.1818–19, Musée Fabre, Montpellier.
- **Eugène Delacroix** *Still Life With Lobster* 1826–27 and *Bouquet of Flowers* 1849–50, Musée du Louvre, Paris.
- **Gustave Caillebotte** *Fruit Displayed on a Stand* c.1881–82, Museum of Fine Arts, Boston.
- **Édouard Manet** *Branch of White Peonies and Shears* 1864, *Still Life With Eel and Red Mullet* 1864, *Pinks and Clematis in a Crystal Vase* 1877 and *The Asparagus* 1880, Musée d'Orsay, Paris.

APPRECIATING...

Throughout the history of the still life, the object of display had been the central, unifying element, whether a religious symbol, an allegorical reference to life's transience, an illusory pleasure, a simulated reality, a graphic representation or a solid object. As the 19th century slipped into the 20th, concern to represent the reality of three-dimensional objects changed to a desire to explore the two-dimensional surface of a painting.

Landscape

'I never saw an ugly thing in my life: for

let the form of an object be what it may

– light, shade, and perspective will always

make it beautiful.'

JOHN CONSTABLE (1776–1837)

QUICK ARTISTS REFERENCE

15th century Fra Angelico, Giovanni Bellini,
Albrecht Dürer, Hugo van der Goes,
Andrea Mantegna, Hans Memling

16th century Hendrick Avercamp, Dosso Dossi, Giorgione,
El Greco, Lorenzo Lotto, Sebastiano del Piombo

17th century Jan Brueghel the Elder, Claude,
Aelbert Cuyp, Jan van Goyen, Meyndert Hobbema, Nicolas Poussin,
Jacob Isaackszon van Ruisdael, Johannes Vermeer van Delft,
Claes Jansz. Visscher

18th century Canaletto, Thomas Gainsborough, Francesco Guardi,
Giovanni Paolo Pannini, Giovanni Battista Piranesi,
Caspar Andriaans van Wittel

19th century Albert Bierstadt, Paul Cézanne, Gustave Caillebotte,
Thomas Cole, John Constable, Camille Corot, Edgar Degas,
Caspar David Friedrich, Claude Monet, Samuel Palmer,
Camille Pissarro, Pierre-Auguste Renoir,
Paul Sérusier, Georges Seurat, Alfred Sisley,
Joseph Mallord William Turner, Vincent van
Gogh, James McNeill Whistler

Landscape reflects our relationship with the land, nature and place. In a landscape painting we see a constructed view which carries a deeper narrative or significance. Academically, the landscape genre was one of the less valued forms of painting. In many early examples landscape was secondary to the main subject. From the 17th century its popularity began to grow as it was used to capture an ideal view of the world, but increasingly also the real landscape in which people lived and worked. Landscape cannot simply be dismissed as a backdrop to the 'main action'. It is fundamental to the message of a painting, to ideas of identity and to our experience of nature.

All landscapes are created by humans, whether through the invention of an ideal pastoral scene or the framing of a vista. The topography of the land itself is often constructed, for example, by field enclosure. Humankind is always in a landscape whether in the maintenance of the land, the artist's choice of subject or the viewer's implied presence. The different elements of a landscape's composition are therefore critical to understanding its meaning. The sky, hills, trees, rivers, plains, buildings and figures have been chosen to support the subject, whilst light, viewpoint and composition convey mood and atmosphere. Together these elements construct meaning and aesthetic impact.

The significance of landscape painting through the centuries has tracked our changing relationship with the land and nature. Artists such as Claude [Lorraine] and Nicolas Poussin created idyllic landscapes in which the figures of the Greek myths acted out their stories in an imaginary Classical world. The Enlightenment sought to catalogue nature and heralded the development of the Industrial Revolution. But these ideas triggered reactions which on the one hand challenged human ability to control nature, and on the other strengthened the desire for symbols of the pre-industrialised rural world. Modernity provided the impetus for the Impressionists to capture instants of light and movement whilst artists such as Vincent van Gogh sublimated their emotions within the landscape. Today, with the threat of climate change, our relationship with nature is more complex, and Land Artists such as Andy Goldsworthy provide new responses to the landscape.

Interpreting the Landscape

Understanding landscape painting centres on identifying the subject – in the broadest sense – and exploring its significance. The subject, however, can have many facets. The apparent familiarity of the natural and human components of a scene can obscure how the detail has been carefully selected and composed to achieve meaning and atmosphere. Exploring the detail and considering the reasons for each selection in landscape painting provides insight into how the world has been perceived through time.

village, Constable spent much of his early life in the county. His paintings captured the landscape that surrounded him, whether in Suffolk, Hampstead or Brighton. He painted numerous different views of this Suffolk district – notably *Dedham Vale* (1802), *The Hay-Wain* (1820–21) and *The Leaping Horse* (1825) – and many studies for each subject. For example, there are at least three drawings, one oil sketch, one unfinished and three finished paintings of *Dedham Lock and Mill* that were completed between 1809 and 1820. Constable explored different compositions, sometimes excluding the nearest sailing boat, capturing different weather effects and changing details. The looser brushwork in Constable's oil sketches anticipated the style of the Impressionists in the use of colour blocks, textured surfaces and sketchy detail, but his finished works were often refined in almost photographic detail to meet the demands of the contemporary market.

Landscape as Place

We can explore the idea of landscape as place by looking at John Constable's work *Dedham Lock and Mill* (1820). Considered by many to be England's greatest landscape painter, Constable is famed for his paintings of the Suffolk countryside. Born in East Bergholt, little more than a mile from Dedham

The Perfect View

Constable's approach to painting reveals not only his desire to perfect the composition, but also the importance of each selected detail to the final scene. His ability to capture the nuances of sky, landscape and life was his response to the places that he knew intimately. Art historian Malcolm

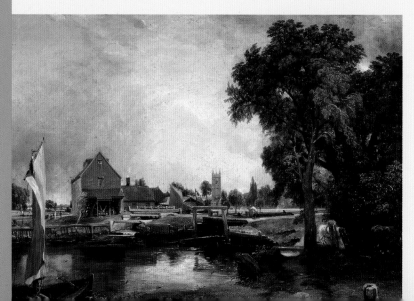

■ **JOHN CONSTABLE** (1776–1837)
Dedham Lock and Mill
1820, Victoria and Albert Museum, London.

Constable's landscapes symbolise an eternally tranquil, pre-industrial England. Dedham village is seen across the river, with the mill in the mid-ground. The serene rural life is emphasised by grazing horses, men working the lock and the sailing boats. The sun glows through rain clouds, silhouetting the church tower and invoking a sense of place.

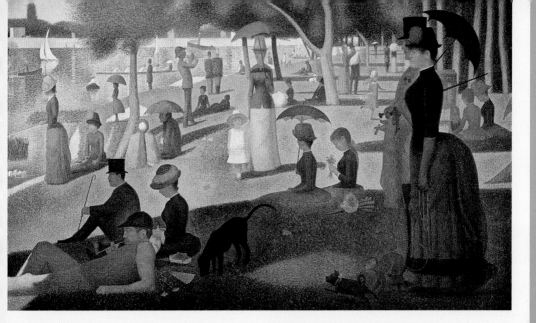

▌GEORGES SEURAT (1859–91)
A Sunday Afternoon on the Grande Jatte 1884–86,
Helen Birch, Bartlett Memorial Collection,
The Art Institute of Chicago.

*Having perfected his Pointillist style, Seurat constructed
this leisurely scene from numerous sketches. Here, the
modern, recreational landscape of Paris is built up with
infinite coloured dots, which make the scene appear to
shimmer beneath the afternoon sun.*

Andrews describes Constable's rural landscapes
as depicting an unspoilt, Utopian England that
contrasted with the realities of his world, especially
London, where he lived after 1817. Seen in this way,
these paintings present much more than a physical
scene, but also the spirit, atmosphere and essence
of the idea of Constable's Suffolk.

Composing a Landscape

The landscape format, where the canvas width is
greater than its height, contains typical elements.
For example, the scene is divided by a horizon,
where sky and land (or sea) meet, and its position
is important to the scene's impact. An equal
balance between sky and land, as in Poussin's
Landscape with Orpheus and Eurydice (see page
125), emphasises harmony, whereas the wide
skies of Dutch landscapes overawe the towns
(page 126–27). Caspar David Friedrich used low
or high horizons to stress the insignificance of
humankind within nature, whereas Georges
Seurat's work concentrates almost entirely on
the foreground activity, ignoring the sky.

All in the Detail

Before the 19th century, landscape almost always
focused on the subject within it. In imaginary
landscapes, buildings might adopt specific forms
alluding to symbolic values. Ruined buildings
might symbolise decay (moral or physical);
churches alluded to God; Greek temples to the

values of the Classical world; and contemporary
architecture to the immediate locale. Figures in
the landscape might be involved in activity – from
religious or mythical narratives; at work or at
leisure; travelling or resting. What was absent
could be equally significant: a destination, part of
the narrative or the human element. The nature
of the sky and weather added atmosphere and
mood, a lowering sky signifying foreboding, a blue
sky, tranquillity. Rivers and seas contributed:
rivers connected the foreground and background,
a sea symbolised parting or the infinite. Visual
and theoretical relationships between different
elements built narrative and meaning.

In *Dedham Lock and Mill*, the highlighted elements
include the church haloed by the clouds, symbolising
God, and the sailing boat in the foreground,
suggesting the human journey in life towards Him.
Human presence is implied by signs of activity, but
is not prominent. The composition's balance and
harmony contribute to the suggested presence of
God and humankind within this Utopian landscape.

God in the Landscape

The landscape of religious scenes has always been important to their message. Many scenes from the life of Christ and the Virgin Mary used in the 13th and 14th centuries were drawn from Byzantine models, which had well-established and stylised compositions. Western European panel painting before the 15th century also used gold-leaf backgrounds to create a heavenly aura. During the 15th century, artists and patrons sought more naturalistic forms. In both Italy and northern Europe, artists created landscapes that related to their region, bringing Christ closer to humankind.

APPRECIATING...

When exploring the significance of landscape in religious art, consider the relationship between landscape and subject:

- how does the landscape contribute to the narrative or message?

- how do the details, figures, activities and architecture contribute to the religious message and provide a context for the scene?

Note that many backgrounds to religious paintings in the Renaissance are anonymous, but place the story of Christ within the real world rather than in a remote heaven.

Supporting the Message

In all religious paintings, the landscape was designed to support the message of the narrative. For example, in the scene of the Annunciation in which the angel Gabriel tells the Virgin Mary of her destiny, the background landscape often includes the expulsion of Adam and Eve from the Garden of Eden. Whereas Eve brought sin into the world, Mary gave birth to Christ to offer redemption from that sin. Beyond these direct narrative connections, the landscape can be used to emphasise underlying messages. For instance, in paintings of Saint Jerome in the wilderness, the scene might be set in a desert or barren landscape that harmonises with Jerome's ragged form and pious demeanour.

Giovanni Bellini's *Agony in the Garden* (c.1465) places a praying Christ and his sleeping disciples in a barren landscape as they await the soldiers in the light of dawn. The desolation of the scene emphasises Christ's situation. Some Byzantine elements can be seen in the left foreground: stylised rock forms, with hard, cut edges and artificially angular shapes. The Bellini family of father Jacopo and sons Giovanni and Gentile were Venetian, and Venice's artistic heritage was rooted in Byzantine art. However, the city on the hillside is more comparable to contemporary Italian architecture, and the naturalism, for example, of the fencing, reinforces the relevance of the scene to the contemporary viewer.

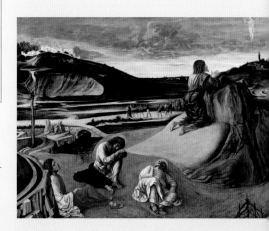

▌ GIOVANNI BELLINI (early 1430s to 1516)
Agony in the Garden c.1465, National Gallery, London.

Early evidence of more naturalistic styles can be seen in the folds of the disciples' robes, in the foreshortening of the figure lying down and in a general feeling of distance and space in the landscape.

HUGO VAN DER GOES (c.1440–82)
right wing of *The Portinari Altarpiece: Saints Margaret and Mary Magdalene with Maria Portinari* 1476–79, Galleria degli Uffizi, Florence.

The detailed and naturalistic rendering of the landscape is contrasted with the stylised figures. Maria Portinari, wife of the patron, and her daughter are much smaller than the saints.

KEYWORDS

Parergon if the landscape is *parergon*, it is subsidiary to the subject, but necessary for its purpose. Can the landscape ever truly be separate from the subject, however? The landscape always frames the main subject and provides context.

Single-point perspective single-point perspective was developed by Filippo Brunelleschi during the early 15th century. Scenes were constructed to have a vanishing point, that is, the line of buildings and sizes of figures were arranged to recede to a single point. Religious paintings were viewed as though from one position, communicating directly to the viewers.

RELATED TOPICS
BACKGROUND LANDSCAPES IN RELIGIOUS PAINTINGS, PAGES 54–61

Sketching the Landscape

In the Netherlands, the backgrounds of religious paintings also alluded to the real world. Hugo van der Goes' *The Portinari Altarpiece* (1476–79) contains detailed and realistic renderings of hills, trees and peasants in contemporary costume. Albrecht Dürer's *View of Nuremberg* (1496–97) sketches his home town and may have been used as a model for backgrounds to religious works. For example, in *The Heller Altar* (1508–9), the background landscape contains houses, trees, fields and lanes comparable to those in this sketch. Dürer's interest in capturing his region's character anticipated later landscape traditions in northern Europe.

RELATED WORKS

- **Fra Angelico** *The Cortona Altarpiece* (*The Annunciation*) 1433–34, Museo Diocesano, Cortona.
- **Andrea Mantegna** (Giovanni Bellini's brother-in-law) *The Agony in the Garden* c.1459, National Gallery, London.
- **Hans Memling** *Saint John Altarpiece* 1474–79, Memlingmuseum, Sint-Janshospitaal, Bruges.

ALBRECHT DÜRER (1471–1528)
View of Nuremberg 1496–97, Kunsthalle, Bremen.

Probably a sketch for another work, the composition of this landscape is carefully worked out, with the road centred between the balanced arrangement of spires and buildings.

Symbolic Landscapes

From the late 15th century, patrons increasingly required artists to paint subjects found within the Classical texts of the Greek myths. The rising interest in the ideas of Classical antiquity underpinned the artistic innovations of the Renaissance. In The Nude (*see pages 20–33*), the naturalistic rendering of the human form drew on Classical models, while Historical Themes (*see pages 86–101*), incorporated the architectural forms of Greece and Rome. In 16th-century Italy, the landscape was used to contextualise the mythical subject and to contribute to the idealisation of the allegory.

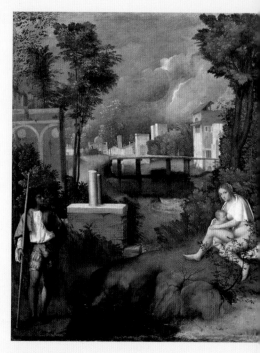

▌GIORGIONE (c.1477–1510)
Tempest c.1505, Gallerie dell'Accademia, Venice.

This is a difficult painting to understand, but it demonstrates an early exploration of the symbolism of landscape. The prominent features – such as the storm and bridge – are used to suggest meanings. But do they allude to the stormy relationship between man and woman? Or, alternatively, to their ties and dependencies?

Developing the Allegorical Scene

Tempest (c.1505), by the Venetian artist Giorgione, has been described as one of the earliest landscape paintings because of its compositional emphasis on the bridge, distant town, river and storm. The two figures are not taken from a literary source and the overall subject is obscure. The nursing mother was described as a gypsy in 1530, but could also allude to the Virgin Mary or a mythological figure. The man, described as a soldier in 1530, replaced a nude figure, which was recently discovered by X-ray. The two are linked by the intervening landscape and their relationship is enigmatic, whether by the intention of the artist or not. Giorgione's style is sometimes described as 'poetic', and there is certainly atmosphere and tension in this work.

The painting *Diana and Calisto* (c.1528) by Dosso Dossi, of Ferrara, is a specific mythological scene depicting the Roman goddess Diana abandoning the nymph Calisto after discovering her pregnant by Jupiter. Calisto had been tricked by Jupiter, suggesting an allegory on love and constancy. The trees and stream provide a context for the scene

APPRECIATING...

The 16th century marks the emergence of landscape as a genre in its own right, but it develops in different directions:

- as the mythical landscape, which was later perfected by French artists in Rome

- as the everyday landscape of the Dutch Republic.

These two strands – one pursuing the ideal and the other, the real world – meet again during the early 19th century in the works of Friedrich, Turner, Constable and the Barbizon group (*see pages 130–35*).

■ DOSSO DOSSI (c.1490–1542)
Diana and Calisto c.1528, Galleria Borghese, Rome.

Drawing on the style developed by Raphael, the landscape here is clearly secondary to the mythical figures. This work is an example of how different genres overlap: it could be classified as a landscape, a nude or a mythological subject.

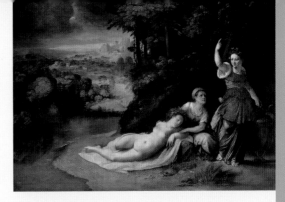

(nymphs are associated with water and woodland), and the vague detail of a distant city balances the composition.

The representation of plants in both of these works is formulaic, with fixed leaf forms in uniform tones billowing like smoke against the background. There is no doubt about what is represented, but it is idealised and artificial.

Frozen Fun for All

In northern Europe artists began painting landscapes that reflected the world around them. Hendrick Avercamp's *Winter Landscape* (c.1608) characterised earlier forms in which community activities are captured in minute detail. In this scene, the townsfolk are enjoying skating on the frozen canal. All forms of fun are portrayed, with skating couples, sleds, ice hockey and the odd tumble. Everyone from the town is apparently present, including its leaders (probably clustered together to the right) and all classes and ages. The buildings and bare trees are captured with naturalism, and the figures are drawn from careful studies. The shared fun on the ice presents a harmonious image of community solidarity.

RELATED WORKS
- **Lorenzo Lotto** *Allegory* 1505, National Gallery of Art, Washington, DC.
- **Sebastiano del Piombo** *Death of Adonis* 1511–12, Galleria degli Uffizi, Florence.
- **El Greco** *A View of Toledo* 1597–99, Metropolitan Museum of Art, New York.

KEYWORDS

Humanism in the context of the Renaissance, *humanism* refers to the idea that humans are in control of their destiny through both the application of rational thought and in acknowledging their limitations. Humanists from the 15th and 16th centuries include Leon Battista Alberti (1404–72), Marsilio Ficino (1433–99) and Desiderius Erasmus of Rotterdam (1466/69–1536). Part of their interest was in studying Classical Greek and Latin manuscripts, including philosophical and historical texts.

■ HENDRICK AVERCAMP
(1585–1635)
Winter Landscape c.1608, Rijksmuseum, Amsterdam.

Avercamp almost exclusively developed the winter skating scene, and numerous versions of it exist. The ice and snow not only present an entertaining subject, but also allow the development of rich, glowing reflections and complex colour combinations in the sky and landscape.

RELATED TOPICS/ARTISTS
ALLEGORICAL SUBJECTS, PAGES 74–77, AND FESTIVAL SCENES BY PIETER BRUEGHEL THE YOUNGER, PAGE 143

Idealising the Landscape

The French artists Nicolas Poussin and Claude (or Claude Lorraine) perfected the mythical landscape. Their paintings were highly sought-after in France, despite working for most of their lives in Rome and landscape's low status at the academy. As they became well known, their works were acquired by collectors in France, laying foundations for the future. Claude's patrons included Pope Urban VIII and King Louis XIII of France.

The Epic Myths
Poussin and Claude constructed complex compositions, whilst their handling of narrative, light, colour and naturalism created depth and symbolism. Claude's sketches show how carefully he studied from life, but these landscapes are from a fantasy world. Drawing on the epic poems

▌CLAUDE (c.1600/5–82)
Ulysses Hands Chryseis Over to her Father 1644, Musée du Louvre, Paris.

The setting sun casts a shadow over the water, highlighting the backs of the foreground figures. This device allows Claude to create a rich, glowing light across the whole scene.

of Classical Greece and Rome – Homer's *Iliad* and *Odyssey* and Virgil's *Aeneid* – they created idealised scenes in which the activities of heroes, gods and goddesses conveyed allegorical meaning. These subjects were attractive to the elite patron as they demonstrated Classical knowledge and ideals.

Arcadia
The composition of Poussin's *Landscape with Orpheus and Eurydice* (c.1650–53) is carefully balanced, with dark trees and bushes framing the central group. Orpheus plays his lyre while the women listen. Despite the harmony of the scene, in a short time Orpheus' wife, Eurydice, will be dead. She has just been bitten by a snake and raises a hand in alarm, but Orpheus is oblivious. The snake, symbolic of death, was often used to introduce tension into tranquil, natural scenes. This vignette of activity raises the painting from a simple pastoral scene to a moral allegory of life and death, pleasure and loss, nature and humankind, man and woman. The landscape has poetic and symbolic levels, its visual qualities contributing to both.

Others pursued the ideal landscape, including the Flemish artist Jan Brueghel the Elder. In *Flora in the Flower Garden* (n.d.), the goddess of spring and flowers resides with her attendants within a blooming garden. Unlike the works of Poussin, this example does not contain the threat of death, but is an idyllic, pastoral scene of fertility, with a tranquil vista and Classical arches.

Sun Shining on the Classical World
Claude devoted all of his life to painting landscapes, and elevated the form to new heights. Although not classically trained at the academy, his handling of light, subtle colours and tones, combined with the heroic subject matter, was unparalleled. *Ulysses Hands Chryseis over to her Father* (1644) captures a key event in the *Iliad*, in which Ulysses (Greek: Odysseus) returns the daughter of Chryses, a priest of the Roman god Apollo. Agamemnon abducted Chryseis on his way to laying siege to Troy, and would not return her. Apollo sent a plague through the Greek encampment to force Agamemnon to

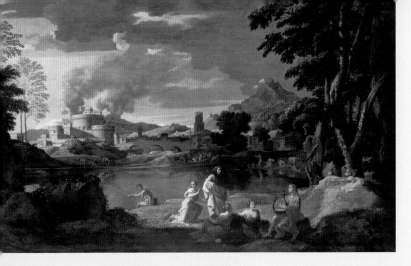

▌ NICOLAS POUSSIN (1594–1665)
Landscape with Orpheus and Eurydice
c.1650–53, Musée du Louvre, Paris.

Poussin draws the eye of the viewer from the red-cloaked Orpheus through the surrounding group to the lake and the castle. Harmonised colours, especially the bright yellow–green, create balance across the landscape.

▌ JAN BRUEGHEL THE ELDER (c.1568–1625)
Flora in the Flower Garden (n.d.),
Schloss Schleissheim, Bavaria.

Jan was from a Flemish family of painters: his father was Pieter Bruegel the Elder; his brother was Pieter Brueghel the Younger; and his son was Jan Brueghel the Younger. This work, with a profusion of flowers against a distant vista, is reminiscent of the still-life flower paintings that were popular in the region (see Still Life, pages 106–12).

KEYWORDS

Arcadia a district of Greece where the people enjoyed simple pleasures, music and dance. Arcadia is used to suggest the idea of an unspoilt world where people go to escape the trials of life.

Pastoral relating to calm, simple rural scenes of life, invoking feelings of perfect happiness.

RELATED WORKS

- **Claude** *Embarkation of the Queen of Sheba* 1648, National Gallery, London.
- **Nicolas Poussin** *Landscape with a Man Killed by a Snake* 1648, National Gallery, London, and *Shepherds of Arcadia* c.1638–40, Musée du Louvre, Paris.

comply, and in his anger the king took Briseis from Achilles in compensation. This precipitated Achilles' withdrawal from the siege.

Claude's fascination with arrivals and departures can be seen in this work, where the impending doom of battle, the key figures and their emotions are suggested, but elided. The activity in the port carries on as the boat approaches, and the Classical buildings, based on Roman and Renaissance models, add grandeur and weight. The significance of this fleeting moment in history is suggested by the vibrant light, depth and imposing composition.

APPRECIATING...

The mythical landscape creates an ideal world by skilfully using:

- balanced and harmonious compositions
- soft and natural colours, tones and light
- heroic and tragic subjects, with moral and emotional messages
- moments in events that encompass a whole narrative.

Dutch Landscape Painting

The Dutch Republic declared its independence from King Philip II of Spain in 1579, separating from the rest of the Netherlands. This struggle, and the character of the resulting, largely Protestant, country, would influence Dutch painting significantly, in particular, landscape painting. Beginning in the early years of the 17th century, artists began to paint the scenes around them. These works used muted and naturalistic tones, in contrast to the vibrant colours of the previous century, to capture the unique characteristics of the local landscape.

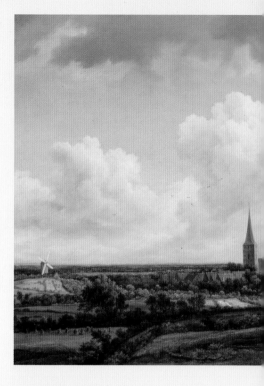

RELATED WORKS

- **Claes Jansz. Visscher** *The Land Yachts of Prince Maurits of Nassau on the Beach at Scheveningen* c.1610–16, The Fitzwilliam Museum, Cambridge.
- **Jan van Goyen** *Windmill by a River* 1642, National Gallery, London.
- **Aelbert Cuyp** *View of Dordrecht* c.1655, Iveagh Bequest, Kenwood House, London.
- **Jacob Isaackszon van Ruisdael** *A Landscape with a Ruined Castle and a Church* c.1665–70, at the National Gallery, London.
- **Meyndert Hobbema** *Dorfstrasse unter Bäumen* (*Village Street Under Trees*) 1665, Gemäldegalerie, Berlin.

Art and Commerce

Dutch landscape painting drew on the precedent of a series of prints by Claes Jansz. Visscher entitled *Pleasant Places* (c.1611–12) and depicting historic landmarks (including sites relating to the recent war) and scenes of production and recreation around Haarlem. By the middle of the 17th century, landscape painting was the most popular form of art in the Dutch Republic, far outstripping historical themes and portraiture, which dominated in Italy and France. As the country's prosperity grew, so did the demand for works that celebrated the qualities and freedoms of its own towns and countryside.

The Dutch Republic prospered through its commercial success, thanks, in particular, to its fast merchant-shipping fleet. The blockade of Antwerp in the southern, Spanish Netherlands during the war

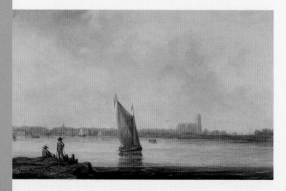

▮ **AELBERT CUYP** (1620–91)
View of Dordrecht 1670,
Museum der Bildenden Künste, Leipzig.

Almost monotonal, the emphasis is on the figures on the near bank, the boat on the river and the silhouette of the town in the distance. The wide, grey sky only serves to reinforce the importance of interdependency between these three elements of Dutch life.

■ JACOB ISAACKSZON
VAN RUISDAEL
(1628–82)
**Landscape with a View of
Ootmarsum** 1670/75,
Alte Pinakothek, Munich.

*The greatest of all Dutch
landscape painters, van
Ruisdael's view of a small
town in the northeast of the
country typifies his work.
The view is taken from a
small hill to the west, and
although the landmarks
have been manipulated
to suit the composition,
the meteorological and
geological details are
represented accurately.
(Ossing and Brauer, 2007)*

APPRECIATING...

**The composition of the landscape painting is paramount
in exploring its meaning. All Dutch landscape artists
carefully chose the detailed elements, the aspects of
light and weather and the arrangement to reflect the
Dutch perception of themselves and their country.**

had enabled Amsterdam's rise to prominence as a
major seaport. Expanding trade with the New World
and the East brought high volumes of goods through
Dutch hands, destined for the rest of Europe. The
decentralised and mutually supportive social and
commercial structures within the country ensured a
prosperous population with interests in art. Strongly
Protestant, demand was directed away from
religious subjects towards landscape and subjects
from everyday life.

Place and Identity

Works by Aelbert Cuyp, Johannes Vermeer and
Jacob Isaackszon van Ruisdael, for example,
demonstrate the common characteristics of Dutch
landscape painting. The low horizons; the balance
between representing the people, their towns and
the countryside; the attention to realistic detail and
topographical accuracy (which has been termed
a 'contrived reality'); and the deceptively simple,
harmonious compositions – all capture the essence
of place. Characteristic features include windmills,
canals, boats, barges and ships, all familiar symbols
of the Dutch landscape and its thriving commerce.
The juxtaposition of God-ordained natural forces and
man-made features, such as canals, reflects Dutch
perceptions of their identity and country. Even the
weather – cloudy, often wet, blustery and possibly
lowering – creates atmosphere and realism of place.
The order in the detail, figures and composition
reflected Dutch society.

JOHANNES
VERMEER VAN DELFT
(1632–75)
View of Delft 1659–60,
Royal Cabinet of
Paintings, Mauritshuis,
The Hague.

*This meticulously detailed
painting of Vermeer's home
town brings the viewer close
to the subject. The 'contrived
reality' can be seen in
the way that dark clouds
shadow the houses and
boats on the river's edge,
whilst the town centre and
near bank glow in sunlight.
This skilfully balances the
foreground and background,
unifying the subject.*

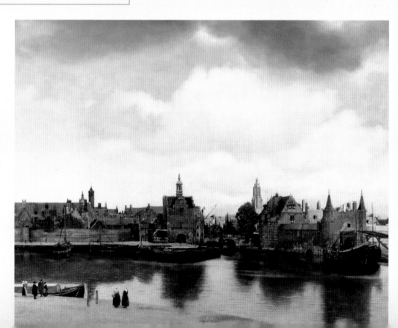

The European Enlightenment

The 18th century saw renewed interest in the Classical world. The age of the Grand Tour brought wealthy young men to Italy for instruction in the arts of antiquity. A market in Classical views developed, whether for actual scenes of Rome or idealised constructions, and the rise of printing meant the widespread availability of such landscapes.

The Grand View

Artists came to Rome from across Europe to sketch and paint the city and its Classical remains, as exemplified by Dutch artist Caspar Andriaans van Wittel's panoramic view across the Tiber to Saint Peter's Basilica. Italian artists, such as Giovanni Paolo Pannini and Giovanni Battista Piranesi, painted and etched the ancient ruins of Italy. These works were always based on surviving remains of ancient Rome, unlike the fantasy Classical landscapes of Poussin and Claude.

Pannini's *Architectural Capriccio* (meaning 'fancy') (1730) brings together many significant sculptures from around Rome.

The tradition of Dutch landscape painting of capturing precise views of cities – or *vedute* – expanded in Italy during the 18th century. Views of Venice became hugely popular, especially in England. The works of Canaletto, for example, capture the life of the city in minute and topographically accurate detail. Canaletto painted many famous Venetian landmarks – the Grand Canal, San Giorgio Maggiore, Santa Maria della Salute, the Dogana, the Rialto Bridge, the piazza around San Marco and the Doge's Palace – and the unique lifestyle features – the gondolas, canals, palazzos and festivals. Canaletto's popularity in England brought him to London, where he painted Westminster, Westminster Bridge, the River

■ **CASPAR ANDRIAANS VAN WITTEL** (1653–1736)
View of Rome c.1730,
Galleria Nazionale d'Arte Antica, Rome.

The landmarks of Rome, such as the Castel Sant'Angelo, Saint Peter's Basilica, the Tiber and the seven hills, as well as the ancient buildings and ruins, were popular subjects for landscape views.

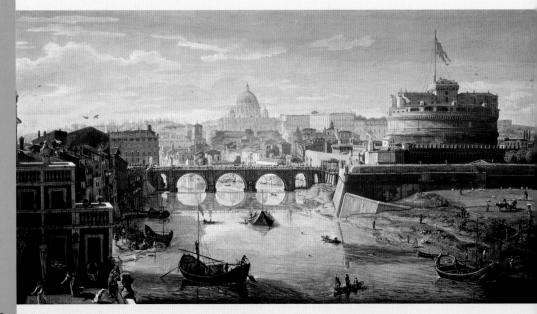

▌ GIOVANNI PAOLO PANNINI (1691–1765)
Architectural Capriccio 1730, Private Collection.

The contemporary visitor would easily recognise the Farnese Hercules in the centre, the equestrian statue of Marcus Aurelius, the arch of Septimus Severus and reconstructions of temples and buildings in the Roman Forum.

RELATED WORKS

- **Giovanni Battista Piranesi** *The Temple at Paestum* c.1770–78, Rijksmuseum, Amsterdam.
- **Canaletto** *The Stonemason's Yard* 1726–30, National Gallery, London, and *London: Westminster Abbey, with a Procession of Knights of the Bath* 1749, Westminster Abbey, London.
- **Francesco Guardi** *The Molo and the Riva Degli Schiavoni from the Bacino di San Marco* 1760–65, Metropolitan Museum of Art, New York, and *Venice: The Punta Della Dogana with Santa Maria Della Salute* c.1770, National Gallery, London.
- **Thomas Gainsborough** *Landscape in Suffolk* 1748, Kunsthistorisches Museum, Vienna.

KEYWORDS

Vedutism based on *veduta* (plural *vedute*), the Italian word for 'view', vedutism became popular in Italy during the 18th century. It particularly satisfied the demand for mementoes of the cities visited by Grand Tourists from northern Europe and Britain.

▌ CANALETTO (1697–1768)
Santa Maria Della Salute 1727,
Musée des Beaux-Arts, Strasbourg.

The perspective in Canaletto's views of Venice is so accurate that it is possible to plot precisely where he was painting from, down to the building and window.

APPRECIATING...

The Grand Tour fuelled a passion for a record of the modern and ancient sites encountered in Italy. Landmarks, activities and curiosities became popular centrepieces for views – *vedute*. The Enlightenment desire to record, catalogue and study the Classical world, amongst other subjects, resulted in detailed paintings and prints of every building, sculpture and fragment. The precise forms of the vedute may also be seen as part of the urge to record and catalogue the world.

Thames, and Greenwich. Francesco Guardi also painted *vedute* of Venice in a more atmospheric, and increasingly impressionistic, style.

Landscape in the Portrait

In 18th-century England, landscape painting in general was not highly sought-after, so, despite his preference for landscape, Thomas Gainsborough had to follow a career in portraiture. Some of his early landscape paintings, such as *Landscape in Suffolk* (1748), illustrate his talent for naturalistic representations. He used this to good effect in many of his portraits, especially *Mr and Mrs Andrews* (see pages 46–47). In this work, the landscape of the Andrews' property is symbolic of power, ownership, prosperity, fertility and identity.

RELATED TOPICS/ARTISTS THOMAS GAINSBOROUGH'S *MR AND MRS ANDREWS*, PAGES 46–47; THE ENLIGHTENMENT, PAGE 67

Exploring the Human Relationship to Nature

Early 19th-century artists explored a more intimate relationship with the landscape. Although the so-called 'Romantic' movement encompassed a disparate group of artists, there were shared concerns in landscape painting of the period. In previous centuries, the human involvement – of the artist and the viewer – can be described as being detached from the landscape; during this period, artists sought explicitly to engage with the human relationship to the landscape and nature.

▌ CASPAR DAVID FRIEDRICH (1774–1840)
Rocky Ravine 1822–23,
Kunsthistorisches Museum, Vienna.

The imposing rocks tower above the viewer, whose way is threatened by fallen trees. The rugged beauty of the pinnacles overwhelms the senses.

The Sublime

In *Critique of Judgement* (1790), the German philosopher Immanuel Kant (1724–1804) sought to understand the nature of aesthetic judgements. His philosophy argued that knowledge of the world came from applying the mind to the experiences of the senses. He theorised that the experience of the sublime centred on our inability to comprehend the totality of the subject.

Caspar David Friedrich's landscape paintings present the sublime. His work *Rocky Ravine* (1822–23) captures the awesomeness of the natural world and our insignificance within it. Vast scenes of untamed vistas confront the viewer. Whether containing figures or not, Friedrich challenges us with nature's enormity and incomprehensibility – uncontrollable by humans. In his more religious subjects, nature can be equated to God. The visual and emotional resonance of Joseph Mallord William Turner's later seascapes also present the sublime, for example, *The Morning of the Deluge* (c.1834) and *Snow Storm: Steam-Boat off a Harbour's Mouth* (c.1842).

The New World

In the newly independent United States of America, artists engaged with British landscape traditions, issues of colonisation and the taming of the wilderness. Albert Bierstadt's *Buffalo Trail: The Impending Storm (The Last of the Buffalo)* (1869) captures the sublime of the American West in the threatening storm and rugged landscape. Buffalo, symbolic of America taming and exploiting the

❚ ALBERT BIERSTADT
(1830–1902)
Buffalo Trail: The Impending Storm (The Last of the Buffalo) 1869, The Corcoran Gallery of Art, Washington DC.

The plains and mountains that characterised the American West were often painted by Bierstadt. In 1859, he went on a survey expedition to the Rockies, and many of his landscapes originated from this, and later, trips west.

frontiers, offer a suggestion of human presence. Landscapes by Bierstadt and Thomas Cole, members of the Romantically inspired Hudson River school, reflected the country's need to establish its identity and heritage within its new territories.

Experiencing Nature

In France, the Barbizon School (c.1830–70) pioneered painting *en plein air* ('in the open air'). Its artists included Camille Corot, Charles-François Daubigny (1817–78), Théodore Rousseau (1812–67) and Jean-François Millet (1814–75). Like Gustave Courbet (1819–77), they pursued realism in the landscape, following Constable's principles of truth to nature (Constable's works were exhibited in Paris in 1824). Corot's *Souvenir de Mortefontaine* (1864) shows a soft handling of foliage and water, as well as the realistic effects of light.

RELATED WORKS

- **Caspar David Friedrich** *Monk by the Sea* 1809, Nationalgalerie, Berlin, and *The Wanderer above the Mists* 1818, Kunsthalle, Hamburg.
- **Joseph Mallord William Turner** *The Morning of the Deluge* (c.1834), *Snow Storm: Steam-Boat off a Harbour's Mouth* (c.1842) and the six watercolours of *The Blue Rigi* (1841–44), Tate Britain, London.
- **Thomas Cole** *View from Mount Holyoke, Northampton, Massachusetts, after a Thunderstorm* 1836, Metropolitan Museum of Art, New York.

KEYWORDS

Aesthetic taken from the Greek word *aesthesis*, meaning 'communication to the senses'. It is concerned with how we perceive things relating to ideas of beauty and judgements of taste. It can be applied to an artist's overall style.

Sublime the experience of the sublime has been described as 'delightful horror' – the moment on the cliff edge caught between exhilaration and terror.

En plein air a method of painting a scene directly onto the canvas in the open air and strongly associated with the Impressionists.

APPRECIATING...

The desire to explore the natural world more specifically was a significant change from earlier, idealised landscape painting. The emphasis was now on the experience of nature and its emotional and visual impact.

RELATED TOPICS/ARTISTS
SAMUEL PALMER'S *IN CUSOP DINGLE NEAR HAY-ON-WYE*, PAGE 9; JOHN CONSTABLE'S *DEDHAM LOCK AND MILL*, ON PAGES 118–19, AND J M W TURNER'S *SLAVE SHIP*, PAGE 100

❚ CAMILLE COROT
(1796–1875)
Souvenir de Mortefontaine 1864, Musée du Louvre, Paris.

The carefully formulated composition has trees cutting across the upper edge of the canvas and framing the scene on one side. Corot used this device often to balance the scene.

The Impressionist Landscape

Claude Monet exhibited *Impression, Sunrise* (1872) at the first independent exhibition in 1874 of the group of artists who became known as the Impressionists. This and several other exhibited works led the critic Louis Leroy to apply the word 'impression', perjoratively, to the style employed. Used to name the group for only two out of eight exhibitions (1877 and 1879), Impressionism has been most prominently characterised by the works of Monet. Other Impressionist landscape artists were Camille Pissarro, Pierre-Auguste Renoir and Alfred Sisley. The concept of an 'impression' encapsulates both the idea of an object and the subjective response of the artist or viewer. The technique developed, based on painting *en plein air*, where the artist captured the fleeting nuances of colour, light and shadow on the landscape. Monet and Sisley extended this to painting the same scene at different times of day and in varying lights, seasons and weather. *Grainstacks, The End of Summer* is one of Monet's series paintings; others include paintings of the façade of Rouen Cathedral, poplars, water lilies and the Japanese bridge at Giverny.

▌CLAUDE MONET
(1840–1926)
Grainstacks, The End of Summer 1891,
Musée d'Orsay, Paris.

RELATED WORKS
- **Claude Monet** *Impression, Sunrise* 1872, Musée Marmottan, Paris.
- **Camille Pissarro** *L'Hermitage at Pointoise* c.1868, Solomon R Guggenheim Museum, New York.
- **Pierre-Auguste Renoir** *Algiers, the Garden of Essai* 1881, Corporate Collection.
- **Alfred Sisley** *Rue Eugène Moussoir at Moret: Winter* 1880, Metropolitan Museum of Art, New York, and *The Church at Moret, Evening* 1894, Musée du Petit Palais, Paris.

Impressionist Style

The fragmented brushstrokes and bold use of colour and tones capture the impression of the scene.

Sunlight

In this version, the light is low but warm, on a late-summer afternoon. Other versions explore different angles for the light, times of day or year and different weather: misty mornings, snow and frosted fields.

Shadows

The shadows are painted using purples and greys, avoiding the darker earth tones and black used by earlier painters.

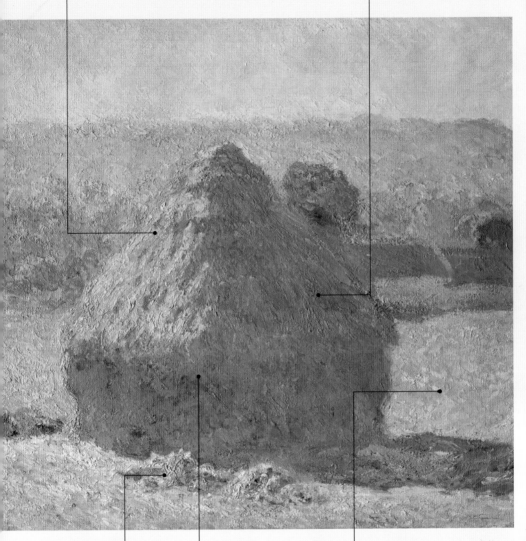

Texture

Paint is laid on thickly, creating texture and reflecting the light.

Composition

Despite the close focus on the subject, Monet always carefully prepared the composition, balancing the grainstacks and bands within the landscape.

Colours

A close study of Impressionist works shows the complex mixing and juxtaposition of colours to achieve the glowing vibrancy of the different lights on the landscape. It shows that the works required careful construction to achieve the 'impressionist' style.

Form & Emotion in the Landscape

Landscape painting remained central to artistic developments during the last decades of the 19th century as artists built on and superseded the innovations of the Impressionists. New forms of landscape laid the foundations for the radical changes in art that took place during the 20th century. The exploration of form in the landscapes by Cézanne linked to the development of Cubism and abstraction, whereas van Gogh, Gauguin and the Symbolists used landscape to express emotions and thoughts.

▌ JAMES MCNEILL WHISTLER (1834–1903)
Nocturne in Black and Gold, the Falling Rocket 1875,
The Detroit Institute of Art, Detroit.

Highly controversial at the time, this painting was the subject of a libel case brought by Whistler against art critic John Ruskin, which eventually bankrupted the artist.

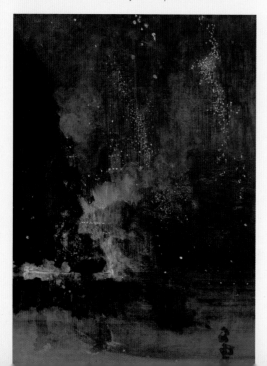

APPRECIATING...

The subject of late-19th-century landscapes was the contemporary natural world, and many paintings were still concerned with capturing the essence of place. However, the painting techniques, motivating concerns of the artist and symbolic meanings had changed. Artists pursued divergent interests, experimenting and exploring personal artistic and expressive goals, which would lead into the avant-garde movements of the 20th century.

Landscape Form as Personal Expression

Paul Cézanne was involved in the Impressionist group and showed at some of their exhibitions, including the first in 1874. He had a close relationship with Camille Pissarro, and during the early 1870s they explored landscape painting together. In contrast to the Impressionists, however, Cézanne perceived the importance of representing the form of objects – their solidity and shape – both in still life and landscape. He painted Mont Saint-Victoire, close to his home in Provence, many times from the 1880s. Early views of the mountain demonstrate his concern with form in the strongly delineated land, trees and houses. In *Mont Saint-Victoire, View from Bibemus* (1897), blocks of vibrant colour with subtle toning create the solid forms of rocks and trees. Although the landscape appears stylised and flat, Cézanne has captured its physical essence.

James McNeill Whistler's *Nocturne in Black and Gold, the Falling Rocket* (1875) captures sparks from a firework against the night sky. Its indistinct forms are comparable to those of the Impressionists, but the orange fireworks, fire sparks and smoke are unmistakable against the inky darkness.

Other artists used landscape to explore form and emotions, including Georges Seurat (*see page 119*), Vincent van Gogh (*see page 10*) and the Symbolists Paul Gauguin and Paul Sérusier. Van Gogh imbued his landscapes with the emotional turmoil of his life, whilst Gauguin and Sérusier painted scenes to express symbolic meanings.

The Landscape of Modernity

In 1863, Charles Baudelaire (1821–67) wrote the essay *The Painter of Modern Life*, in which he argued that artists should paint the modern

■ CAMILLE
PISSARRO
(1830–1903)
*La Place du Théâtre
Français, Sunlight*
1898, National
Museum, Belgrade.

*The impression of a hot
day on the boulevard is
emphasised by patches
of red paint and the
pink and orange glow
across the street and
buildings. This scene
of busy activity on
the wide boulevards
captures the essence of
contemporary Paris.*

RELATED TOPICS/ARTISTS
VINCENT VAN GOGH'S *STARRY NIGHT*, PAGE 10; *SYMBOLISM*, PAGE 85;
AND *TOWARDS ABSTRACTION*, PAGES 158–59

world around them rather than the idealised
historical and mythical subjects of the academy.
Many of his ideas anticipated the Impressionists:
capturing fleeting moments with rapid painting
techniques; observing the nuances of everyday
life. The cityscape of Paris was a popular subject
for the Impressionists. Camille Pissarro's *La Place*
du Théâtre Français, Sunlight (1898) encapsulates
a moment on a hot Parisian boulevard (created by
Baron Haussmann's modernisation of Paris during
the 1850s and 1860s) and the idea of the leisurely
observer – the *flâneur* – of contemporary life.

■ PAUL CÉZANNE (1839–1906)
Mont Saint-Victoire, View from Bibemus 1897,
Museum of Art, Baltimore.

*Despite the flat and almost abstract style, a closer look –
for example, at the mountain – shows how blocks of greys
and blues in varying tones have been painted to capture
the cliffs and crags.*

RELATED WORKS

- **Paul Cézanne** *Mont Saint-Victoire Seen from Bellevue*
 c.1882–85, Metropolitan Museum of Art, New York.
- **Paul Gauguin** *Tahitian Landscape* 1891, The
 Minneapolis Institute of Arts, Minneapolis.
- **Paul Sérusier** *Le Talisman* 1888, Musée d'Orsay,
 Paris.
- Also, cityscapes by **Claude Monet, Gustave
 Caillebotte, Pierre-Auguste Renoir** and
 Edgar Degas.

KEYWORDS

Flâneur from the French word for 'to stroll', *flâneur*
describes the man of leisure who observes other
people. The term encompasses both the detachment
of the observer and the intimacy involved in
scrutinising people's lives.

Genre

'In order for the artist to have a world to
express he must first be situated in this
world, oppressed or oppressing, resigned
or rebellious, a man among men.'

CHARLES BAUDELAIRE (1821–67)

Genre painting represents scenes of everyday life and, like still life, was not highly valued by the academies. The subjects depicted might be in domestic settings or out amongst the community, at markets or festivals. Genre encompassed a wide range of scenes, from working peasants to aristocracy at leisure; thieves, musicians; professionals and servants. As with still life, its popularity in the 17th-century Dutch Republic may have been on account of its descriptive or allegorical qualities. During the 19th century, the rejection of idealised subjects for realistic depictions of the modern world linked genre painting to political and social issues.

Why would a patron or an artist choose to paint an everyday scene? Perhaps to moralise on or idealise a subject that, although apparently ordinary, reflected status, personal aspirations and values or the social order. The subject might embody qualities that the patron or artist admired or was stimulated by in the world around him or her. It might contain a moral or political message. The implied realism of ordinary subjects and scenes added to the power of their symbolism, descriptive qualities and subliminal meanings. As with still life, genre painting operated within the spheres of reality versus illusion and description versus allegory. Debates on the mechanisms used to paint 'realistic' genre scenes revolve around whether artists used the *camera obscura* to capture precise details of perspective. The mathematical calculation of the recession and vanishing point of single-point perspective developed in 15th-century Florence (*see page 121*) could be bypassed by reflecting an image onto a canvas through the *camera obscura*. Artists would not generally admit to relying upon this device, however, but recent critics have suggested widespread covert use (*see pages 146–47*). Whether the *camera obscura* was employed, in secret or overtly, the debate reflects the degree to which 17th-century Dutch landscape and genre paintings created the illusion of reality.

Realism is itself a problematic concept, however. It was first used to categorise the work of 19th-century French artists who sought to paint everyday, contemporary subjects (*see pages 100–1*). During the 20th century, artists who painted in ways that appeared to simulate the real world were often involved in political propaganda (*see pages 164–65*). Yet it is possible to trace connections between genre painting and 20th-century realism.

Scenes from Everyday Life

The representation of scenes from everyday life dates back at least to Classical Greece. Greek pot decoration depicted mythological subjects, but also domestic, leisure and sporting scenes, for example, women in a garden or men enjoying the pleasures of the symposium (a drinking party). The Parthenon Frieze (c.438–32BC) may depict contemporary Athenians in procession at the Great Panathenaic Festival. The choice of such subjects could affirm unity and reinforce the social values that underpinned a community's shared identity.

▌ ROMAN EMPIRE (1st–5th centuries AD)
Pompeiian Ladies With Their Slave Hairdresser
1st century AD, Pompeii, Naples

Three women at leisure are attended by a hairdresser. They have elaborate hairstyles and wear jewellery and ornaments, suggesting their high status. Although there appear to be no mirrors in the scene, the adornment and viewing of women were often depicted in Roman art.

Roman Wall Paintings

Wall paintings from the Roman period suggest that everyday subjects continued to be popular. Paintings in Pompeii, Herculaneum and Boscoreale seem to depict people engaged in everyday activities. Women at their toilet or at leisure, as in the hairdressing scene from Pompeii shown here, were popular subjects. In the *Villa of Mysteries, Pompeii,* another series of wall paintings stretches around the room and include women having their hair prepared, carrying trays or starting in alarm, as well as semi-erotic and titillating scenes. It seems to have been designed to excite curiosity, but its meaning is obscure. Another leisure scene, the so-called 'Aldobrandini Wedding' (c.30BC–AD15), found in Rome in around 1600, presents groups of figures casually enjoying a garden and music. These paintings suggest that female adornment and leisure signified social status and wealth.

Parties and Celebration

The world of food and drink, symbolic of abundance and prosperity, was often represented in genre paintings, including more or less all of the processes associated with it. The display and purchase of food and drink at market, its preparation in the kitchen and its consumption were regular subjects of genre painting. The abundance of produce – choice, fresh and rich – was sometimes emphasised, while in other paintings, a simple glass of wine was enough. Food and drink featured at parties and celebrations; it linked genre painting to still life and portraiture, notably in the banquet group portrait (*see page 43*). Music was also a popular subject, both in its playing and for dancing and celebrations.

Jan Steen's *The Family Celebration* (1655) includes these elements in a rowdy scene of drinking and carousing. Steen's tone is moralising, with clear indications of excess and debauchery being depicted. What might have started as a

happy event is degenerating into chaos; Steen's paintings often play off the ideals of an ordered society against the realities of life, cautioning against the abuse of excess. In his *In Luxury, Look Out* (1663, Kunsthistorisches Museum, Vienna), the baleful consequences of luxurious over-indulgence are even more explicit. Other 17th-century Dutch artists chose more sober subjects and activities to represent moral and social values. Whether showing the conscientious housewife out buying her vegetables or the harmonious, domestic setting of the family, the scenes depicted explored idealised representations of life that symbolised cultural identity.

Leisure and Pleasure

Beyond the Dutch Republic, paintings of everyday subjects engaged with different concerns, from the overt pleasure-seeking of French Rococo paintings to the animal paintings that were popular in Britain. It is difficult to generalise on the subjects chosen by diverse societies across Europe, but many involved pleasure or leisure activities. These might include the depiction of groups out and about at a party or festival. Pietro Longhi, Francesco Guardi and Canaletto's portrayals of the carnival and annual festivals in Venice emphasise the traditions and values of a Venetian society that, by the 18th century, was all but defunct.

More individual pleasures might involve animals: in Britain there was a long tradition of artists painting horses and dogs, both symbols of the country gentleman. Through the 17th and 18th centuries, interest in science, the natural world and the empirical studies of the Enlightenment popularised depictions of collections, instruments and experiments. This can also be seen in some still-life paintings of the period. During the 19th century, genre painting effectively became central to the work of Impressionist and Post-Impressionist artists (*see pages 114–15*), who particularly sought to represent scenes of pleasure in a modern, urban world.

The Domestic Interior

The different subjects of genre painting were set in a range of contexts, but the domestic interior was more than simply a backdrop. Johannes Vermeer van Delft made this the main context for his work, representing a range of contemplative, intimate, social and domestic activities in calm spaces. Interiors might be used as settings for activities, but their layout, content and décor were important for registering wealth, space and family unity. Jean-Baptiste-Siméon Chardin also painted interior scenes that symbolised the ideal harmony of the domestic world. The Impressionists, particularly the female artists – Berthe Morisot and Mary Cassatt – used the interior to explore the effects of light and the modern, domestic world. In broad terms, genre painting might be understood as indicative – whether of an individual, a family or a community.

RELATED TOPICS/ARTISTS
ARTISTS' PORTRAITS, PAGES 42–43

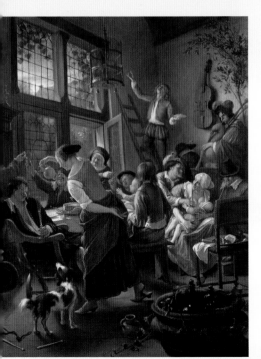

▎ JAN STEEN (1626–79)
The Family Celebration 1655, Musée du Louvre, Paris.

The central female figure makes a big gesture of pouring wine into the drunken man's tall glass. The two figures above and to the right seem to be struggling to make music – one appears to be singing to a caged bird. Below, another drunken man tries to grab the nursing mother, and figures in various stages of intoxication can be seen around the scene.

Labour & Leisure

Genre painting as an art-historical category was used retrospectively during the 18th century, primarily to refer to art of the 17th and early 18th centuries, but a broader understanding of everyday subjects encompasses representations undertaken before 1600. In the late medieval period, some manuscript illumination represented non-religious subjects often associated with landed aristocracy, such as hunting, fishing and jousting scenes. During the 15th and early 16th centuries, there was still little demand for everyday subjects, however.

The Book of Hours
Les Très Riches Heures du Duc de Berry (1412–16) was illuminated extensively by the Limbourg brothers. A book of hours such as this was a text used to record the events of the religious calendar, and the illuminations plotted the cycle of the months and year. Les Très Riches Heures is probably known for being one of Europe's most expensively decorated books, with its extensive use of ultramarine, the highly prized blue pigment obtained from pulverised semi-precious lapis lazuli. Each illumination shows the events of the month in the lands surrounding ornate châteaux. The emphasis on the hegemony of the landowners and the underpinning labour of the peasants is vividly portrayed.

Courtly Pleasure
The Camera degli Sposi is a small room in the Palazzo Ducale in Mantua, all of whose walls and ceiling were painted by Andrea Mantegna for the duke, Ludovico Gonzaga. The trompe l'oeil effect (see pages 112–13) throughout the room means that it is very difficult to distinguish real

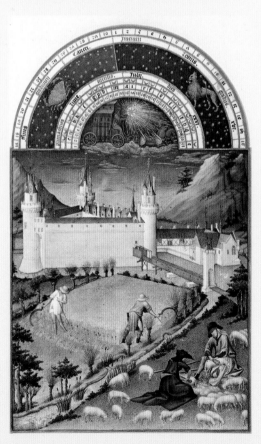

RELATED WORKS
- **Hieronymus Bosch** The Magician 1475–80, Musée Municipal, Saint-Germain-en-Laye.
- **Quentin Massys** The Moneylender and his Wife 1514, Musée du Louvre, Paris.
- **Lucas Cranach the Elder** Amorous Old Woman and Young Man 1520–22, Museum of Fine Arts, Budapest.
- **Titian** The Concert c.1510, Galleria Palatina (Palazzo Pitti), Florence.

▌ LIMBOURG BROTHERS: HERMAN (c.1385–1416) PAUL (c.1386/87–1416) & JOHAN (c.1388–1416)
Les Très Riches Heures du Duc de Berry: Juillet (July) 1412–16, Musée Condé, Chantilly.

The month of July is clearly hot, with some peasants in light clothes. The harvest is being cut and the sheep are being shorn. The references to the riches of the land are echoed in the monthly illuminations throughout the year.

RELATED TOPICS/ARTISTS
TROMPLE L'OEIL, PAGES112–13; GIORGIONE, PAGE 75; VITTORE CARPACCIO, PAGE 107

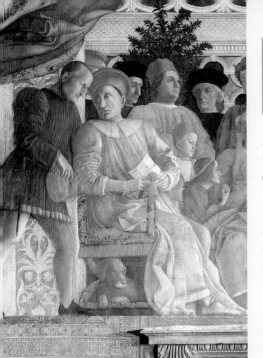

KEYWORDS

Oculus an opening to the sky in a domed ceiling, for example, in the Pantheon in Rome.

▌ANDREA MANTEGNA (c.1430/31–1506)
Camera degli Sposi, detail of The Gonzaga Family,
1465–74, Palazzo Ducale, Mantua.

Mantegna went to great lengths to create the illusion of a real scene, including the carpet draped as if over the edge of a dais; the curtain pulled back, revealing a crumpled, red lining and Ludovico's dog snoozing under his chair.

architecture from imaginary. The ceiling is especially skilful as Mantegna painted an oculus with figures, *putti*, a peacock and a flowerpot perched on a balcony, the effect being so successful that the figures really appear to be peering down, into the room. The walls contain various figure groups and vistas over the Italian countryside, as though the walls of the room were open to the air. On one wall, Ludovico and his family sit at their leisure, as though in a courtyard, giving an audience to visitors. The figures' casual stance and the illusions of the painting style make viewers feel as though they have simply happened upon a Renaissance court on a sunny afternoon. Although many of the figures are probably represented by portraits, the informal life of the palazzo is what stands out.

Moral Tales

In northern Europe, everyday subjects were painted to allude to human weakness and folly – a more light-hearted approach to morality than Bosch's (*see pages 60 and 72*). *The Fortune Teller (Cards)* (c.1508–10), by Lucas van Leyden, an early example of Netherlandish genre painting, depicts a group clustered around a female fortune teller dealing cards. The flower being passed between the fortune teller and the man suggests that he is asking for details of how he will fare in love. The figures behind also seem to be involved in an encounter. The painting alludes to the vanity and folly of love, and to the games that people play in its pursuit.

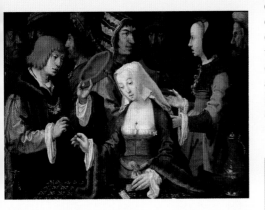

▌LUCAS VAN LEYDEN (1494–1533)
The Fortune Teller (Cards) c.1508–10,
Musée du Louvre, Paris.

Lucas van Leyden is rated as one of the best engravers in art history. He painted several scenes of card players, and was the first artist to paint genre subjects in the Netherlands. The vibrant colours, the action, the individual faces and their animated expressions give his work intimacy and liveliness.

APPRECIATING...

During the 15th and early 16th centuries, genre subjects were uncommon, but some were used to represent the social order and differences in social status. In the Netherlands, a concern for morality and social values combined with a mild sense of humour to create the first genre paintings. The observation of the morals of contemporary life was well suited to the precise and realistic style of the north.

The Social Order

In the Netherlands, interest in constructing scenes that explored the moral and social order continued through the 16th century, and was developed particularly by artists from the Flemish Brueghel family. In Italy, Caravaggio's tightly focused and sharply illuminated subjects explored human vices, intrigue and the seamier side of life. Styles differed, but engagement with the human condition was a common theme.

Nobles and Peasants

Pieter Bruegel the Elder, who has been described as 'the greatest Flemish artist' of the 16th century, founded a dynasty of artists that lasted for two centuries. His early works followed 15th-century Netherlandish tradition, especially Hieronymus Bosch. His later style, however, drew on art from Italy, where he is known to have travelled, and his works covered a wide range of subjects, from landscape and religious to moralising paintings.

Many of Bruegel's paintings (he changed the spelling of his name from Brueghel after 1559, although his family retained that name) were concerned with representing the peasantry. The slightly bucolic and comic scenes of peasants dancing or celebrating a wedding contain finely observed caricatures and incidents that present the apparently honest enjoyment of simple pleasures. It is worth noting, however, that neither the contemporary collectors of his work nor Bruegel himself were peasants, and that these scenes also have an air of condescension. This is particularly evident in *Noble Visitors to the Peasants' Living Room* (1560), in which a group of well-dressed nobles are visiting a peasant family's house. The contrast between the austerely, but finely, dressed nobles and the industrious, but

■ PIETER BRUEGEL THE ELDER (c.1525–69)
Noble Visitors to the Peasants' Living Room 1560, Kunsthistorisches Museum, Vienna.

The nobles' dark dress recedes beside the peasants' colourful clothing, perhaps suggesting that the peasants' life may be hard but lively. Although their lives are simple – the food, basic; the room, used for all activities; and the comforts, minimal – their needs appear satisfied. Is Bruegel saluting or mocking the static social order of working peasants and leisured nobles? Many interpretations are possible.

RELATED TOPICS/ARTISTS
HENRIK AVERCAMP, PAGE 123 AND CARAVAGGIO, PAGE 64

▌PIETER BRUEGHEL THE YOUNGER (1564–1638)
Country Festival 1600, Musée Rolin, Autun.

This painting makes the most of representing the fun, folly and comedy of humanity letting its hair down. The dancers, lovers, drinkers and more sober figures are exaggerated, but they are carefully observed and convincingly painted. The limited palette of greys, beiges, black and dull reds unifies the scene and reinforces the sense of community.

▌CARAVAGGIO (c.1571–1610)
The Cardsharps c.1596, Kimbell Art Museum, Fort Worth.

Caravaggio's intensely 'real' style is apparent in the black velvet of the youth's costume, the silk and satin of the cardsharps' colourful clothes and the incidental details – the lace cuffs, feathers and the older cardsharp's split glove. The light on the faces and the subtle contrasts between the fresh-faced youth and the more rugged thieves add an extra layer of power to the scene.

chaotic, scene that they are witnessing is striking. Most of the family appear to be continuing with their labours, but the encounter between the lady in the foreground and the child encapsulates the imbalance between the two classes. The painting is an eloquent observation of the social order.

Community Spirit

Bruegel's son, Pieter Brueghel the Younger, continued his father's tradition of painting peasant scenes, drawing on compositions and subjects developed by Pieter the Elder. The large scenes involve country festivals, winter scenes (similar to Avercamp's, *see page 123*) and allegorical subjects set in contemporary Flemish landscapes. Many of the subjects were repeatedly copied, with some being reproduced more than ten times. *Country Festival* (1600) exemplifies Pieter the Younger's work, with its frenetic activity and somewhat comical characters and vignettes, like the drunks on the table to the right and the exhausted-looking peasant on the left. Pieter Brueghel's continued success with the elder Bruegel's subjects and style shows how well they fitted with Flemish taste throughout the 16th century.

Character and Expression

Many of Caravaggio's paintings capture the intimate interplay of characters, whether in religious or genre paintings. The dramatic potential is fully realised in *The Cardsharps* (c.1596), in which two thieves are about to fleece a young and naïve aristocrat. The sting is so clearly written on the faces of the figures: the mature man's 'honest' advice, the young thief's hopeful gaze and the thoughtful youth seriously considering his compromised options. The two cards sticking out of the young cardsharp's belt are only one of several indications of the true state of affairs.

APPRECIATING...

During the 16th century, paintings of scenes drawn from everyday life became more popular, although the artifice in them was pronounced. Subjects explored the social order and were often ambiguous in their interpretation – was it satirical or not? Was the care taken to represent the scene implying a positive or negative view of the world? In many cases, the complexity of the message was intended as an observation of the ambiguities of life.

Pleasures & Pastimes

Dutch genre painting encompassed a wide range of scenes, subjects and messages in the 17th century. Jan Steen's moralising images contrasted with works by other artists who sought to capture everyday scenes that represented or symbolised the Dutch at leisure in their homes. Hanging on the walls of affluent Dutch people, these paintings reflected their good fortune and status. Developments in science and the fascination of collecting also offered subjects for paintings.

RELATED WORKS

- **Bartolomé Murillo** *Boys Eating Fruit (Grape and Melon Eaters)* 1645–46, Alte Pinakothek, Munich.
- **Nicolaes Maes** *The Lacemaker* 1650s, Metropolitan Museum of Art, New York.
- **Gerard Terborch** *Paternal Admonition* 1654–55, Staatliche Museen, Berlin.
- **Jacob Jordaens** *The Bean King* c.1655, Kunsthistorisches Museum, Vienna.
- **Samuel van Hoogstraten** *View of a Corridor* 1662, National Trust, Dyrham Park, near Bath.
- **Giovanni Paolo Pannini** *Picture Gallery with Views of Modern Rome* 1757, Museum of Fine Arts, Boston.

APPRECIATING...

The Dutch Republic's new status as an independent country, and its wealth from international trade, encouraged a broad middle class to invest in art that reflected its values and good fortune. Sold largely through art dealers, the demand for genre, still life and landscape paintings which represented the Dutch way of life was well satisfied. The realities and illusions of these paintings underlay their considerable visual power.

Dutch Genre Painting

Dutch paintings of everyday life exude a strong sense of identity, confidence and simplicity that can belie their more complex nature. Each element – room layout, aspect, decoration, furniture, accoutrements, even cleanliness – contributes to their impact and underlying message. Artists went to great lengths to represent interiors with carefully planned perspective, using light, doorways and flooring to emphasise space and serenity. Additionally, the figures in these scenes reinforced aspects of family, prosperity and community. For example, external scenes and interiors of churches stressed community identity, Protestant values and the qualities of local architecture. For a small country, space itself was a luxury to be signified. Overall, the reflection of the Dutch world sought to strengthen a self-perception of a mercantile and prosperous society.

Art and Science

The Flemish artist David Teniers the Younger continued Bruegel's genre tradition; he married Pieter the Elder's daughter, Anna, and became Court Painter in the Netherlands. Teniers' paintings of the collection of old masters acted partly as an inventory and partly to demonstrate his patron's artistic credentials. Gerrit Dou, a pupil of Rembrandt, painted many genre scenes, including academic, medical and scientific subjects. In *The Physician* (1653), the central figure is framed, apparently on a balcony, by the tools of his trade (an anatomy book and a bleeding

RELATED TOPICS/ARTISTS
DUTCH REPUBLIC ON PAGES 126–27 AND JAN STEEN, PAGE 139

❚ DAVID TENIERS THE YOUNGER (1610–90)
The Gallery of Archduke Leopold in Brussels
1640, Bayerische Staatsgemäldesammlungen, Munich.

Teniers painted many views and versions of the paintings in the archduke's collection. The gallery with floor-to-ceiling paintings, all recognisable, became a popular subject in the 18th century for demonstrating artistic interests, as exemplified, for example, by Johann Zoffany's The Tribune at the Uffizi (1772–78).

KEYWORDS

Guilds since medieval times, guilds had represented groups of professionals, artisans, merchants and tradesmen. For artists in Italy, they were eventually replaced by the academy. In the Dutch Republic, guilds protected their members' economic interests and helped control prices. The artists' guilds operated alongside informal academies set up in Haarlem, Utrecht and The Hague.

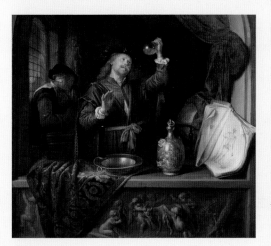

❚ GERRIT DOU (1613–75)
The Physician (detail) 1653,
Kunsthistorisches Museum, Vienna.

Dou's soft painting style draws on Rembrandt more than the precise styles of his contemporaries. He particularly uses light to stress elements of the painting: the flask, dish and carpet; the physician's face and hands; the anatomy book; and the female attending in the background. The rise of science during the 16th century was clearly admired by the Dutch.

dish) and other allusions to learning and knowledge. Of particular note are the Classical frieze on the balustrade and the signs of wealth (the rich carpet and velvet curtain).

The Family at Leisure
Pieter Codde painted many genre scenes of wealthy Dutch enjoying their leisure. Scenes might be set in a Dutch house, with its characteristic windows, austere contents and typical domestic layout (families usually occupied one room, in which they lived, entertained and slept). The décor represented was important, often including expensive fabrics and objects from foreign trade. Costumes could also be lavish. In Codde's *Three Figures Round a Table* the lady's dress is of shot silk, and many elements in the room point to foreign trade (the carpet and orange), intellectual pursuits (books and musical instruments) and affluence (the painting and silk bed-hangings).

❚ PIETER CODDE (1599–1678)
Three Figures Round a Table (n.d.),
Private Collection.

The scene is deceptively simple. Looking more closely reveals the signs of affluence, good taste and status: the carpet on the table is richly decorated and foreign, as is the tasselled silk throw peeping out of the bed curtains. On the wall, a mandolin alludes to musical pleasures, and a ceremonial sword, to guard duties in the community.

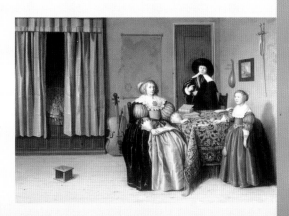

Discerning the Everyday

■ JOHANNES
VERMEER VAN DELFT
(1632–75) *The Milkmaid*
c.1658, Rijksmuseum,
Amsterdam.

Vermeer's genre paintings stand out for their intimacy, simplicity and style. They often contain domestic scenes or shared moments. His compositions include objects or still-life displays that allude to prosperity and status, but the overall scenes are unified by the soft textures of Vermeer's distinctive style. It is generally believed that he used the camera obscura to achieve accurate spatial relationships, and art historians point to effects in his paintings, some disputed, that could only have been seen through the instrument. For example, white dots picking out the detail in *View of Delft* (see pages 126–27) are attributed to light effects created by the camera obscura. This cannot detract from the serenity and the astonishingly rich, soft, glowing colours and textures that Vermeer achieved in his paintings.

RELATED WORKS

- **Johannes Vermeer van Delf**t *Young Woman with a Water Jug* 1660–62, Metropolitan Museum of Art, New York; *Lady with Her Maidservant Holding a Letter* c.1667, Frick Collection, New York; *The Lacemaker* 1669–70, Musée du Louvre, Paris; and *Lady Seated at a Virginal* c.1673, National Gallery, London.
- **Gerrit Dou** *Old Woman Watering Flowers* 1660–65, Kunsthistorisches Museum, Vienna.
- **Pieter de Hooch** *Musical Party in a Courtyard* 1677, National Gallery, London.

KEYWORDS

Camera obscura a box arrangement with a pinhole through which an image is directed onto a backdrop or canvas by mirrors. The pinhole captures the image as though through a single eye, creating a view with perfect perspective. The addition of a lens behind the pinhole was used to focus the image. During the early 19th century, a plate coated with a light-sensitive material was placed to receive the image, creating the first photographs.

Attention to Detail

The viewer's eye is drawn to the food laid out, the pouring jug and the sturdy maid at her work. In the background, a few details serve to add realism without distracting the eye – the broken windowpane, the copper pot and the hanging basket, the nail in the wall, along with its shadow, and the painted tiles along the skirting.

Texture of the Brush

In contrast to the precise painting style of his contemporaries, Vermeer left the texture of the brushstrokes to add vibrancy, depth and light to the simplest elements. The battered, earthenware jug is enlivened by texture and light.

Bread and Light

Vermeer used a technique called pointillé that highlighted objects with dots. Pinpoints of light on the bread against the rough texture of brown and beige paint make it stand out beside the smoother fabrics.

Complementary Colours

The light from the window catches the ochre-yellow colour of the maid's bodice and the ultramarine of her skirt, emphasising their harmonious relationship. The slightly rough texture of the fabrics serves to add vibrancy and richness to what were inexpensive clothes.

Costly Ultramarine

Vermeer used the rich, blue colour of expensive ultramarine throughout his paintings, even when his funds were limited. It was used here not only on the maid's skirt and the cloth on the table, but also with yellow on the green oversleeves. He sometimes used it extravagantly as an undercolour to add depth to fabrics and to give rich shadows to white linen.

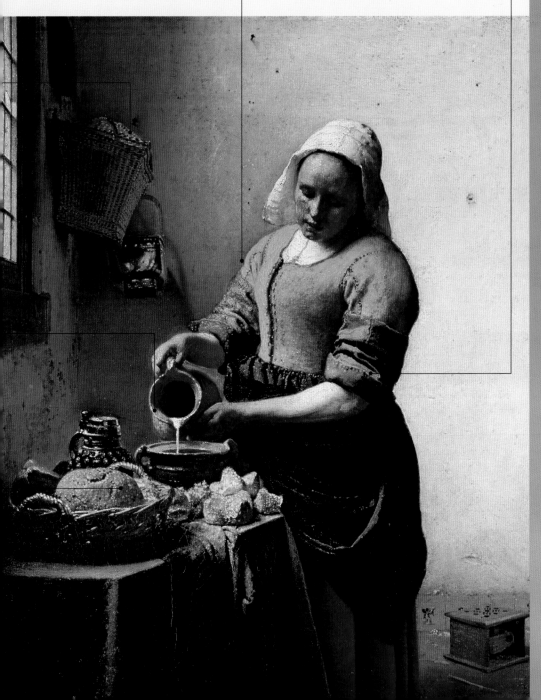

RELATED TOPICS/ARTISTS
VIEW OF DELFT, PAGE 127

Fête & Carnival

During the early 18th century, the contrast between the scenes of an aristocratic and leisured idyll painted by such artists as Jean-Antoine Watteau contrasted with the simple domestic scenes by Jean-Baptiste-Siméon Chardin. In Venice, too, representations of carnival and festivals were popular. In Britain, the domestic setting and everyday scenes were appropriated by William Hogarth to make witty and satirical observations on contemporary morals and society.

Masked Revellers

At the height of its hegemony over the Eastern Mediterranean trade routes throughout the 15th century, and in its struggles for power in Italy during the 16th century, the Venetian Republic formalised a great political, social and cultural tradition. Art was central to representations of its heritage and status. As trade routes to America and the East opened up beyond Venice's influence, and the Ottoman Turks ate away at its territories, its power and economy declined. By the 18th century, Venice had little left but the celebrations of past glory and the ghosts of its once dynamic traditions. Paintings by Pietro Longhi, Francesco Guardi and Canaletto of the carnival and festivals, such as the *Festa della Sensa* (symbolising the doge's union with the sea on Ascension Day), renewed memories of past times and were popular with the consumers of Venice's new industry – tourists.

■ PIETRO LONGHI (1702–83)
Masked Venetians (Il Ridotto)
1740s, Raccotta Salon, Venice.

Dressed for carnival, Venetians met in theatre or opera foyers (il ridotti) to see and be seen in their splendid masks and costumes. Longhi's light touch captures the colours and richness of the scene, but also the slightly dubious-looking card game in the background.

Gentlewomen and Gentle Women

One of the unmistakable features of genre painting is the representation of women. Whether depicted as the hard-working country wife, the dutiful maidservant, the well-dressed merchant's wife or in the rich silks of the aristocrat, women were among the most regular figures to appear in everyday scenes. Their importance was to underpin their value to society through their roles as wives, homemakers and mothers, contributing to family stability and status. They were occasionally depicted employed in suitable occupations, obviously as servants, but also as lace-makers, cooks, musicians or shopkeepers. They were depicted engaged in less salubrious employment surprisingly rarely before the 18th century, and even then, infrequently. These depictions demonstrate the status and position of women, which was subordinated to, and supportive of, the patriarchal social structures of family and household.

Chardin's genre paintings of women continue this tradition, with representations of them in the nurturing roles of schoolmistress, servant, nurse or governess. Compared with Watteau and

Jean-Honoré Fragonard's elegant, playful ladies, Chardin's women are plainly dressed and dutiful. In *The Prayer Before the Meal* (before 1740), a well-dressed child sits at a table being encouraged to say her prayers by an older child and a mother or governess. Although the room is dark and austere, there are signs of wealth in the form of the elegant chairs and neat table setting. The woman is represented as being dutiful and submissive, and the children as being well-behaved and caring – the perfect family scene.

Marriage of Convenience

Women's roles were more explicitly observed and satirised in Hogarth's work, most memorably, perhaps, in *A Harlot's Progress* (1732) and *Gin Alley* (1750–51), in which dissolute women were lambasted. In the series *Marriage à la Mode* (c.1743), and in *The Marriage Contract* (early 1730s), a wealthy merchant contracts a socially advantageous marriage for his daughter, regardless of the consequences. The surrounding art objects in *The Marriage Contract* seem to suggest that the daughter is simply another possession to be traded – which, of course, she was during the 18th century. In *Marriage à la Mode*, the marriage goes from bad to worse as the husband visits prostitutes, the wife takes a lover and all three die tragically.

▌ WILLIAM HOGARTH (1697–1764)
The Marriage Contract early 1730s
Ashmolean Museum, Oxford.

The wealthy man in the centre is joining his daughter's hand with the aristocratic young man's. He, dressed in rich silk, is more interested in placing a bet, however, presumably with his newly acquired funds, than in his future wife. The crowd in the background could be viewers preparing for the auction of the aristocrat's bankrupt estate.

APPRECIATING...

Genre painting diversified during the early 18th century as everyday subjects became popular beyond the Dutch Republic. The role of women in these paintings, while always important, became particularly central to the themes of this period. In France, aristocratic and dutiful women were popular subjects, whilst Hogarth's satirical paintings and prints focused on the deplorable aspects of women's status in marriages of convenience.

RELATED WORKS

- **Jean-Antoine Watteau** *Pilgrimage to Cythera* 1717, Charlottenburg Palace, Berlin.
- **Jean-Baptiste-Siméon Chardin** *The Young Schoolmistress* c.1736, National Gallery, London.
- **William Hogarth** *Marriage à la Mode* c.1743, National Gallery, London.
- **Pietro Longhi** *The Rhinoceros* 1751, Ca' Rezzonico, Venice.

▌ JEAN-BAPTISTE-SIMÉON CHARDIN (1699–1779)
The Prayer Before the Meal pre-1740,
Musée du Louvre, Paris.

Chardin's soft painting style and muted tones capture the warmth of the scene. Reds and browns contrast with a subtle dark grey in the woman's apron, the older child's bonnet, the drum and the stripes on the chair backs. Chardin has carefully unified the image.

Looking Forwards & Backwards

Through the late 18th century, the subjects of genre painting continued to diversify. Until the French Revolution, the art of the Court continued to hold sway in France. In England, representations of animals – especially horses and dogs – became popular. Artists drew on subjects from the Enlightenment to represent advances in science and industry, while renewed interest in the Classical world was represented in gallery paintings.

Love in the Park

Jean-Honoré Fragonard painted many scenes of aristocratic ladies and gentlemen enjoying the pleasures of courting and love-making. His distinctive style was particularly suited to floral bowers, rich satin dresses with numerous petticoat layers, fine jackets in bright, expensive colours and the frothy vegetation of the idyllic landscape. The vibrant peach-satin dress of the lady in *The Swing* (1767) contrasts with the blue-green foliage and the grey clothes of her suitors. Her pert little face is a picture of empty-headed pleasure. By contrast, Jean-Baptiste Greuze continued Chardin's tradition of representing domestic scenes, albeit employing a more melodramatic and exaggerated style. In his works, women were depicted in more tragic or deplorable circumstances.

APPRECIATING...

While the artists of the French Court were capturing the pleasures and amorous pursuits of a doomed society, elsewhere, artists and patrons looked to the future of science and industry for inspiration. This was a watershed for society and culture as the values of the past centuries were replaced with new ideals. The advent of the modern world would be represented most clearly in the paintings of everyday life of the next century.

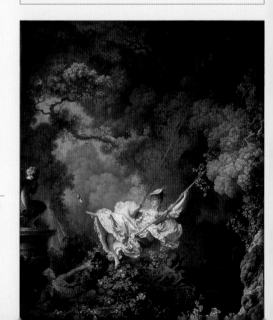

 JEAN-HONORÉ FRAGONARD (1732–1806)
The Swing 1767, Wallace Collection, London.

Possibly one of Fragonard's best-known images, The Swing *encapsulates the world of the French Court during its last decades. The richly dressed figures cavort in a garden, surrounded by statues of Cupid. Fragonard captures the provocative moment when the lady's skirts billow out and the suitor looks up adoringly – the effect is not subtle, but amusing.*

RELATED TOPICS/ARTISTS
ORIENTALISM, PAGE 33 AND PORTRAITS, PAGES 46–47

▌ JOSEPH WRIGHT OF DERBY (1734–97)
A Philosopher Lecturing on the Orrery (Mechanical Planetary) 1766, Museum and Art Gallery, Derby.

Wright's paintings explored the effects of artificial light, both in terms of the colours and highlights that it created and experimentation with unusual light sources. Here, the candlelight at the centre of the scene illuminates the awed faces and focuses the viewer's attention on the planetary instrument.

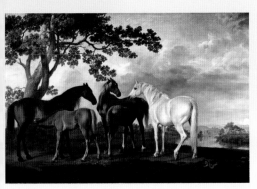

▌ GEORGE STUBBS (1724–1806)
Mares and Fillies 1763–68, Tate Britain, London.

The 18th century was the era of the portrait in Britain, and that included the wealthy landowner's horses. Stubbs was the leading horse painter of the century, and was skilled at capturing the sleek coat, well-defined muscles and fine bearing of the animal that was so important to the gentry.

RELATED WORKS
- **George Stubbs** *Whistlejacket* c.1762, National Gallery, London.
- **Joseph Wright of Derby** *The Experiment on a Bird in the Air Pump* 1768, National Gallery, London and –*The Iron Forge* 1772, Tate Britain, London.
- **Jean-Baptiste Greuze** *The Broken Mirror* 1763, Wallace Collection, London.
- **Johann Zoffany** *The Tribune at the Uffizi* 1772–78, Royal Collection, Windsor.

KEYWORDS

Chinoiserie as trade with the East grew during the 17th century, goods from China became increasingly popular and common in western Europe. Additionally, decorative goods were specifically made in China for the Western markets. Images of the East fascinated Europeans, and local manufacturers began to create designs containing Eastern motifs (for example, willow pattern); this was called 'chinoiserie'. Fantastical oriental elements were also incorporated into paintings, including Eastern costumes, pagodas, fans, fabrics and porcelain.

Science and Industry

Joseph Wright of Derby came from the Midlands and chose to mark his origins in his name at the beginning of the Industrial Revolution that was transforming that region of England. In addition to scientific scenes, such as *A Philosopher Lecturing on the Orrery (Mechanical Planetary)* (1766) and *The Experiment on a Bird in the Air Pump* (1768), he painted industrial subjects, for example *The Iron Forge* (1772). His patrons included the major industrialists Josiah Wedgwood and Richard Arkwright. In reflecting changes in science and industry, Wright chose innovative subjects to depict, and his style – often using an artificial light source – was also appropriately novel. In his paintings, a new society can be seen emerging, one centred on the Midlands and the north that was concerned with progress, science and modernity.

A Man and his Horse

George Stubbs studied equine anatomy in great detail to produce his intensely naturalistic depictions of horses. As well as capturing the fine qualities of the horses he painted, he represented individual animals with great sensitivity. Country gentlemen always owned a horse, and the English passion for the animal extended to horseracing. Stubbs' skill meant that his horse portraits were in great demand – his portrait *Whistlejacket* (c.1762) depicted a famous racehorse that won the 2000 Guineas in 1759; the portrait was commissioned by its owner, the 2nd Marquess of Rockingham. The details of its hair, veins, soft muzzle and mane are precisely painted, but most dramatic of all is the bright white in the horse's eye, which captures its nervous energy and character.

Politics & Modernity

During the 19th century, painting scenes of everyday life became the central aim of artists, both in France and in England. Artists rejected the constraints and values of the academy in pursuit of subjects that had greater perceived social or political relevance. Both the style of representation and the scenes depicted were increasingly directed towards the modern world.

RELATED WORKS

- **Francisco de Goya y Lucientes** *Majas on a Balcony* 1800–14, Metropolitan Museum of Art, New York.
- **William Powell Frith** *Life at the Seaside (Ramsgate Sands)* 1854, Royal Collection, St James's Palace, London.
- **Jean-François Millet** *The Gleaners* 1857, Musée d'Orsay, Paris.
- **Honoré Daumier** *Crispin and Scapin* 1858–60, Musée d'Orsay, Paris.
- **Edgar Degas** *Mlle La La at the Circus Fernando* 1879, National Gallery, London.
- **Vincent van Gogh** *The Potato Eaters* 1885, Vincent van Gogh Foundation, Rijksmuseum Vincent van Gogh, Amsterdam.
- **Walter Sickert** *The Old Bedford Music Hall* c.1885, Walker Art Gallery, Liverpool.

APPRECIATING...

The opportunities of the modern world and the rising middle classes provided the context for new forms of art that rejected the strictures of the academy and sought to depict life as it was. Everyday scenes now became the main subject of painting across Europe, whether exploring social issues, making political comment, depicting people at leisure or observing the seedy side of life.

Realism and Hardship

In France, artists of the Barbizon School (*see page 131*) and the Realists painted subjects and scenes with sharp political and social messages. Gustave Courbet's *The Stonebreakers* (1849) and Jean-François Millet's *The Gleaners* (1857) represented the hardships and working conditions of the poorest members of society. Considered shocking by some contemporary art commentators, these artists had chosen powerfully evocative and uncompromisingly realistic representations that contrasted radically with the élite and idealised paintings of the Salon. In England, such artists as Ford Madox Brown, Henry Wallis and Luke Fildes also represented subjects that questioned social structures and conditions.

Modern Pleasures

The Industrial Revolution brought prosperity to new strata of society in Europe, and a rising middle class (the *bourgeoisie* in France) had new interests

▌ GUSTAVE COURBET (1819–77)
The Stonebreakers 1849, destroyed, formerly Gemäldegalerie, Dresden.

Courbet has captured the punitive labour involved in breaking stones for new road surfaces, emphasising the back-breaking hardship, the futility of such a menial job and the ragged state of the labourers. Henry Wallis' work of the same title depicts a labourer lying dead beside the road.

■ WILLIAM POWELL FRITH (1819–1909)
The Opera Box 1855,
Harris Museum and Art Gallery, Preston.

The opera goer was a popular subject. Frith's representation captures the slight boredom on the woman's face.

KEYWORDS

Juste milieu art of the middle ground deploying both innovative and traditional elements for example, artists of the Barbizon school, Boudin and Jongkind.

RELATED TOPICS/ARTISTS
BARBIZON SCHOOL, PAGES 130–31; INGRES, PAGES 32 AND 51; SALON, PAGE 99

■ MARY CASSATT
(1844–1926)
Mother and Child 1896,
Musée d'Orsay, Paris.

The restricted world of female Impressionist artists meant they often painted interior and family scenes. Cassatt captured mothers and children with cleverly observed sensitivity. The accurate depiction of the child's expression and awkward pose draws the viewer into the intimate scene.

events like Derby Day through to more intimate moments of everyday life including melodramatic interpretations of Victorian society.

Social Observation

As well as Parisians at leisure, such artists as Edgar Degas and Toulouse-Lautrec sought out more intimate subjects in café-concerts (cafés with musical entertainment), opera, ballet, bars and street scenes. The vibrancy and colour of these scenes highlighted the voyeurism and seediness of observing performers and customers involved in the shared spectacles of *fin-de-siècle* (French for 'end of the century') entertainment. Toulouse-Lautrec's style of representation – highly exaggerated figures from the bars that he frequented – often pointed to caricature. His close intimacy with this world suggests a satire on its nature and on his own obsession with it.

and pleasures. The advent of the railway allowed easy travel to the coast and leisure facilities in cities' suburbs, and with mass-produced manufacturing, consumer goods flooded the shops. The Impressionists not only rejected the rigidity of highly refined painting styles, such as Jean-Auguste-Dominique Ingres' (*see pages 32 and 51*), to explore fleeting impressions of light and colour, but also chose to represent scenes of modernity rather than remote, mythological subjects. Many of the Post-Impressionists, including Georges Seurat, Vincent van Gogh and Henri de Toulouse-Lautrec, also explored different aspects of contemporary life. These artists captured men and women out and about, enjoying their new-found leisure, wearing off-the-peg fashions and pursuing the pleasures of dancing, drinking, swimming and promenading.

In Victorian Britain, too, such artists as William Powell Frith, George Elgar Hicks, Emily Mary Osborn, Hubert von Herkomer and Frank Holl painted contemporary scenes. These ranged from large crowd scenes commemorating social

■ HENRI DE TOULOUSE-LAUTREC
(1864–1901)
The Englishman in the Moulin Rouge
1892, Staatliche Kunstsammlungen, Dresden.

With a few well-placed brushstrokes, a splash of colour and the line of a dress, Toulouse-Lautrec has captured the essence of the Moulin Rouge. Almost all of his paintings explore such scenes of adult titillation, self-indulgence and excess, doing so with vibrancy and intimacy.

1900 to the Present

'The painting has a life of its own.

I try to let it come through.'

JACKSON POLLOCK (1912–56)

QUICK ARTISTS REFERENCE

Towards abstraction Umberto Boccioni,
André Derain, Samuel John Peploe, Pablo Picasso

Abstraction and Modernism Vassily Kandinsky,
Kasimir Malevich, Jackson Pollock, Mark Rothko

Dada and Surrealism Giorgio de Chirico, Salvador Dalí,
Max Ernst, René Magritte

New realisms Isaac Brodsky, David Hockney, Pablo Picasso

Pop Art Richard Hamilton, Roy Lichtenstein, Andy Warhol

Minimalism Sol LeWitt, Bridget Riley, Frank Stella

Plurality and Postmodernity Tracey Emin,
Anselm Kiefer, Jenny Saville

The 21st century and beyond Anish Kapoor,
Gerald Laing, Marc Quinn

In previous centuries, stretching back to Classical times, painting on a two-dimensional surface was concerned with representing figures and objects from the real world. The degree of naturalism varied, with the imitation of three-dimensions achieving its peak with single-point perspective and *trompe l'oeil*, yet what the artist sought to represent was almost always evident. At the end of the 19th century, Paul Cézanne challenged such naturalism by exploring the surfaces, colours and textures of objects rather than their appearance. This led to a radical revision of aesthetic values, and to the concept of painting. It was also accompanied by a growing awareness of the artifice involved in conventional representation.

During the early 20th century, artists and critics increasingly considered what it meant to paint, and what the aims and values of painting should be. Art exploded in numerous new directions during the 1900s, following the innovations and challenges initiated by the Post-Impressionists *(see pages 114–15)*. Artists across Europe formed avant-garde movements that sought new artistic goals and values. The rules of the academy had long since been discarded, and instead they sought inspiration from their predecessors and contemporaries to construct new principles for aesthetic practice.

The succession of avant-garde movements during the first decades of the century changed the form and style of painting very quickly. Within a few years, painting encompassed a spectrum of styles, from figuration to total abstraction. Eventually, the critical acclaim achieved by painting during the 1950s contributed to its downfall as new artists, in their turn, rejected its hegemony and used other art media to explore innovation and meaning.

In parallel to this diversification of painting practice were challenges to the broader concept of art and its role in society. The political and social upheavals of World War I, the Russian Revolution, the economic depression of the 1930s and World War II brought new political ideas and ideals to prominence, which in turn influenced painting. The rise of post-war consumerism and the challenges to traditional ideas of gender, identity, social structure, politics and global relationships provided new contexts both for painting specifically and for art generally. At the beginning of the 21st century, painting remains a central art practice, and its forms are more diverse than ever.

Art Theories During the 20th Century

The 20th century saw a number of theories develop that were critical to painting and its interpretation. Central to these were questions about how to assess the aesthetic qualities of a work of art. In previous centuries, the academy had defined the system that determined the artistic (and economic) value of art. With this framework gone, theorists began to seek new criteria and methods for understanding aesthetic value, particularly the qualities of painting.

■ SAMUEL JOHN PEPLOE (1871–1935)
The Luxembourg Gardens 1923,
Private Collection.

Peploe was a Scottish Colourist who drew on innovations in France, especially those of Édouard Manet and Paul Cézanne. The fragmentation of the image, the strong contrast and the bright colours are typical of his work.

Formalism: Immediate Aesthetic Judgements

The evaluation of a work of art begins with a close analysis of its formal qualities: colour, line, texture, tone, form and so on (*see pages 12–13*). This is concerned with exploring the material qualities of a painting before considering its subject or meaning. In 1910, Roger Fry organised an exhibition in London entitled 'Manet and the Post-Impressionists'. It was followed by a second exhibition in 1912, and both featured works by Paul Cézanne, Paul Gauguin and Vincent van Gogh. These exhibitions galvanised Fry and his Bloomsbury Group colleague, Clive Bell, to argue that the formal qualities of a painting determined its aesthetic impact. In other words, the judgement of a painting's artistic value was based entirely on its formal qualities, and was not dependent upon subject or content. This judgement was understood to be intuitive and spontaneous.

Modernism: New Art for a New Century

Such theoretical revisions were paralleled by innovations in painting across Europe, in which avant-garde artists began to explore the construction of the image on the canvas. The term 'modernism' is used to refer to this avant-garde art, and to the innovations that followed during

the 20th century. The progression to complete abstraction was swift, with artists and movements exploring different concepts and forms of the two-dimensional image. Many modernist artists and theorists also believed that this new language of art could play a beneficial role in society; that art could be a force for the improvement of social conditions was of particular concern during the years of economic depression between the wars.

Fry and Bell's formalist theories, and the rise of abstraction, were supported during the late 1930s by the American art critic Clement Greenberg. Greenberg took their theories further, arguing for a polarised view of avant-garde art. At one end was kitsch – art produced for a commercial and mass culture – and at the other was abstract art, which had an aesthetic, a cultural and an ideological purity. Greenberg considered that the best abstract art had the potential to create a heightened

aesthetic experience. For its refusal of figuration abstract art was regarded as the preferred form of painting. Greenberg saw the fulfilment of this ideal in the work of the American Abstract Expressionists, and particularly in the drip paintings of Jackson Pollock. Greenberg's critical, and, for a time, hegemonic concept was called Modernism.

The rise of abstract art in the United States after World War II was also partly a reaction to the realist propaganda art of the Soviet Union and Fascist regimes of Europe (*see pages 164–65*). Figurative art was perceived as being fundamentally compromised in its illusory power and simulated realism. However, Greenberg's criteria for artistic value were restrictive, and the 1960s generation of artists rejected it in pursuit of a spectrum of new artistic engagements and interventions.

Postmodernism: No Limits

The belief that there was a fixed set of artistic and aesthetic values, determined first by the academies and then reconstructed within the framework of Modernism, had finally been abandoned by the 1960s. Several art movements, including Land Art, Pop Art and Minimalism, rejected Greenberg's Modernism to explore art beyond traditional painting and sculptural techniques. The diversity of media, meaning and context undermined the idea of only one all-encompassing system for judging the value

and quality of art. In the 1970s, a new term was coined in recognition that culture and society, including art, had moved away from Modernism: Postmodernism.

During the 19th and early 20th centuries, new concepts had developed that explored humanity in great depth. Sigmund Freud developed theories of psychoanalysis and the framework of the mind (the psyche); Marx and Engels set out their ideas for economic, social, cultural and political emancipation; and other theorists explored the origins of knowledge and language. Jean-François Lyotard questioned the relevance of these all-encompassing value systems, identifying a sensibility that treated claims of transcendent cultural value or meaning with scepticism. Since the 1960s, artists have used these new theories to frame their work, and art historians to explain developments in art. The resulting artistic landscape in Europe, the United States and the wider world is extremely diverse, but painting still provides a medium for artistic expression.

▌ **JACKSON POLLOCK** (1912–56)
Alchemy 1947, Penny Guggenheim Collection, Venice.

Pollock's painting style involved dripping paint, or pouring it from the can, onto the canvas placed on the floor without a frame. Pollock layered paint using the wrong end of the brush to stream paint onto the surface. His paintings have both freedom and control, which contribute equally to the visual impact of the image.

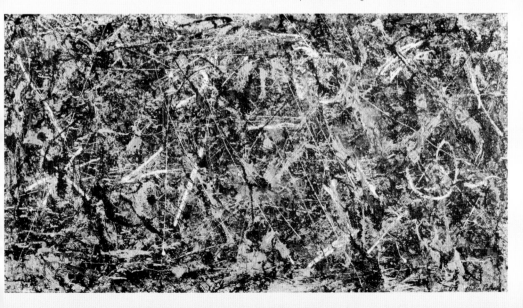

RELATED TOPICS/ARTISTS
PAUL CEZANNE, PAGES 115 AND 135

The Flattened Image

Artists' groups in the 1910s created visually stimulating and decorative images concentrating on colour relationships, line and form instead of naturalistic representation. Some, like Vassily Kandinsky, were involved in several groups. Between 1907 and 1914 Pablo Picasso and Georges Braque developed the principles of Cubism.

KEYWORDS AND MOVEMENTS

Fauvism (French for 'wild beasts', c.1905–8) artists in France who painted vibrant scenes with complementary and non-naturalistic colours.

Expressionism (including *Die Brücke*, German for 'the Bridge', c.1905–11, and *Der Blaue Reiter*, 'The Blue Rider', 1911– 14) artists used colours to express meaning and emotion, mostly in observing pre-war society.

Futurism (1909–14) and **Vorticism** (c.1913–1920s) the Italian Futurists painted dynamic representations of the modern world with a so-called 'machine aesthetic'. In England, the Vorticists followed the Futurists, creating angular and dynamic-looking images.

The Legacy of the Post-Impressionists

The 'Post-Impressionists' took the freedoms created by the Impressionists to develop their own artistic individuality. The ideas of Paul Cézanne, Georges Seurat, Vincent van Gogh and Paul Gauguin influenced the avant-garde across Europe, the United States and Russia. Their use of colour, exploration of form, rejection of naturalistic representation and innovative painting techniques stimulated new experimentation and subject matter.

Cubism: Seeing the World Anew

The invention of Cubism by Braque and Picasso went through stages in which the image became increasingly fragmented and distorted. The catalyst for this artistic 'dialogue' was Picasso's *Les Demoiselles d'Avignon* (1907), in which the elements of nearly nude women were manipulated in planes of colour. Braque responded with *Large Nude* (1907–8), using simplifications of shape, colour and tone. This early stage was also applied through 1908 to landscapes, in which blocks of colour represented buildings and trees. During 1909 and 1910, images became more incomplete, emphasising shapes with tonal and colour variations. By 1910, shapes had begun to break up and merge, so that the outline and form of the

▌ ANDRÉ DERAIN
(1880–1954)
Collioure 1905, Scottish
National Gallery of
Modern Art, Edinburgh.

The Fauves used bright complementary colours (for example, blue and orange), sometimes straight from the tube, to capture the vibrancy of hot sparkling landscapes. The thick brushstrokes and bold blocks of colour flatten the image reducing the elements to shapes. As the group developed, the colours became increasingly non-naturalistic and exaggerated.

■ PABLO PICASSO (1881–1973)
Les Demoiselles d'Avignon 1907,
Museum of Modern Art, New York.

*Picasso explored the construction of images from different
perspectives. The angular faces draw on the stylised and
geometric forms of African masks. The soft flesh pinks and
blue drapes silhouette the figures, at once emphasising and
negating their nudity.*

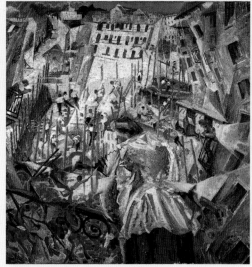

■ UMBERTO BOCCIONI (1882–1916)
The Street Enters the House 1911,
Kunstmuseum Hanover, Hanover.

*The Futurists celebrated the modern world of machines and
technology representing buildings, vehicles and industry as
well as the speed and energy they embodied. World War I
brought new perspectives on technology and disillusionment
resulted in many artists rejecting this ideal after the war.*

original objects faded. In 1911, colour and tonal
qualities of the shapes dominated, and the objects
receded further, until eventually, from 1912, object
elements were rearranged on the canvas to form
new relationships. During the last stage, 1912–1914
(when the works were collectively termed Synthetic
Cubism, as opposed to the Analytical Cubism period
c.1908–12), fragmentary elements of objects moved
in and out of focus on a surface that appeared
entirely flat. Later in life, Braque believed that
Cubism had freed painting from false illusionism,
paving the way for total abstraction.

The Avant-garde: Looking to the Future

The artistic movements of the early 20th century,
and those that followed them, have been
termed 'avant-garde', referring to innovative
and forward-looking practices. There have been
successive avant-garde waves, each building on,
or challenging, its predecessors. In the years
before World War I, the avant-garde movements
maintained a tenuous contact with the represented
object, but challenged its form and colour.

APPRECIATING...

Artists of the pre-war period challenged ideas of
representation, exploring the colour and forms
of painted objects. The emphasis on colour, tone
and shape centred artistic attention on the two-
dimensional surface of the canvas as the last vestiges
of naturalistic representation were abandoned.

RELATED WORKS

- Fauvism – **Henri Matisse, Derain, Raoul Dufy,
 Maurice de Vlaminck, Georges Braque, Kandinsky.**
- Expressionism – **Ernst Ludwig Kirchner, Egon Schiele,
 Karl Schmidt-Rottluff, Georges Rouault, Emil Nolde,
 Edvard Munch, Kandinsky, Franz Marc, Paul Klee.**
- Cubism – **Picasso, Braque, Juan Gris, Fernand Léger.**
- Futurism – **Umberto Boccioni, Filippo Tommaso
 Marinetti, Giacomo Balla, Gino Severini.**
- Vorticism – **Percy Wyndham Lewis, David Bomberg,
 Christopher Wynne Nevinson, Henri Gaudier-Brzeska.**
- **Mikhail Larionov, Natalya Goncharova, Marc
 Chagall, Amedeo Modigliani.**

RELATED TOPICS/ARTISTS
THE POST-IMPRESSIONISTS ON PAGES 69, 85, 114, 115, 135 AND 153

The Achievement of Total Abstraction

Vassily Kandinsky is sometimes credited with creating the first abstract painting in 1910. He claimed to hear music when he saw colours that influenced his colour juxtapositions, shapes and aesthetic relationships. His early abstract compositions feature geometric and organic coloured shapes, which move across the canvas with rhythmic intensity. Driven by his inner sense of colour, his abstract paintings went through several stages that explored different forms of line, colour and spatial relationships.

APPRECIATING...

Abstract painting developed through the rejection of figurative forms, focusing instead on colour relationships, shapes and lines. It was also associated with the principles of modern design and architecture. In New York after 1945, abstraction was used as a means of personal expression, and to underscore the United States' claims of increasing cultural autonomy from Europe.

The 'Zero of Form'

In Russia, the impact of Post-Impressionism combined with native art forms, such as icons and the *lubok* (a satirical print), to stimulate innovations in art that explored representation and form through the 1900s. In 1913, Kasimir Malevich drew upon Synthetic Cubism to paint Suprematist works before abandoning figurative painting, as is evident in his first *Black Square* (c.1913). At the '0.10' (zero–ten) exhibition in 1915, he declared his Suprematist system with a series of geometric paintings in simple colours, inspired by his designs for the opera *Victory Over the Sun* of 1913. In the accompanying pamphlet, he wrote, 'I have transformed myself *in the zero of form*' (quoted in Harrison and Wood, 1992, 2003). Progressing from colours, he painted a *White on White* series from 1917 to 1918.

As the new Soviet regime took control after the Russian Revolution in 1917, Malevich, with other artists, including Vladimir Tatlin, was involved with Constructivism, a movement that sought to develop a new art for a new era. The movement created posters, models, designs and paintings with geometric forms in primary colours (often red and black). It was ultimately suppressed during the late 1920s by Soviet cultural policy, which favoured the propaganda potential of realist art (*see pages 164–65*).

Abstract Principles, Forms and Design

Many artists developed abstract forms of painting during the early decades of the 20th century. The relationships between the primary colours (red, yellow and blue) and the secondary colours (orange, purple and green) offered a new language of expression. In Germany, the Bauhaus was concerned with matching function, design and modern materials, employing basic colours and

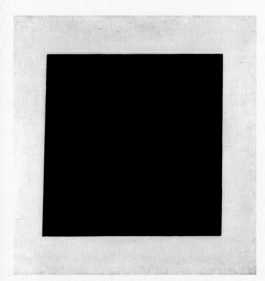

█ KASIMIR MALEVICH (1878–1935)
Black Square c.1913,
Russian State Museum, Saint Petersburg.

Black Square was hung across a corner at the '0.10' exhibition, emulating the position of a Russian icon. Malevich perceived his Suprematist art as having a new dynamic centred on geometric shapes and colours that offered a radical alternative to past art forms.

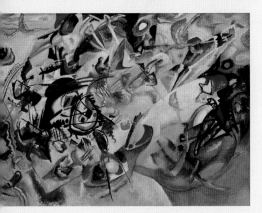

VASSILY KANDINSKY (1866–1944)
Composition VII 1913, Tretyakov Gallery, Moscow.

Kandinsky claimed that this was his most complex painting, with multiple forms and colour relationships. As the viewer's eye moves across the canvas, colour elements and shapes come forward and recede, sometimes blending, sometimes contrasting. The colours and shapes have a logic that is difficult to explain, but hard to ignore.

KEYWORDS AND MOVEMENTS

De Stijl (Dutch for 'The Style', c.1917–31) an artistic movement in the Netherlands concerned with theories of colour, geometric abstraction and design.

Bauhaus (1919–33) founded by Walter Gropius in Dessau, Germany, the Bauhaus school of art and architecture taught functional design principles. It was dissolved in 1933 when the National Socialists came to power under Hitler. Some of those involved moved to the United States.

Post-Painterly Abstraction a movement comprising the next generation of abstract artists after the Abstract Expressionists.

forms in its work. In France, Le Corbusier (1887–1965) developed art and architectural theory, which defined rules to harmonise modern design principles for mass-produced objects.

Abstract Expressionism and the Colour Field

The term 'Abstract Expressionism' was first used in the United States in 1945 to describe the work of a group of New York artists. Promoted by art critics Clement Greenberg and Harold Rosenberg, artists like Jackson Pollock (*see page 157*), Barnett Newman, Clyfford Still and Willem de Kooning dominated the early post-war era. Their abstract works were interpreted as an expression of inner emotions rather than the logical design principles of pre-war abstraction. Some of these artists had painted figurative works before turning to abstraction (Pollock had explored Native American art). The colour-field artists like Rothko used contrasting colours, textures and layering to create a sense of pulsing movement and depth.

RELATED ARTISTS

- Suprematism and Constructivism – Kasimir Malevich, El Lissitzky, Vladimir Tatlin, Liubov Popova, Alexander Rodchenko.
- De Stijl – Piet Mondrian, Theo van Doesburg.
- Bauhaus – Walter Gropius, Ludwig Mies van der Rohe, László Moholy-Nagy, Vassily Kandinsky.
- Abstract Expressionism – Jackson Pollock, Arshile Gorky, Mark Rothko, Barnett Newman, Clyfford Still, Lee Krasner, Willem de Kooning, Robert Motherwell.
- Post-Painterly Abstraction – Robert Ryman, Helen Frankenthaler, Joan Mitchell, Cy Twombly.

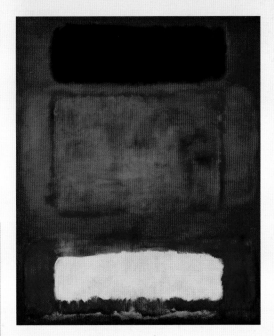

MARK ROTHKO (1903–70)
Red, White, Brown 1957, Kunstmuseum, Basel.

Rothko's typically monotonal or limited colour range works appear deceptively simple. The bleeding superimposed colours give the image depth.

RELATED TOPICS/ARTISTS
JACKSON POLLOCK, PAGE 157

Challenges to the Concept of Art

In 1915, Marcel Duchamp displayed a bicycle wheel mounted upside down on a stool at an independent exhibition. He later termed such objects, which included a urinal titled *Fountain* (1917) and *Bottlerack* (1914), 'readymades'. The term signified his rejection of the principle that art was limited to traditional art-making processes and related ideas of the pictorial. Duchamp's innovation paved the way for Dada's subversive, object-based practice and its aftermath.

❚ RENÉ MAGRITTE (1898–1967)
The Human Condition II 1935,
Museum Mme Harpe-Lorge, Brussels.

Magritte's illusionistic images explore human perception and consciousness. He particularly engaged with deceptive images and the tricks of human perception. What is real and what is illusion? Can we tell the difference? A painting within a painting sets out these challenges.

KEYWORDS & MOVEMENTS

Dada (1916–c.1922) founded as an anarchistic reaction to avant-garde idealism and the horror of war, Dada's principles of disruption, contingency, nihilism and unpredictability meant that it was not a movement. The title itself is a made-up word with no meaning. Dada became a loose group of anti-art artists and writers initially based in neutral Zürich, at the Café Voltaire, and subsequently in New York, Berlin and Paris.

Surrealism (from c.1922) the exploration of the mind in painting had long-established roots in Romanticism (*see pages 80–83*), and in Symbolism (*see pages 84–85*). During the late 19th century, Sigmund Freud developed the theory of the unconscious mind containing hidden urges, desires and experiences. Surrealist artists sought to explore the unconscious through automatic drawing and the visual expression of dreams and dream-like states.

Rejecting Art

World War I created disillusionment for many artists. Several died in the conflict, including Gaudier-Brzeska (a Vorticist), Boccioni (a Futurist) and Marc (an Expressionist). Others responded with war art, including Wyndham Lewis, Paul Nash, Augustus John, Singer Sargent and Otto Dix. For many, the ideals of the pre-war period were destroyed.

Initiated in Zürich in 1916 by Tristan Tzara, Dada provided artists with a platform from which to challenge academic and avant-garde values. Fundamentally anarchistic, Dada was initially a reaction to the horrors of war, and to the systems that caused it. Dada art, poetry and performances were not 'organised' or cohesive, but a personal expression of anger, satire, criticism and negation.

Art and the Unconscious

Surrealism (from the French *surréalisme*, meaning 'super-realism', that is, above or beyond realism)

APPRECIATING...

Dada and Surrealism paralleled developments in abstraction during the first half of the 20th century. Their challenges explored the irrational, subverting more conventional ideas of representation in response to the social and political upheavals of the period.

▌GIORGIO DE CHIRICO (1888–1978)
Metaphysical Composition 1913,
Sidney Hillman Foundation, New York.

The Surrealists admired de Chirico's disturbing paintings. The low-lit, desolate spaces contain object assemblies of half-symbolic or half-human forms. The metaphysical, mental or philosophical allusions create silent visions which defy simple symbolic interpretation.

emerged out of Dada. Artists were drawn to its first manifesto, issued in 1924 by the poet André Breton, who had trained in the developing theories of psychoanalysis. He believed that automatic writing or drawing (allowing the hand to write without conscious direction) would enable access to the unconscious mind. The first Surrealist exhibition held in Paris in 1925 included works by Jean (Hans) Arp, Max Ernst and Joan Miró; the group was later joined by others, including Salvador Dalí and René Magritte.

Surrealist artists challenged and subverted the rational order of the conscious mind by representing ideas and subjects drawn from the unconscious. Their styles varied considerably, with many combining rational and irrational elements. Human forms would metamorphose into other objects, figures would be headless and limbs would float on their own. Some works represented the female body in fantasy landscapes or activities, re-objectifying the female nude within the dream world. Others explored nightmare elements, such as endless spaces, snakes, confinement, silence, death and disfigurement.

A Continuing Legacy

Surrealism inspired artists throughout the 1950s and 1960s, but Duchamp and Dada's rejection of all artistic values had a more lasting legacy. During the period after World War II, new challenges to the rigid systems that judged and valued art arose that would lead to the innovations associated with Postmodernism.

RELATED WORKS

- Dada – **Marcel Duchamp, Tristan Tzara, John Heartfield, Francis Picabia**.
- Surrealism – **André Breton, Giorgio de Chirico, Max Ernst, André Masson, Joan Miró, Jean (Hans) Arp, Man Ray, Salvador Dalí, René Magritte, Meret Oppenheim, Hans Bellmer, Yves Tanguy, Dorothea Tanning**.

▌MAX ERNST (1891–1976)
Oedipus Rex 1922, Private Collection.

This refers to Freud's theories of a child's developing sexuality: the Oedipus complex, when a male child desires his mother and wishes to kill his father. Ernst was obsessed with birds, and the motifs of the hand, animal heads, piercings and apertures may allude to sexual desires.

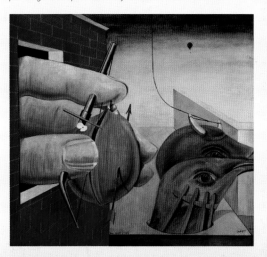

RELATED TOPICS/ARTISTS
ROMANTICISM, PAGES 80–81, AND SYMBOLISM, PAGES 84–85.

Art with a Message

Despite the move to abstraction pursued by many artists, figurative art continued to be widely made. It was employed for state-sponsored propaganda by the totalitarian regimes of Stalin and Hitler, but was also used by artists to articulate social issues and poor economic conditions. Artists across Europe and the United States responded to the experiences of severe economic depression and social instability in the period between the wars.

Socialist Realism and Propaganda

In Russia, the Constructivists' ideal for a new art for the Soviet state was gradually undermined as Stalin took power during the 1920s. Stalin believed that abstract forms were élitist and socially irrelevant; figurative art was endorsed for its propaganda purpose. A number of paintings closely associated Stalin with Lenin, legitimizing his claims to be the heir of the revolution's founder at a time when he was asserting control over the government. Isaac Brodsky's *Lenin at Smolny* (1930) typically contained a symbolic message conveying Stalin's rightful position. Abstract art was suppressed, and even artists like Kasimir Malevich were encouraged to paint figurative subjects. Art promoted political, social and economic ideals, portraying Soviet

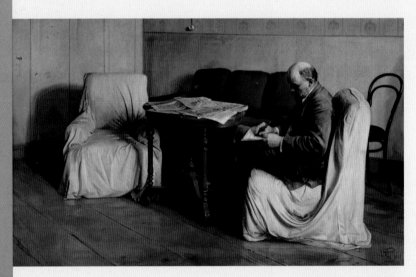

■ **ISAAC BRODSKY**
(1884–1939)
Lenin at Smolny 1930,
Tretyakov Gallery,
Moscow.

Lenin is portrayed in almost photographic detail at the school where the plans for the revolution were formulated. The empty chair – awaiting the return of Marx or Stalin – the open newspaper, Lenin's concentration and the austere setting suggest a real event. Painted six years after Lenin's death, it is a heavily symbolic image.

APPRECIATING...

The power of figuration to communicate an ideal or to capture a reality was used during the mid-20th century within a wide range of contexts. On the one hand, it was used extensively for state-sponsored propaganda, while on the other, artists employed it to represent social issues or to express critical observations.

RELATED WORKS

- Soviet Socialist Realism – **Ilya Repin, Sergei Gerasimov, Boris Vladimirsky**.
- Germany – **Otto Dix, Max Beckmann**.
- United States – **Grant Wood, Edward Hopper, Ben Shahn**.
- Mexican muralists – **Diego Rivera, José Clemente Orozco, David Alfaro Siqueiros**.
- Britain – **William Coldstream, Percy Horton, Laura Knight, Graham Sutherland, Paul Nash**.

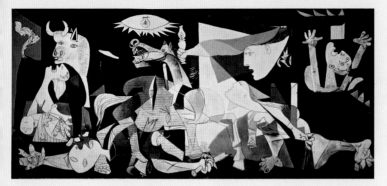

▌ PABLO PICASSO
(1881–1973)
Guernica 1937, Museo
Nacional Reina Sofía, Madrid.

*This was Picasso's response
to the German Luftwaffe's
carpet-bombing of Guernica,
requested by General Franco
during the Spanish Civil
War. The fragmentation and
screaming mouths portray the
horror of the destruction.*

citizens as happy and prosperous workers in the thriving new Soviet Union. Such images glossed over the harsher realities of life in the new Soviet state.

In Germany, under the control of National Socialism from 1933 to 1945, abstract art was also discouraged in favour of figurative styles. Posters and film drew heavily upon traditions of realism in order to emphasise the strengths and ideals of the new Germany. The use of figurative art in propaganda posters extended to Britain and the United States. Notable examples were World War I recruiting posters and anti-communist images propagated in America's McCarthy era in the 1940s and 1950s.

Alternative Viewpoints

Realism continued to be used to explore social issues. Otto Dix painted grotesque parodies of Weimar Germany's decadent society (1919–33), as well as the horrifying consequences of war. Edward Hopper's paintings captured the sparse realities of American life during the inter-war years. During the 1930s, faced with crippling economic depression and the prospect of social unrest, the Roosevelt administration sought to increase employment in socially relevant ways. One of these programmes was the Federal Art Project (FAP). For a basic allowance provided by the government, artists produced work that was then 'purchased' for schools, civic centres, clinics and museums. Although conceived as a pragmatic policy to reduce the prospect of social and political unrest, it also supported many artists who were later to make their names during the post-war period, for example, Jackson Pollock. Belief in the socially educative power of painting was widespread during this period. During the

1930s and 1940s, mural painting underwent a renaissance because it was perceived to be a relevant and accessible art form. Two of its best-known artists were the Mexican muralists Diego Rivera and José Clemente Orozco; both produced large-scale, figurative paintings that typically celebrated civic, socialist and communist themes.

▌ DAVID HOCKNEY (b.1937)
California 1967, County Museum, Los Angeles.

*As a new consumer society emerged in the United States,
the Californian lifestyle symbolised the values and ideals
of many. Hockney's swimming pools epitomise that lifestyle,
representing both its luxuries and its emptiness. The
vibrant colours and simple forms reflect the heat of the
Californian 'paradise'.*

KEYWORDS & MOVEMENTS

Soviet Socialist Realism: the officially sanctioned art form of the Soviet Union from 1934.

The Consumer Society

The reaction against the dominance of Abstract Expressionism was articulated most dramatically in Pop Art. In both the United States and Britain during the 1960s, artists rejected the principle that art should embody deep self-expression in favour of more inclusive and 'impersonal' iconography. In their different ways, Pop artists created art that at once parodied, embraced and capitalised on the symbols of consumerism, celebrity and mass culture.

■ RICHARD HAMILTON (b.1922)
Just What Is It That Makes Today's Homes So Different, So Appealing? 1956, Collection of Professor Dr Georg Kundel, Kunsthalle, Tübingen.

This collage of contemporary consumer goods, pin-up figures, television and household conveniences was intended by Hamilton to bring 'what is epic in everyday subjects' into art. The use of the word 'Pop' on the oversized lollipop makes this among the first works of Pop Art.

The Pop Image: New and Sexy

During the 1950s, Jasper Johns and Robert Rauschenberg created art works with contemporary and highly charged images. Johns' *Flag* (1954–55, Museum of Modern Art, New York) is painted in encaustic (pigment mixed with hot wax) creating a textured and refined surface. The ambiguity of the image is both challenging and superficial. Richard Hamilton's works aimed to broaden the appeal of art by making it witty, glamorous and fun. The use of well-known imagery was not intended to be critical, but to target popular tastes and to have mass appeal.

'Fifteen Minutes of Fame'

In the United States, the attractions of the consumer society, fuelled by low-cost household and mass-media goods and appliances, were both familiar and exotic. American Pop artists therefore sought more exaggerated and extreme ways in which to develop the subject. Andy Warhol's paintings of familiar, household brands, such as Campbell's soup cans, Brillo boxes and Coca-Cola bottles, exploited their ubiquity, providing him with instant recognition whilst challenging the idea of art. His screenprints of photographs of famous people captured the essential superficiality of celebrity while reinforcing the iconic status of

RELATED WORKS & ARTISTS

- Neo-Dada – **Jasper Johns, Robert Rauschenberg**.
- Pop Art in Britain – **Richard Hamilton, Allen Jones, Peter Phillips**.
- Pop Art in the United States – **Andy Warhol, Roy Lichtenstein, James Rosenquist, Patrick Caulfield, Eduardo Paolozzi, Claes Oldenburg**.

APPRECIATING...

Pop Art can be seen as the first and most radical move away from Greenberg's Modernism, which laid the foundation for the emergence of Postmodernism. Its symbiotic relationship with the culture of the 1960s makes it one of the first art movements to explore and exploit a conscious awareness of the role of image-making in society.

the individual. Warhol is sometimes regarded as cynically capitalising on his own, self-generating image, with his 'factory' and mass-produced works. An alternative interpretation is that the systems of consumerism and celebrity fuelled the nature of his aesthetic practice. His perception of the public's hunger for sensation reached a climax with his repeated images of the electric chair, suicides and car crashes.

Jean Baudrillard's theory of the simulacrum informs the phenomenon of Warhol's art. Baudrillard hypothesised that there are four stages of representation – the four orders of simulacra. Each order is increasingly detached from the original image until the connection with the original is completely lost. Baudrillard believed that contemporary America was one big simulacrum. Warhol's multiple image-making can therefore be seen in the context of broader processes of social and technological change.

A Cartoon World

Roy Lichtenstein's *Big Painting* (1965, Kunstsammlung Nordrhein-Westfalen, Düsseldorf) represents paintbrush strokes enlarged to gigantic proportions. Painted in primary colours, black, grey and white on a background of Benday pattern (small dots used commercially for printing comics), the image focuses on the artificiality and actuality of acrylic paint on canvas. By turning painting into the creation of cartoon imagery, Lichtenstein exploited the exaggerated actions and formulaic responses of the cartoon world. His reproductions of large cartoons, revealing the Benday dots, and using simple colours, exclamations and comic actions on a huge scale, suggested an ironic observation of the world that they reflected.

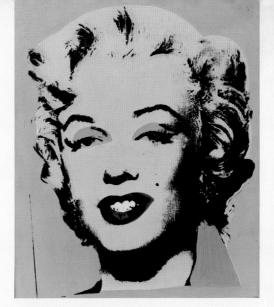

▮ **ANDY WARHOL** (1928–87)
Lavender Marilyn 1962, Uli Knecht Collection, Stuttgart.

Warhol's multi-image reproductions of Marilyn Monroe's photograph, coloured in crude, and often clashing, hues, flattered and extended the actress' fame. Her early death, in 1962, cemented her image as an icon of glamour and sexuality for the post-war generation.

KEYWORDS & MOVEMENTS

Neo-Dada the title given to Rauschenberg and Johns' works during the 1950s as they were perceived as continuing the ideas of anti-art and the use of consumer objects in art.

Pop Art this movement arose in the late 1950s as a reaction to the élitism and high ideals of Abstract Expressionism. It particularly engaged with consumer society, exploring and exploiting issues of celebrity and mass culture.

▮ ROY LICHTENSTEIN (1923–97)
Whaam! 1963,
Tate Modern, London.

Cartoon heroes battling in bloodless fights, sounds reproduced in large lettering and romantic outcomes were features of popular culture. Cartoons simplified and polarised life's ideals and Lichtenstein exaggerated the imagery with irony.

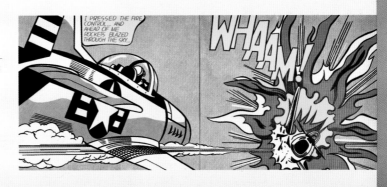

Towards the Anti-aesthetic

Minimalism was one of the first avant-garde movements to react against the tenets of Modernism during the 1960s. Among its principle concerns was escaping from the pictorial and expressive emphasis associated with painting. There was no agreement as to what 'the movement' should be called, or if, indeed, it had sufficient coherence to claim such a status. Some labels included 'ABC Art' and 'Rejective Art'. The term 'Minimalism' was applied retrospectively, but many of the artists did not like it or did not apply it to their own work.

■ **SOL LEWITT** (1928–2007)
Untitled 1972, Musée de l'Abbaye, Les Sables d'Olonne.

Simply using the contours of a folded sheet of paper, LeWitt captured the essential forms, repetition and progression of larger Minimalist works. Geometric forms were preferred by Minimalist artists, and LeWitt in particular used the square and cube.

KEYWORDS & MOVEMENTS

Installation traditional sculpture was usually displayed on a plinth, detached from the surrounding space. Installations are art works, often mixed media, that involve and mobilise the display space. They can be location-specific or independent of such concerns.

The Institutional Theory of Art proposed by the philosopher George Dickie in 1974, it has two requirements that must be fulfilled for something to be a work of art:

• The object must have been changed by human agency, although this could be the artist's selection.

• The object must have been displayed at a museum, gallery or exhibition.

Critics of the theory argue that it does not take traditional art-making skills into account or provide a qualitative basis for exploring it. It does encompass the many art forms created since the 1960s.

Op Art short for Optical Art, this exploits the way in which the eye responds to images, using forms to suggest distortion and effects of illusory movement.

Repetition and Form

Minimalist art was primarily object-based using industrial materials, such as steel and bricks. Donald Judd constructed stacks comprising metal and Perspex boxes, which were cantilevered off the gallery walls. These were typically painted using thin commercial paints in simple colours. In *Untitled* (1980, Tate Modern, London), Judd's signature stacks of boxes and intervening voids were equally spaced. These works required the spectator to engage with the object in an entirely different way from the experience of viewing paintings. They had to walk around and between the art object in order to experience it fully. Modernist critics like Michael Fried insisted that such art was merely 'theatrical' – relying upon spectacle for aesthetic effect.

Probably one of the most canonical Minimalist art works was Carl Andre's *Equivalent VIII* (1966, Tate Modern, London). This comprised eight installations of 120 firebricks, each arranged in a different way, for example, two courses of six across and ten along. Although each arrangement looked different, the height, mass and volume were always the same – equivalent. Andre's

❚ FRANK STELLA (b.1936)
Ctesiphon III 1968, Museum Ludwig, Cologne.

Stella made several works with segmented and interlocking forms. The titles allude to ancient Middle Eastern cities, including Harran and Darabjerd. The Roman numeral signifies the form: I, 'interlaces'; II; 'rainbows'; III, 'fan'.

installation de-familiarised a seemingly non-art object, forcing the viewer to challenge aesthetic preconceptions. American artist Dan Flavin experimented with fluorescent light bulbs, typically arranged in differing permutations and orders. The coloured lights illuminated walls and surrounding space, turning a whole room into a work of art. Flavin's work required the viewer to walk around the installations to appreciate their aesthetic impact. Whereas reactions to Modernist works were claimed to be spontaneous and immediate, the impact of these installations was both spectacular and cumulative.

Reshaping the Canvas

Frank Stella's early works of symmetrical lines and shapes, painted on the canvas with mathematical precision, eliminated the personal expression and symbolism associated with painting. Stella extended his work to paint on atypically shaped canvases, curved in *Ctesiphon III* (1968), but also rectilinear in *Six Mile Bottom* (1960, Tate Modern, London). Sol LeWitt had his images of symmetrical and precisely placed lines reproduced directly on the gallery wall. His objects effectively became instructions for the creation of the work by a team of assistants, comparable to an architect's drawings, for example, *Wall Drawing # 1042 (Isometric Form)* (2002).

Kinetic or Op Art: the Illusion of Movement

Kinetic or Op Art, a variation of this art form, manipulated visual responses to images. Artists drew on the theories and practices of the Bauhaus, many of whose members had relocated to the United States in 1933. The initial use of black-and-white forms to achieve the desired visual effects was developed further by Bridget Riley, using colour combinations and forms.

APPRECIATING...

Minimalism can best be understood in the context of its rejection of the principles of Modernism and its use of objects and forms to create an aesthetic experience. Artists sought impersonal and non-expressive forms that the viewer could engage with and could explore from many perspectives.

RELATED WORKS & ARTISTS

- Minimalism – **Jo Baer, Donald Judd, Frank Stella, Sol LeWitt, Dan Flavin, Carl Andre, Eva Hesse, Robert Morris, Ellsworth Kelly, John McCracken, Richard Serra**.
- Op Art – **Bridget Riley, Victor Vasarely, John McHale, Julian Stanczak, Richard Anuszkiewicz**.

❚ BRIDGET RILEY (b.1931)
Movement in Squares 1961,
Arts Council Collection, London.

The precisely painted squares and rhythmic size variation create the optical illusion of movement and depth. The instability of the image has been perceived as a metaphor for the uncertainties and cultural changes of the 1960s.

After Modernism

The concept of Postmodernism was first articulated during the 1970s, when theorists perceived that we were no longer in the era of Modernism. It has been used, however, to mean many things, and the word itself is problematic. 'Modern' is derived from the Latin word *modo*, meaning 'just now', so 'post-modern' means 'after just now'. Despite this, the period starting around the 1960s is usually referred to as Postmodern. Yet much of the art characterised as being Postmodern can be seen to have roots stretching as far back as the work of Marcel Duchamp.

APPRECIATING...

The Postmodern era presents complex and diverse issues for art and painting. Plurality has led to a revival of painting, and it is employed by artists in new, innovative ways. There are 'no rules' or limits restricting how it might be used, and materials other than paint are sometimes applied to canvas: Chris Ofili has used elephant dung in some of his works.

A New Spirit in Painting

The rejection of Modernism by artists during the 1950s and 1960s led to the diversification of art into new media, new modes of expression and new contexts. Artists favoured installations, performance, photography, video, Land Art and Conceptual Art – art made using almost any material or media except paint on canvas. In turn, there was a reaction that sought to bring painting back into the mainstream. In 1981, an exhibition held at the Royal Academy, London, entitled 'A New Spirit of Painting', displayed works by a range of artists, including the Neo-Expressionists. Such artists as Anselm Kiefer used paint to explore contemporary issues: his early paintings in particular engaged with Germany's war record and the collective memory in relation to the Holocaust. More recently, other painters, among them Paula Rego, have painted subjects that have a more personal resonance.

Anything Goes

The perception of the art world during the 1990s was that all constraints had been removed and that literally 'anything went'. The inclusive definition encapsulated by the Institutional Theory of Art (*see page 168*) was paralleled by a plurality of forms, media, subjects and approaches. Critical theorists, such as Michel Foucault, Roland Barthes, Charles Jenks, Jean-François Lyotard and Jean Baudrillard, variously articulated

■ **ANSELM KIEFER** (b.1945)
Noch ist Polen Nicht Verloren (Poland is Not Yet Lost) 1968–88, Private Collection.

Kiefer's works are often dark and monotonal, using texture to create atmosphere and mood. The subject here seems to refer to Germany's invasion by Poland. German tanks were met by the Polish cavalry in an impossible defence of their country.

scepticism regarding value systems and the so-called 'meta-narratives' that society had been encouraged to follow. The ideas of these theorists provide a conceptual framework that underpins the plurality and self-awareness of contemporary art. With no universal value system, art can be anything that its makers assert it to be, while its commercial value is linked more closely than ever to managing perceptions in the market. It can be read in multiple ways, often contrary to artistic intention, or it can refer to past art forms.

The eclectic and diverse nature of art during the 1990s was most aptly expressed in the 'Sensation' exhibition held at London's Royal Academy in 1997. Such works as Damien Hirst's *The Physical Impossibility of Death in the Mind of Someone Living* (1991, Saatchi Collection, London), and Tracey Emin's *Everyone I Have Ever Slept With 1963–95* (1995), might be seen as encapsulating the concept of Postmodernism.

The Body and Gender in Painting

The body was largely marginalised by Modernism, but concerns with ideas of beauty, feminism and gender have brought it back to prominence in recent decades. Georgia O'Keeffe's flower paintings symbolised a new feminist art for many, whilst such artists as Francis Bacon and Lucian Freud continued the traditions of figure and nude paintings. Jenny Saville's work explores preconceptions about body shape, gender identity and beauty through graphic and complex photographs and paintings. Feminist theorists and feminist artists have sought to challenge patriarchal hegemony in art both by re-interpreting art from past centuries and by exploring feminine contexts and forms of expression.

TRACEY EMIN (b.1963)
Everyone I Have Ever Slept With 1963–95 (1995), destroyed 2004, formerly Saatchi Collection, London.

Emin's work involved embroidery, quilting and drawing to commemorate all the people she had slept with, including her brother in her childhood, as well as her lovers. Emin's work is a personal exploration of experience, and possibly catharsis.

JENNY SAVILLE (b.1970)
Rubens Flap 1999, Gagosian Gallery, London, Los Angeles, New York and Rome.

Saville explores perceptions of the body and gender, challenging preconceptions of beauty and physical identity

KEYWORDS & MOVEMENTS

Conceptual Art arose during the late 1960s and gave precedence to the concept to be expressed rather than the constraints of traditional painting or sculptural media. Artists could use any appropriate materials.

Neo-Expressionism coined in the 1980s to encompass works by artists who sought to revive the idea of expression in painting. It was perceived as being a reaction to Minimalism and Conceptual Art. A number of sub-groups are based in different countries.

Young British Artists (YBAs) artists largely trained at Goldsmiths College, London, who showed works at 'Freeze' (1988, an East London warehouse) and 'Sensation' (1997, Royal Academy, London) exhibitions. Charles Saatchi was involved in promoting the group.

RELATED WORKS & ARTISTS

- **Georgia O'Keeffe, Francis Bacon, Lucian Freud, Chuck Close, Jack Vettriano, R B Kitaj, Billy Childish**.
- Neo-Expressionism – **Philip Guston, Leon Kossoff, Gerhard Richter, Paula Rego, Georg Baselitz, Sigmar Polke, Anselm Kiefer, Julian Schnabel, Francesco Clemente, Jean-Michel Basquiat**.
- YBAs – **Tracey Emin, Marcus Harvey, Damien Hirst, Gary Hume, Sarah Lucas, Chris Ofili, Fiona Rae, Jenny Saville**.

New Horizons

The events of 11 September 2001 changed the world. Their impact on art is, perhaps, still in its early stages, but they brought new global perspectives to the fore. Perhaps most pertinent are the aims and ideals of Post-Colonialism. Set against the struggles of societies across the world, the concerns of Western art – from the academy to Postmodernity – appear marginal. Non-Western artists, with their own aesthetic heritage and agendas, are increasingly coming to prominence.

APPRECIATING...

The 21st century has brought new issues and horizons to art. Painting continues to be an important medium, but the changing perspectives of art in the global arena will set it new challenges for the future.

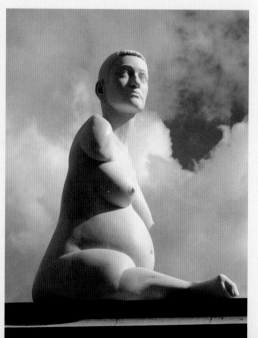

RELATED WORKS & ARTISTS

- **Peter Kennard** *Santa's Ghetto* 2006, Private Collection.
- **Yinka Shonibare** *Mr and Mrs Andrews Without Their Heads* 1998, National Gallery of Canada, Ottawa.
- **Mark Wallinger** *State of Britain* 2007, Tate Britain, London (Turner Prize nomination, 2007).
- Galleries exhibiting contemporary art are displaying the work of Non-Western artists in London, New York and other cities.

Hybridity

The aim of Post-Colonialism is equal economic and cultural status for Non-Western societies against the impositions of present and past Western colonial activities. It raises issues of identity, ethnicity, class and gender across a broad spectrum of circumstances. For artists with a Non-Western heritage, or from diasporic backgrounds, questions arise regarding the form and interpretation of artistic and cultural expression. There is an argument that the phenomenon of Postmodernism is entirely Western, and of little relevance to Non-Westerncultures. If this is the case, then how are we to perceive art in the 21st century? Alternatively, the freedoms of expression engendered in Postmodernity may provide a new, inclusive platform for future artists across the world.

Responses to the issues raised by Post-Colonial studies in literature have suggested hybridity as a way forward. Artists, both Western and Non-Western, have drawn on artistic forms across cultural boundaries. Recently, for example, Anish Kapoor, who was born in India, and Yinka Shonibare, who was born in England of Nigerian parents, have drawn on their cultural heritage in their works. Shonibare explores paintings in the Western canon from a Post-Colonial perspective, whilst Kapoor draws on the colours and textures of India in his works.

▌ MARC QUINN (b.1964)
Alison Lapper Pregnant 2005,
Fourth Plinth, Trafalgar Square, London.

The fourth plinth in Trafalgar Square, London, was empty for many years before a programme to display contemporary art works on it began during the late 1990s. Surrounded by heroes of Britain's naval and military past, it is, perhaps, appropriate that this sculpture should symbolise the values and ideals of contemporary Britain, as its neighbours once did.

▌ANISH KAPOOR (b.1954)
From Blackness From Her Womb 2000,
Tate, London.

This etching is part of a series in which rich glowing colours and textures create images with spiritual resonance. The strong tonal contrasts create depth and radiance whilst the forms reference organic or human shapes.

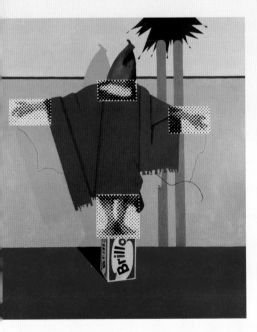

▌GERALD LAING (b.1936)
Study for Capriccio 2005, Private Collection.

Responding to the abuse of prisoners at Abu Ghraib prison in Iraq, Laing uses Pop Art forms to symbolise US imperialism and to raise political concerns about its role in Iraq. The use of art for political comment and satire has again become an important form of artistic expression.

KEYWORDS & MOVEMENTS

Post-Colonialism a movement galvanised by Edward Said's *Orientalism* (*see page 33*), according to which the West has systematically constructed the idea of a subordinate and inferior East – or 'other'. Western countries colonised the world from the 16th century to exploit the commercial potential of Non-Western territories. Although most countries now have their independence, continued economic dominance by Europe and the United States generally places the West's interests above those of Non-Western countries. Post-Colonialism seeks to redress this imbalance.

Politics and Art

The use of art and painting for comment, criticism and satire can be dated back to at least the 18th century, and to William Hogarth. During the 20th century, starting with Dada, painting has been used to observe, represent or raise awareness of social, political, economic, and recently ecological, issues. During the 21st century, these issues continue to provide subjects for European artists like Anselm Kiefer, Gerald Laing, Mark Wallinger, Banksy, Michael Sandle and Peter Kennard, but Non-Western artists are also engaging with them. At the 2007 international art exhibition 'Documenta 12', held in Kassel, Germany, artists from many circumstances and backgrounds across the world explored these issues in a range of media and forms. Many of them used art to draw attention to personal, local, regional or global concerns: immigration, war, oppression, economic circumstances, work, ethnicity, identity, gender and the impact of globalisation.

The Future of Painting

In 2006, the winner of the Turner Prize, in London, was Tomma Abts, whose display of abstract works used the paint's texture and surface to create the illusion of three-dimensional forms and spatial relationships. There were few works at 'Documenta 12' that consisted solely of painting on canvas, but others incorporated paint media in other ways. Conversely, London's annual Royal Academy summer exhibition of 2007 displayed a wide range of paintings in styles ranging from abstraction to political realism. The canvas continues to provide a medium for expression, whether of personal or of more wide-ranging concerns.

Appendices

Major Museums & Art Galleries

AUSTRALIA

CANBERRA

National Gallery of Australia
Parkes Place
Parkes ACT 2600
Canberra
www.nga.gov.au

SYDNEY

Art Gallery of New South Wales
Art Gallery Road
The Domain
NSW 2000 Sydney
www.artgallery.nsw.gov.au

AUSTRIA

VIENNA

Kunsthistorisches Museum
(pages 26, 36, 49, 50, 77, 113,
129, 130, 142, 144, 145, 146)
Main Building
Maria Theresien-Platz
1010 Vienna
www.khm.at

Österreichische Galerie
(pages 68, 85)
Austrian National Library
Josefsplatz 1
P.O. Box 308
A-1015 Vienna
www.onb.ac.at/ev/collections

BELGIUM

ANTWERP

Koninklijk Museum voor Schone Kunsten
(page 60)
Kunsten Antwerpen
Leopold De Waelplaats
B-2000 Antwerpen
www.kmska.be

Musée Mayer van den Burgh
(page 110)
Lange Gasthuisstraat 19
2000 Antwerpen
museum.antwerpen.be/
mayervandenbergh/

BRUGES

Groeninge Museum
(page 113)
www.brugge.be/internet/en/
musea/Groeningemuseum-
Arentshuis/Groeningemuseum/
index.htm

Memlingmuseum Sint-Janshospitaal
(page 121)
www.brugge.be/internet/en/
musea/Hospitaalmuseum/
Historische_hospitalen_1/index.
htm

BRUSSELS

Musées Royaux des Beaux-Arts (Musée d'Art Ancien Musée d'Art Moderne)
Rue Du Musée 9
1000 Brussels, Belgium
www.fine-arts-museum.be

CANADA

OTTAWA

National Gallery of Canada
(page 172)
380 Sussex Drive Box 427
Station A
Ottawa, Ontario
Canada
K1N 9N4
www.gallery.ca

CZECH REPUBLIC

PRAGUE

National Gallery
Národní galerie v Praze
Palais Sternberk (Šternbersky
Palác)
Hradcanske-Platz 15
Prague
www.ngprague.cz

DENMARK

COPENHAGEN

Ny Carlsberg Glyptotek
Dantes Plads 7
DK–1556 Copenhagen V
www.glyptoteket.dk

FRANCE

ALBI

Musée Toulouse-Lautrec
Palais de la Berbie
B.P. 100
81003 Albi Cedex
www.musee-toulouse-lautrec.
com

AUTUN

Musée Rolin
(page 143)
3, rue des Bancs
71400 Autun
www.musees-bourgogne.org/
les_musees/musee_bourgogne_
resultat.php?id=69&theme=arch
eologie

BAYEUX

Musée de la Tapisserie
(page 89)
Centre Guillaume le Conquérant
Rue de Nesmond
14400 Bayeux
www.bayeux-tourism.com/eng/
decouvrir/decouvrir.html

BORDEAUX

Musée des Beaux-Arts
Jardin de la Mairie
20 Cours d'Albret
33000 Bordeaux
*www.culture.gouv.fr/culture/
bordeaux/*

CHANTILLY

Musée Condé
(page 140)
Château de Chantilly – Musée
Condé
BP 70243
60631 Chantilly Cedex
www.museeconde.com

LILLE

Musée des Beaux-Arts
Palais des Beaux-Arts
Place de la République
59000 Lille
www.pba-lille.fr

LYON

Musée d'Art Contemporain
Cité Internationale
81 quai Charles de Gaulle
69006 Lyon
www.moca-lyon.org/vdl/

MONTPELLIER

Musée Fabre
(pages 112, 115)
39 boulevard Bonne Nouvelle
34200 Montpellier
*www.montpellier.fr/328-le-
musee-fabre-montpellier.htm*

NICE

**Le Musée d'Art Moderne et
d'Art Contemporain**
Promenade des Arts
06364 Nice Cedex 4
www.mamac-nice.org

PARIS

Musée Cognacq-Jay
(page 97)
Hôtel Donon
8, rue Elzévir
75003 Paris
*www.paris.org/Musees/Cognacq.
Jay/info.html*

Musée du Louvre
(pages 12/13, 23, 30, 31, 32, 33, 37,
39, 40, 43, 47, 49, 51, 63, 72, 75,
79, 80, 94, 90, 98/99, 101/2, 107,
109, 110/1, 113, 114/5, 124/5, 131,
139, 140, 141, 146, 149)
34, rue du Louvre
75001 Paris
www.louvre.fr

Musée d'Orsay
(pages 7, 32, 33, 105, 115, 132/3,
135, 153, 152)
1 rue de la Légion d'Honneur
75007 Paris
*www.musee-orsay.fr/en/home.
html*

Musée du Petit Palais
(page 132)
Avenue Winston Churchill
75008 Paris
*www.paris.org/Musees/PPalais/
info.html*

Musée Marmottan
(page 132)
2, rue Louis-Boilly
75016 Paris
www.marmottan.com

**Musée National d'Art Moderne,
Centre Georges Pompidou**
Place Georges Pompidou
75004, Paris
www.centrepompidou.fr

ROUEN

Musée des Beaux-Arts
Esplanade Marcel-Duchamp
76000 Rouen
www.rouen-musees.com

STRASBOURG

Musee des Beaux Arts
(page 129)
Palais Rohan
2, place du Château
67076 Strasbourg
*www.musees-strasbourg.org/F/
musees/bbaa/beauxarts.html*

GERMANY

BERLIN

**Alte Nationalgalerie Kunst des
19 Jahrhunderts**
(pages 27, 113, 131, 144)
Bodestrasse 1-3
10178 Berlin-Mitte
www.alte-nationalgalerie.de

Charlottenburg Palace
(page 149)
Spandauer Damm 10-22
14059 Berlin
www.spsg.de/index.php?id=134

Gemäldegalerie
(page 127)
Matthäikirchplatz 4/6
10785 Berlin-Tiergarten
*www.smb.spk-berlin.de/
smb/sammlungen/details.
php?objectId=5*

Neue Nationalgalerie
Potsdamer Strasse 50
10785 Berlin, Germany
*www.smb.spk-berlin.de/
smb/sammlungen/details.
php?objectId=20*

BREMEN

Kunsthalle
(page 121)
Am Wall 207
28195 Bremen
www.kunsthalle-bremen.de

DRESDEN

Gemäldegalerie Alte Meister
(page 29, 31, 140)
Zwinger, Semperbau
Theaterplatz 1
01067 Dresden
*www.skd-dresden.de/en/museen/
alte_meister.html*

Staatliche Kunstsammlungen
(page 153)
Residenzschloss
Taschenberg 2
*www.skd-dresden.de/en/index.
html*

FRANKFURT

Frankfurt Museum für Moderne Kunst
Domstrasse 10
60311 Frankfurt, Germany
www.mmk-frankfurt.de

HAMBURG

Kunsthalle
(page 131)
Glockengiesserwall
20095 Hamburg, Germany
www.hamburger-kunsthalle.de

KASSEL

Staatliche Museen
(page 29)
Museumslandschaft Hessen Kassel
Schlos Wilhelmshöhe
34131 Kassel
www.museum-kassel.de

KÖLN (COLOGNE)

Museum Ludwig
(page 169)
Bischofsgartenstr. 1
50667 Cologne
www.museum-ludwig.de

MÜNCHEN (MUNICH)

Alte Pinakothek
(pages 30, 43, 45, 57, 127, 144)
Barer Strasse 27
80333 Munich
www.pinakothek.de/alte-pinakothek

Neue Pinakothek/Staatsgalerie Moderne Kunst
Barer Strasse 29
80799 Munich
www.pinakothek.de/neue-pinakothek

STUTTGART

Staatsgalerie Stuttgart
Konrad-Adenauer-Str. 30–32
70173 Stuttgart
www.staatsgalerie.de

HUNGARY

BUDAPEST

Museum of Fine Arts
(pages 66, 140)
Buda Castle, The Royal Palace Building B,C,D, 2 Szent György Square
1014 Budapest
www.museum.hu/budapest/nemzetigaleria

IRELAND

DUBLIN

National Gallery of Ireland
(page 64)
Collins Barracks
Benburb Street
Dublin 7
www.museum.ie

ITALY

FLORENCE

Brancacci Chapel, Santa Maria del Carmine
(page 25)
Piazza del Carmine
50124 Firenze
www.comune.firenze.it/servizi_pubblici/arte/musei/h.htm

Galleria degli Uffizi
(pages 6, 24, 26, 38, 49, 55, 62/63, 65, 72, 74/75, 77, 90, 107, 121, 123, 142)
Piazzale degli Uffizi
50122 Firenze
www.polomuseale.firenze.it/english/musei/uffizi

Galleria Palatina (Palazzo Pitti)
(page 140)
Piazza Pitti 1
50125 Firenze
www.polomuseale.firenze.it/english/musei/palazzopitti

Medici Chapel, Palazzo Medici-Riccardi
(page 38)
Via Cavour 3
50129 Firenze
www.palazzo-medici.it/index.php

Palazzo Vecchio
(page 42)
Piazza della Signoria
50100 Firenze
www.comune.firenze.it/servizi_pubblici/arte/musei/a.htm

San Lorenzo
(page 107)
Piazza Madonna degli Aldobrandini 6
50123 Firenze
www.polomuseale.firenze.it/english/musei/cappellemedicee

San Marco Monastery
(pages 57, 60)
Piazza San Marco 3
50121 Firenze
www.polomuseale.firenze.it/english/musei/sanmarco/

Santa Maria Novella
(page 56)
Piazza S. M. Novella
50123 Firenze

www.comune.firenze.it/servizi_pubblici/arte/musei/b.htm

Villa Medici
(page 93)
Piazza de Medici 14
59016 Poggio a Caiano (PO)
www.polomuseale.firenze.it/english/musei/poggiocaiano

MANTUA

Palazzo Ducale
(page 141)
Piazza Sordello, 40
46100 Mantova
www.mantovaducale.beniculturali.it/

MILAN

Galleria d'Arte Moderna
Via Palestro 16
20121 Milan

Pinacoteca di Brera
(page 61)
Via Brera, 28
20121 Milano
www.brera.beniculturali.it

NAPLES

Galleria Nazionale di Capodimonte
(pages 45, 142)
via Miano 2
80132 Naples
www.museo-capodimonte.it

Museo Archeologico Nazionale
(page 104)
Piazza Museo
19 Napoli
www.marketplace.it/museo.nazionale/

RAVENNA

San Vitale
(page 36)
Museo Nazionale
Via Fiandrini
48100 Ravenna
www.turismo.ra.it/contenuti/index.php?t=arte_monumenti&id=10&cat=3

ROME

Galleria Borghese
(page 123)
Piazzale Scipione Borghese 5
00197 Roma
www.galleriaborghese.it/info-en.htm

Galleria Colonna
(page 142)
Piazza SS. Apostoli 66
00187 Roma
www.galleriacolonna.it

Palazzo Barberini, Gallerie Nazionale d'Arte Antica
(pages 41, 66, 128)
Via delle Quattro Fontane 13
00184 Roma
www.galleriaborghese.it/barberini/en/einfo.htm

Palazzo Farnese
(page 93)
Piazza Cittadella 1
00186 Rome

Pinacoteca Capitolina
(page 78)
Piazza del Campidoglio 1
00186 Roma
www2.comune.roma.it/museicapitolini/pinacoteca/

Pinacoteca Vaticana (Vatican Museums)
(pages 25, 45, 89, 93)
Vatican City
Holy See (Vatican)
mv.vatican.va/3_EN/pages/MV_Home.html

SANSEPOLCRO

Museo Civico
(page 58)
Via Aggiunti n. 65
Sansepolcro Arezzo
musei.provincia.ar.it/scheda_museo.asp?id=4

VENICE

Ca' Rezzonico
(page 149)
Dorsoduro 3136
30123 Venezia
www.museicivicieveneziani.it/frame.asp?musid=7&sezione=musei

Gallerie dell'Accademia
(pages 90, 91, 93, 122)
Campo della Carità
Dorsoduro n.1050
30130 Venezia
www.gallerieaccademia.org/museo.html

Museo Civico Correr
(page 107)
San Marco 52
30124 Venezia
www.museicivicieveneziani.it/frame.asp?musid=9&sezione=musei&tipo=

Palazzo Ducale
(pages 64, 78, 90)
San Marco 1
30124 Venice
www.museicivicieveneziani.it/frame.asp?musid=8&sezione=musei&tipo=

Palazzo Labia
(page 80)
Cannaregio
Campo S. Geremia 275
30121 Venezia
www.palazzolabia.it

Penny Guggenheim Collection
(page 157)
Palazzo Venier dei Leoni
Dorsoduro 701
30123 Venezia
www.guggenheim-venice.it/inglese/default.html

Santa Maria Gloriosa dei Frari
(page 41)
Campo dei Frari
San Polo, Venice
www.basilicadeifrari.it

Scuola di San Rocco
(page 64)
San Polo, 3052
30125 Venezia
www.scuolagrandesanrocco.it/#

JAPAN

TOKYO

Bridgestone Bijutsukan (Bridgestone Museum of Art)
1-10-1, Kyobashi
Chuo-ku
Tokyo 104-0031
www.bridgestone-museum.gr.jp

NETHERLANDS

AMSTERDAM

Rijksmuseum
(pages 43, 92/93, 123, 129, 146/7)
Jan Luijkenstraat 1
1071 ZD Amsterdam
www.rijksmuseum.nl

Van Gogh Museum
(page 152)
Paulus Potterstraat 7,
Museumplein
1070 AJ Amsterdam
www.vangoghmuseum.nl

Stedelijk Museum
Paulus Potterstraat 13
Museumplein
1071 CX Amsterdam
www.stedelijk.nl

HAARLEM

Frans Halsmuseum
(page 43)
Groot Heiligland 62
Haarlem
www.franshalsmuseum.nl

THE HAGUE

Haags Gemeentemuseum
Stadhouderslaan 41
2517 HV Den Haag
Postbus 72
2501 CB Den hag
www.gemeentemuseum.nl

Mauritshuis
(pages 108, 110, 126/7)
Korte Vijverberg 8
NL 2513 AB Den Haag
www.mauritshuis.nl

NORWAY

OSLO

Nasjonalgalleriet
Kristian Augusts gate 23
Oslo
www.nationalmuseum.no

POLAND

POZNAN

Muzeum Narodowe w Poznaniu
Aleje Marcinkowskiego 9
61-745 Poznan
www.mnp.art.pl

GDANSK

Muzeum Narodowe
(page 41)
ul. Torunska 1
80-822 Gdansk
www.muzeum.narodowe.gda.pl

PORTUGAL

LISBON

Museu Nacional de Arte Antiga
(page 60)
Rua das Janelas Verdes
1249-017 Lisboa
www.mnarteantiga-ipmuseus.pt

RUSSIA

MOSCOW

**The Pushkin Museum of
Fine Arts**
(pages 30, 146)
12, Ulitsa Volkhonka
121019 Moscow
*www.museum.ru/gmii/defengl.
htm*

Tretyakov Gallery
(pages 161, 164)
Lavrushinsky perculok 10
Moscow
www.tretyakovgallery.ru/english/

SAINT PETERSBURG

The State Hermitage Museum
(pages 49, 51, 78, 81, 110, 158)
Winter Palace, 34 Dvortovaya
Naberezhaya
Saint Petersburg 19000
www.hermitagemuseum.org/

Russian State Museum
(page 160)
Mickhailovsky Palace
4 Inzhenernaya Str.
www.rusmuseum.ru/eng

SERBIA AND MONTENEGRO

BELGRADE

Narodni Muzej
(page 135)
Trg Republike 1a
11000 Beograd
www.narodnimuzej.org.yu

SPAIN

BILBAO

Museo Guggenheim Bilbao
Abandoibarra Et. 2
48001 Bilbao
*www.guggenheim-bilbao.es/
ingles/home.htm*

MADRID

**Museo de la Real Academia de
Bellas Artes San Fernando**
(page 49)
C/ Alcalá, 13
28014 Madrid
rabasf.insde.es

Museo Nacional del Prado
(pages 26, 29, 30, 40, 44, 45, 60,
63, 65, 66, 74, 78, 80, 101)
Calle Ruiz de Alarcón 23
28014 Madrid
*www.museodelprado.es/
bienvenido/*

Museo Nacional Reina Sofia
(page 165)
Santa Isabel 52
28012 Madrid
*www.museoreinasofia.es/
portada/portada.php*

**Thyssen-Bornemisza
Collection**
(page 106)
Paseo del Prado, 8
28014 Madrid
*www.museothyssen.org/
thyssen_ing/home.html*

SWEDEN

STOCKHOLM

Moderna Museet
Skeppsholmen
SE-103 27 Stockholm
www.modernamuseet.se

Nationalmuseum
(page 95)
Södra Blasieholmshamnen
103 24 Stockholm
www.nationalmuseum.se

UPPSALA

Museum Gustavianum
(page 142)
Akademigatan 3
753 10 Uppsala
www.gustavianum.uu.se/english.
shtml

SWITZERLAND

BASEL

Kunstmuseum
(page 161)
St. Alban-Graben 16
CH-4010 Basel
www.kunstmuseumbasel.
ch/en.html

BERNE

Kunstmuseum
Hodlerstrasse 8–12
3000 Bern 7
www.kunstmuseumbern.ch/index.
cfm?nav=567,1333&SID=1&DID=9

ZURICH

Kunsthaus
Heimplatz 1
CH 8001 Zurich

UNITED KINGDOM

BIRMINGHAM

**The Barber Institute of
Fine Arts**
University of Birmingham
Edgbaston
Birmingham B15 2TS
www.barber.org.uk

**Birmingham Museums and
Art Gallery**
Chamberlain Square
Birmingham B3 3DH
www.bmag.org.uk

CAMBRIDGE

The Fitzwilliam Museum
(page 126)
Trumpington Street
Cambridge CB2 1RB
www.fitzmuseum.cam.ac.uk

DERBY

Museum and Art Gallery
(pages 150–51)
The Strand
Derby DE1 1BS
www.derby.gov.uk/LeisureCulture/
MuseumsGalleries/Derby_
Museum_and_Art_Gallery.htm

EDINBURGH

National Gallery of Scotland
(pages 47, 51)
The Mound
Edinburgh EH2 2EL
www.nationalgalleries.org

**Scottish National Gallery of
Modern Art**
(page 158)
75 Belford Road
Edinburgh EH4 3DR
www.nationalgalleries.org

Portrait Gallery
1 Queen Street
Edinburgh EH2 1JD
www.nationalgalleries.org

HATFIELD

Hatfield House
(page 40)
Hatfield
Hertfordshire AL9 5NQ
www.hatfield-house.co.uk

LIVERPOOL

Lady Lever Art Gallery
(page 85)
Port Sunlight Village
Wirral CH62 5EQ
www.liverpoolmuseums.org.
uk/ladylever

Tate Gallery
Albert Dock
Liverpool L3 4BB
www.tate.org.uk/liverpool

LONDON

Courtauld Institute Galleries
(pages 51, 115)
Somerset House
Strand
London WC2R 0RN
www.courtauld.ac.uk

**Institute of Contemporary Arts
(ICA)**
The Mall
London SW1Y 5AH
www.ica.org.uk

The Iveagh Bequest
Kenwood House
(pages 43, 47, 127)
Hampstead
London NW3 7JR
www.english-heritage.org.uk/
server/show/nav.12783

National Army Museum
(page 97)
Royal Hospital Road
Chelsea
London SW3 4HT
www.national-army-museum.
ac.uk

National Gallery
(pages 26, 28, 30, 39, 40, 43,
46, 47, 49, 57/58, 64, 72, 74, 77,
90/91, 95, 101, 113, 120/1, 125,
127, 129, 146, 149, 152)
Trafalgar Square
London WC2N 5DN
www.nationalgallery.org.uk

National Portrait Gallery
(page 49)
St Martin's Place
London WC2H 0HE
www.npg.org.uk/live/index.asp

Royal Academy of Arts
Burlington House
Piccadilly
London W1J 0BD
www.royalacademy.org.uk

The Royal Collection
(pages 45, 49, 152)
The Official Residences of
The Queen
London SW1A 1AA
www.royalcollection.org.uk

Sir John Soane's Museum
(pages 96/97)
13 Lincoln's Inn Fields
London WC2A 3BP
www.soane.org

Tate Britain
(pages 49, 66, 68, 82/83, 85,
131, 151, 172)
Millbank
London SW1P 4RG
www.tate.org.uk/britain/

Tate Modern
(pages 167, 173)
Bankside
London SE1 9TG
www.tate.org.uk/modern/

Victoria and Albert Museum
(page 118)
Cromwell Road
London SW7 2RL
www.vam.ac.uk

Wallace Collection
(pages 144, 149, 150, 151)
Hertford House
Manchester Square
London W1U 3BN
www.wallacecollection.org

MANCHESTER

The Whitworth Art Gallery
(page 82)
The University of Manchester
Oxford Road
Manchester M13 9PL
www.whitworth.manchester.ac.uk

OXFORD

Ashmolean Museum
(page 149)
Beaumont Street
Oxford OX1 2PH
www.ashmolean.org

PRESTON

Harris Museum and Art Gallery
(page 153)
Market Square
Preston
Lancashire PR1 2PP
www.harrismuseum.org.uk

ST IVES

Tate St Ives
Porthmeor Beach
St Ives
Cornwall TR26 1TG
www.tate.org.uk/stives/

WINDSOR

The Royal Collection
(pages 8/9, 45, 151)
Windsor Castle
Windsor SL4 1NJ
*www.royalcollection.org.uk/
default.asp?action=article&ID=34*

UNITED STATES OF AMERICA

BALTIMORE, MD

The Baltimore Museum of Art
(page 135)
10 Art Museum Drive
Baltimore, MD 21218-3898
artbma.org

BOSTON, MA

Museum of Fine Arts
(pages 33, 100, 115)
Avenue of the Arts
465 Huntington Avenue
Boston, MA 02115-5597
www.mfa.org

BUFFALO, NY

Albright-Knox Art Gallery
(page 69)
1285 Elmwood Avenue
Buffalo, NY 14222-1096
www.albrightknox.org

CHICAGO, IL

The Art Institute of Chicago
(page 119)
111 S Michigan Avenue
Chicago, IL 60603
www.artic.edu

DETROIT, MI

The Detroit Institute of Art
(pages 81, 134)
5200 Woodward Avenue
Detroit, Michigan 48202
www.dia.org

FORT WORTH, TX

Kimbell Art Museum
(page 143)
3333 Camp Bowie Boulevard
Fort Worth, TX 76107-2792
www.kimbellart.org

HOUSTON, TX

The Museum of Fine Arts
(page 49)
1001 Bissonnet Street
Houston, TX 77005
www.mfah.org

INDIANAPOLIS, IN

Indianapolis Museum of Art
(page 110)
4000 Michigan Road
Indianapolis, IN 46208-3326
www.imamuseum.org

LOS ANGELES, CA

The Getty Center
(page 107)
J Paul Getty Museum
1200 Getty Center Drive
Los Angeles, CA 90049-1687
www.getty.edu/museum/

Los Angeles County Museum of Art
(page 165)
5905 Wilshire Blvd.
Los Angeles, CA 90036
www.lacma.org

MINNEAPOLIS, MN

Minneapolis Institute of Arts
(pages 95, 135)
2400 Third Avenue South
Minneapolis, MN 55404
www.artsmia.org

NEW HAVEN, CT

The Yale University Art Gallery
(page 29)
1111 Chapel Street (at York Street)
New Haven, CT 203.432.0600
artgallery.yale.edu

NEW YORK, NY

Frick Collection
(page 146)
1 East 70th Street
New York, NY 10021
www.frick.org

Metropolitan Museum of Art
(pages 38, 51, 77, 123, 129, 131, 132, 135, 144, 146, 152)
1000 Fifth Avenue
New York, NY 10028-0198
www.metmuseum.org

The Museum of Modern Art
(pages 10, 159)
West 53 Street 11
New York, NY 10019-5497
www.moma.org

Pierpont Morgan Library
(page 67)
225 Madison Avenue at 36th Street
New York, NY 10016
www.morganlibrary.org

Solomon R Guggenheim Museum
(page 132)
1071 5th Avenue (at 89th Street)
New York, NY 10128 0173
www.guggenheim.org/new_york_index.shtml

NORFOLK, VA

Chrysler Museum of Art
(page 85)
245 West Olney Road
Norfolk, VA 23510
www.chrysler.org

PHILADELPHIA, PA

Pennsylvania Academy of Fine Arts
(page 96)
118 North Broad Street
Philadelphia, PA 19102
www.pafa.org/splashHtml.jsp

Philadelphia Museum of Art
(page 29)
26th Street and the Benjamin Franklin Parkway
Philadelphia, PA 19130
www.philamuseum.org

PITTSBURGH, PA

The Andy Warhol Museum
117 Sandusky Street
Pittsburgh, PA 15212-5890
www.warhol.org

SAN FRANCISCO, CA

San Francisco Museum of Modern Art
151 Third Street
San Francisco, CA 94103
www.sfmoma.org

WASHINGTON, DC

The Corcoran Gallery of Art
(pages 130/1)
500 Seventeenth Street NW
Washington, DC 20006
www.corcoran.org

National Gallery of Art
(pages 47, 51, 58, 77, 123)
4th and Constitution Avenue NW
Washington, DC 20565
www.nga.gov

WILLIAMSTOWN, MA

Clark Art Institute
(page 33)
225 South Street
Williamstown, MA 01267
www.clarkart.edu

Glossary & Keywords

abstract a representation which does not look like anything in the real world.

Academies the organisations set up in Rome (1593), Paris (1648) and London (1768) to train and set standards for the arts including painting and sculpture.

aesthetic 131

apotheosis 79

arcadia 125

avant-garde a movement or group of artists in the 20th century who were innovative and perceived to be before their time.

Baroque 65

Bauhaus 161

camera obscura 146

canon, canonical a work is said to be part of the canon if it exemplifies the highest standard of art for the period.

chinoiserie 151

Classical primarily refers to the art of Greece in the 5th century BC but can more loosely be used to describe art from Greece and Rome.

colore 61

composition the structure and layout of a painting taking account of the position of the individual elements and how they relate to each other visually.

conceptual art 171

contrapposto the pose of a figure with the weight on one leg so that the hips are twisted.

Cubism 158–59

culture used to describe a range of values, ideas and activities of a social group.

Dada 162

De Stijl 161

disegno 61

Enlightenment, The 67

en plein air 131

Expressionism 158

Fauvism 158

fête galante 148

flâneur 135

formalism, formalist the approach to analysing art which focuses on the formal qualities, for example colour, line, tone, shape.

fresco 57

Futurism 158

gender generally relates to the sexuality of an individual which is constructed within a society.

Genre 93

globalisation refers to contemporary activities which affect communities across the world, for example international trade, the internet.

grand tour travels taken by men from aristocratic backgrounds during the 18th and 19th centuries to countries of cultural importance, especially Italy.

guilds 145

hegemony the power someone has over another.

High Renaissance 63

Humanism 123

hybrid, hybridisation when art forms from two different cultures are combined.

icon a form of religious art through which the viewer can communicate or experience a spiritual connection to Christ, the Virgin, the saints.

iconography the signs and symbols which add meaning to a painting.

Impressionsim 132

installation 168

Institutional Theory of Art 168

International Gothic 39

juste milieu 153

Les Nabis 69

mannerism 65

media in the context of painting it refers to the type of paint, for example oil, tempera, fresco, watercolour or acrylic.

mimesis to visually imitate a subject so that it is a recognisable representation.

Modernism refers to art of the first half of the 20th century and especially to the art of the Abstract Expressionists.

Modernity 51

Muses 79

naturalism a representation which closely imitates the characteristics of the real and natural world.

Neo-Classicisim 98

Neo-Dada 167

Neo-Expressionism 171

Northern Renaissance 27

nude the representation of a naked figure which has been produced for display and viewing, especially of women displayed for the male viewer.

oculus 141

odalisque 33

oil painting 63

Op Art 168

parergon 121

pastoral 125

pendant portrait 44

Pop Art 167

Post-Colonialism 173

Post-Impressionism 115

Postmodern, Postmodernism, Postmodernity the period which has been identified as moving beyond or rejecting the values of modernism.

Post-Painterly Abstraction 161

psychoanalysis term coined by Sigmund Freud to describe his technique for exploring the unconscious mind in order to resolve trauma and mental illnesses.

Realism 101

Renaissance 24

Renaissance Neo-Platonism 75

Rococo 31

Romanticism 81

sacra conversazione 57

Salon, The 99

sex generally refers to natural sexual characteristic.

single point perspective 121

Soviet Socialist Realism 165

spectacle a work of art or performance which has more elaborate or site-specific features.

sublime 131

Surrealism 162

Symbolism 85

tempera 58

trompe l'oeil 112

vanitas 109

vedutism 129

Vorticism 158

Young British Artists (YBAs) 171

Further Reading

Survey Books

There are many books which survey part or all of the development of Western art from the Classical period onwards. A well written and comprehensive survey of the whole subject is *A World History of Art* by Hugh Honour and John Fleming (seventh edition, Laurence King Publishing, 1982–2005).

More detail can be obtained for specific centuries, for example Frederick Hartt and David G Wilkins' *History of Italian Renaissance Art, Painting, Sculpture, Architecture* (Pearson Prentice Hall, 2007) provides detailed coverage of the 15th and early 16th centuries. For the 17th century Ann Sutherland Harris' *Seventeenth-Century Art and Architecture* (Laurence King Publishing, 2005) is comprehensive; the 18th century is explored from critical perspectives by Matthew Craske in *Art in Europe, 1700–1830* (Oxford History of Art, 1997), and art of the 19th century is discussed in depth by Stephen F Eisenman and Thomas E Crow in *Nineteenth Century Art, A Critical History* (2nd edition, Thames & Hudson Ltd, 1994).

For an up-to-date view of the art of classical Greece and Rome and how it has influenced western art since the Renaissance consider Mary Beard and John Henderson's *Classical Art. From Greece to Rome* (Oxford University Press, 2001). Similarly the development of Roman and early Christian art is explored incisively in Jas Elsner's *Imperial Rome Christian Triumph* (Oxford History of Art, 1998).

Exhibition Catalogues & Gallery Guides

An excellent source of information about art is usually found in exhibition catalogues. They have the advantage of exploring a particular theme in some depth, often referencing the latest research on the subject and spanning a comprehensive range of art works. Both the essays in the catalogue and the descriptive entries can provide a thorough understanding of art at a detailed level.

Reference Books

Several useful books explore the terminology and concepts in this book including James Hall's *Dictionary of Subjects & Symbols in Art* (John Murray, 2000) and *The Thames & Hudson Dictionary of Art Terms* by Edward Lucie-Smith (Thames & Hudson Ltd, 1984) is useful for basic definitions. A more in-depth reference book on terms used in art history is provided by Jonathan Harris in *Art History, Key Concepts* (Routledge, 2006).

Introduction to Art History & Theory

The approach taken by this book to art and art history has introduced a number of concepts and theories about how to explore art and painting in more depth. Underlying these are methods and analytical approaches from the academic study of art history. There are several books that should be useful in extending engagement and understanding of these areas.

Mary Acton's *Learning to Look at Paintings*, (Routledge, 1997) provides clear guidance on how to look at and analyse compositions and paintings. Grant Pooke and Graham Whitham's *Teach Yourself Art History* (Hodder & Stoughton, 2003) is a clear introduction to exploring other aspects of art including contextual approaches, issues of display and contemporary theories. John Berger's *Ways of Seeing* (British Broadcasting Corporation & Penguin Books, 1972) offered a radical new approach to looking at art and the realm of the aesthetic. It is still widely used as a foundational text.

Eric Fernie's *Art History and Its Methods*, (Phaidon, 1995) introduces texts by key figures in art history since the 15th century and has a good glossary. Grant Pooke and Diana Newall's *Art History: The Basics* (Routledge, 2007) introduces and explains the central topics and contemporary issues for studying art and art history including Modernism, psychoanalytical approaches, gender, Postmodernism and globalisation.

Portrait

Shearer West's *Portraiture* (Oxford History of Art, 2004) provides a clear and well structured introduction to the different types of, and motivations for, portraiture. For a more in-depth study which addresses some of the contemporary issues affecting portraiture, consider *Portraiture, Facing the Subject* edited by Joanna Woodall (Manchester University Press, 1997).

The Nude

Kenneth Clark's *The Nude* (Penguin Books, 1956) still provides a thorough survey of the forms of the nude in Western art, although its approach is dated. More recent consideration of representations of gender in art is provided by Gillian Perry's *Gender and Art* (Yale University Press, 1999).

Religious Painting

To a large extent, most books that consider art of the 15th and 16th centuries are focused on religious art and painting. Books on the Florentine Renaissance and the High Renaissance in Rome are largely concerned with the developments in religious art through the period. To explore the origins of Christian art before 1400 Robin Cormack's *Byzantine Art* (Oxford History of Art, 2000), John Lowden's *Early Christian and Byzantine Art* (Phaidon, 1997) and Veronica Sekules' *Medieval Art* (Oxford History of Art, 2001) provide comprehensive studies.

For a broader study of art in Italy until 1500, Evelyn Welch's *Art in Renaissance Italy* (Oxford History of Art, 1997) explores many aspects of art including forms of production, media, context and function. For a detailed insight into the commissioning and patronage of art in 15th-century Italy see Michael Baxandall *Painting and Experience in 15th-Century Italy* (Oxford University Press, 1972, 1988). A good introduction to the Northern Renaissance is provided by Jeffrey Chipps Smith's *The Northern Renaissance* (Phaidon, 2004). For the later centuries, religious art tends to be included in books on broader surveys of art periods and styles. From the 19th century, books on the Pre-Raphaelites and Symbolism consider their differing approach to religious subjects.

Myth, Allegory & Historical Themes

Few books explore these subjects as separate topics and paintings of mythological, allegorical and historical subjects are usually covered within broader survey books. Ann Sutherland Harris' book (above), for example, includes discussion of works from the 17th century. The Getty series book *Symbols and Allegories in Art* by Matilde Battistini (Getty Publishing, 2005) provides a reference for interpreting symbols within allegorical paintings. For 18th-century France, Michael Levey's *Painting and Sculpture in France, 1700–89* (Yale University Press, 1993) is comprehensive and informative. For the late 18th century David Irwin's *Neo-Classicism* (Phaidon, 1997) is a useful reference.

Still Life & Genre

As much of the still life and genre painting takes place in the Dutch Republic, books on this subject provide a good introduction, for example *The Art of the Dutch Republic 1585–1718* by Mariet Westermann (Laurence King Publishing, 2005) and *Dutch Painting, 1600–1800* by Seymour Slive (Yale University Press, 1995). Contemporary interpretations of these subjects in art are provided by Svetlana Alpers' *The Art of Describing, Dutch Art in the Seventeenth Century* (new edition, Penguin Books Ltd, 1989) and Norman Bryson's *Looking at the Overlooked, Four Essays on Still Life Painting* (Reaktion Books, 1990). Representations of women in genre painting are explored in Wayne E Franits' *Paragons of Virtue, Women and Domesticity in 17th Century Dutch Art* (Cambridge University Press, 1993). The Getty series book on natural symbols is *Nature and Its Symbols* by Lucia Impelluso (Getty Publishing, 2005).

Landscape Painting

A contemporary and insightful study of landscape is provided by Malcolm Andrews' *Landscape and Western Art*, (Oxford History of Art, 1999). For the Impressionist landscape, James H Rubin's *Impressionism* (Phaidon, 1999) provides an excellent introduction. The analysis of van Ruisdael's painting is in 'Contrived Reality: Weather and Geology in Jacob van Ruisdael's painting "View of Ootmarsum" ' by Franz Ossing and Achim Brauer (GFZ Potsdam, 2006).

1900 to the Present

The 20th century is served by a huge range of books on the avant-garde movements and their underlying themes and ideas. For a good introduction consider *Varieties of Modernism* by Paul Wood (Yale University Press, 2004) and *Art of the Twentieth Century: A Reader* edited by Jason Gaiger and Paul Wood (Yale University Press, 2003). On specific movements there is *Cubism* by Neil Cox (Phaidon, 2000), *The Russian Experiment in Art 1863–1922* by Camilla Gray (Thames & Hudson, 1962) and *Abstract Art* by Anna Moszynska (Thames & Hudson Ltd, 1990). Malevich's quote is taken from *Art in Theory 1900–2000: An Anthology of Changing Ideas* edited by Charles Harrison and Paul Wood (new edition, Blackwell Publishers, 1992, 2003). For art since 1945 consider Robert Hughes' *The Shock of the New. Art and the Century of Change* (Thames & Hudson, 1980 and 1991) and *Themes in Contemporary Art* edited by Gillian Perry and Paul Wood (Yale University Press, 2004).

Web Resources

Art on the Internet

There are an increasing number of websites on the internet offering images and information about art, artists, art movements and periods. This is in addition to the image search facilities of the basic search engines like Google (www.google.co.uk), Yahoo (www.yahoo.com), Altavista (www.altavista.com) and Microsoft Windows Live Search (www.live.com) which allow you to search for an image anywhere on the internet. To narrow the search using these websites, enter the work of art's title and the artist's name into the search field, for example 'Michelangelo Sistine Chapel'. The largest and highest quality images should be displayed on the first page of the search results. If the required image does not appear, change the search parameters and try again.

Art Websites

There are several websites that provide descriptive information about artists and art works but the quality of the information is variable:

The Artchive (www.artchive.com) provides extensive coverage of artists and movements with reasonable descriptions and images covering a wide range of western European art including contemporary art.

The Web Gallery of Art (www.wga.hu) is well structured and comprehensive for art from 1100 to 1850 with good quality images, some art work descriptions, artist's biographies and a useful search engine. Although not all works of art are included on the website the coverage is relatively good.

For details of artists, artist's dates and lists of galleries with artist's works, the Artcyclopedia (www.artcyclopedia.com) is thorough and accurate. It can be used to find an artist and then go to the gallery or museum website to view images.

Other examples of websites with images are:
Art.com (www.art.com)
World Wide Art resources (wwar.com)
Artnet (www.artnet.com)
Webmuseum (www.ibiblio.org/wm/paint/auth).

The Wikipedia website will also have artists and art movements with a small number of images but care should be taken as the information provided is of variable quality and is sometimes incomplete.

Museums & Gallery Websites

Many of the major museums and galleries now have their collections on-line and available for viewing. The museum and gallery websites are listed in the section on Museums and Galleries (pages 175–82) and these will often have a 'Collection' link where you can either search for an artist or an art work or review the highlights of the collection.

Index – Artists

Page numbers in **bold** refer to illustrations.

Index – General

Acknowledgements

This book would not have been possible without the guidance and expertise of Dr Grant Pooke, University of Kent. I am enormously grateful for his time, effort and help. I would especially like to thank Stephanie Evans for all her support and assistance, and all those who have worked with me from The Ivy Press including Caroline Earle, Jason Hook, Andrew Milne, Kate Haynes, and Clare Haworth-Maden.

Picture Credits